RITUAL

RITUAL

Good Friday in Toronto's Italian
Immigrant Community
1969–2016

VINCENZO PIETROPAOLO

black dog
publishing
london uk

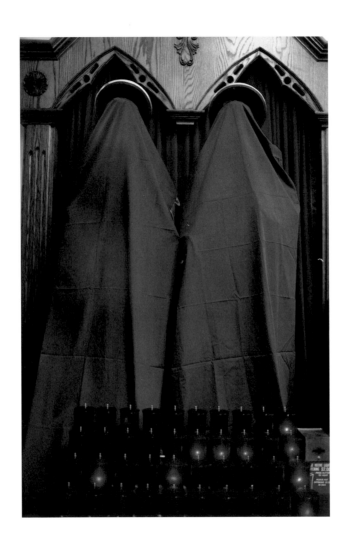

To the memory of

Maria Carmela Spanò & Paolo Pietropaolo, my parents

Concetta Sinibaldi & Diodato Colalillo, my parents-in-law

Devoted observers of the Good Friday ritual
who proudly interpreted my work
as a testimonial to their immigrant culture

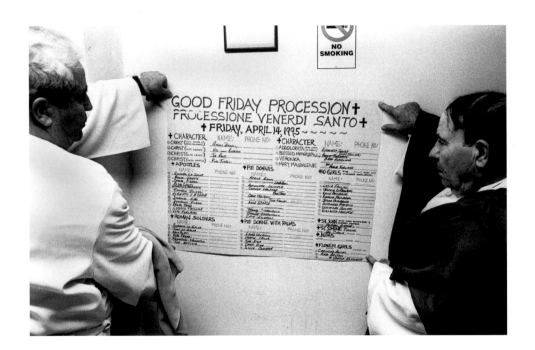

VINCENZO PIETROPAOLO'S DOCUMENTARY ROOTS
MAIA-MARI SUTNIK
9

PHOTOGRAPHY: A PERSONAL RITUAL
VINCENZO PIETROPAOLO
12

RITUAL: FOUR DECADES OF GOOD FRIDAY PHOTOGRAPHS
DON SNYDER
21

THE SEVENTIES
28

THE EIGHTIES
58

THE NINETIES
100

THE MILLENNIAL YEARS
152

IN THEIR OWN WORDS: CONVERSATIONS AND INTERVIEWS
188

LIST OF WORKS
204

PUBLICATION HISTORY OF PHOTOGRAPHS
212

EXHIBITION HISTORY OF PHOTOGRAPHS
213

ABOUT THE PROCESS
213

ACKNOWLEDGEMENTS
215

VINCENZO PIETROPAOLO'S DOCUMENTARY ROOTS

MAIA-MARI SUTNIK

In 1852, the art critic Henri de Lacretelle noted his impression of the nascent medium of photography:

> His [Charles Nègre] lens is as fast as movement. He has captured with incredible daring a market scene.... Street porters are walking, vendors raise arms, and the chicken quivers beneath the hand that seized it. They have all left their exact image in Nègre's camera, more rapidly than their shadow on the pavement. This is life itself, and Nègre has stopped it with a marvel, in a hundredth of a second.[1]

This extraordinary claim was made enthusiastically more in awe of the medium's transformative qualities than on accuracy. Many of Nègre's splendid accomplishments—architecture, vistas, doorways, portraits (all taken with long exposures)—emanate atmospheric qualities, often revealing impressions of movement. His *Chimney-Sweeps Walking* of 1851 is noteworthy for its candid sense of freedom in a grainy environment, animated by the "slice-of-life" sensibility that the sweeps bring to the image. On the other hand, his attempt to show off the panoramic pomp and drama of the *Funeral procession of Grand Duke Nicholas Tsarevich of Russia, at Nice,* in 1865, clearly foregrounds the challenge of delineating such a grand spectacle.

The procession and horde of participants is a static imprint, and indicates the shortcoming of tools to capture the event imminently. It took nearly another 70 years of optical progress and faster film sensitivity to give the photographer the chance of capturing movement instantaneously. With modern tools, the agile-minded photographer could now encounter the complexity of the documentary impulse, and engage in the potential for socially responsive work. Vincenzo Pietropaolo clearly belongs to the group of photographers who seek out challenges in subjects that call for social understanding. Approaching the annual College Street processional event in Toronto with documentary

insight, his visual acuity and vivid engagement affirm the social and cultural unfolding of a deeply felt religious narrative.

Pietropaolo sets the tone of *Ritual* as a community instilled story. With photographic roots in the humanistic tradition, his approach is not only to observe carefully and take photographs, but also to locate the structure of the ritual's spiritual centre—to capture a telling portrait of the devotional re-enactments by individuals whose lives are deeply embedded in the Good Friday Passion. Perceptively, he focuses on both the internal and external levels of community participation. To unify the emotional pitch of the event, intimate images blend with views delineating the fuller scope of the procession and its participants.

With his antecedents in the documentary work of pioneering photographers who expressed timely realities with the ideological power held in photographic images, Pietropaolo's documentary oeuvre is connected to this legacy inspired by the Photo League. Its emergence in New York City in 1936 evolved out of the political ferment of the 1920s and, until its demise in 1951, the photographers espoused the idea of photography assisting the working class struggle. Similarly, Pietropaolo links the Good Friday procession as a slice of "working class culture" by connecting the men solemnly carrying the recumbent *Cristo Morto* (Dead Christ) on their shoulders with the men who boldly carry placards at demonstrations that demand social justice and reform.

The Photo League formed a uniquely creative hub. Paul Strand, Lewis Hine, Walter Rosenblum, Sid Grossman, among the many affiliates, espoused the importance of artistic expression. Governed by their belief that a photograph was not only a document, they also considered photography to be valued aesthetically, as a conscientious statement of cultural and social currency. Nevertheless, unsympathetic forces generated political tension, thus contributing to the League's demise. With the reality of the Depression taking hold in America, photography became an official representative of conveying the declining social conditions. Evidenced in the developing Farm Security Administration (FSA, a government agency), photographers such as Dorothea Lange, Walker Evans, Arthur Rothstein, among other recruits, were commissioned to document the social hardships of destitute communities and the fortitude of the suffering population.

The influence of both the Photo League and FSA relate to the documentary photographer today, whose point of view of humanistic realism and attendant conditions is a challenge in itself. As values of documentary endeavours remain as open debates between the efficacy of the subjective vision—the photographer as a conscientious witness— and the academia of critics who suspect photography's visual content and placements, definitive answers are not likely to emerge. Differing critical positions have not achieved resolution of either the 'truth' or the 'deception' of photographic images. Neither is verifiable. What is evident are bodies of work, motivated and revealing of individual creativity. One can easily appreciate Pietropaolo's *Ritual*; its historical tradition embedded and at the same time, a sustained personal insight and interpretive engagement that has evolved across more than four decades of a dedicated career in documentary endeavours.

Pietropaolo's photographic participation and interface with the ritual's public presence has demanded more than the dexterity of using his camera. A self-confidence of interpretation, situating him into both the proximity and immediacy of the ritual (an experience developed over years), accounts for his skillful telling of the story. There is rarely a single universal truth to experience (or how we view it) yet the photographer is privileged to reflect his or her own version. This book is a culmination of personal experience and observation, a path revealing Pietropaolo's roots in socially conscientious work.

The status of photography has considerably changed from its nineteenth-century aspirations. Yet, Nègre expressed a belief in photographic "facts" transcending to embody expressions of personal value. It would be intriguing to know whether Pietropaolo's ritual procession is a work that meets the early practitioner's enthusiastic notion of camera fulfilment of "one hundredth of a second". Yet even more noteworthy are the accumulative observations of all the seconds that Pietropaolo invested in the "rapid, sane, and uniform means of working, which is at the artist's service... with form and effect as well as the poetry which is the immediate result of harmonious contention."[2] Nègre's point of view clearly matches an analogue that claims Vincenzo Pietropaolo's *Ritual* to live on as a compelling photographic achievement.

Maia-Mari Sutnik is the Curator Emeritus of Photography, Art Gallery of Ontario.

NOTES
1 de Lacretelle, Henri, *La Lumière,* vol 2, 18 February 1852, p 32.
2 Nègre, Charles, *Le midi de la France photographié, ms c. 1854,* Archives nationales, Paris.

PHOTOGRAPHY: A PERSONAL RITUAL

VINCENZO PIETROPAOLO

Every year as Good Friday approaches, I become restless with the pleasurable expectation that a significant event is about to unfold. It is caused by the knowledge that an elaborate religious procession in the streets of Toronto is about to get underway. This recurring event, a much anticipated and familiar journey, is now a personal pilgrimage that takes me back to familiar places and times. As I make my way towards College and Grace Streets in the heart of the city's historic Little Italy, I reflect on just how the Good Friday procession has become such an intricate part of my life. It has been re-enacted every single year since 1962 by the Italian parish at St Agnes Church, moving in 1966 to nearby St Francis of Assisi Church. I have photographed the event nearly every year since 1969.

The area near the church has already been closed to vehicular traffic and converted into a welcoming gathering space, a temporary piazza. I can visualize in my mind's eye the first gestures that I will exchange with people whom I have come to know through the viewfinder of my camera: how a simple gaze, the wave of the hand from a distance, or a subtle smile will soon turn into an intimate handshake, a warm embrace, and if I am fortunate, a photograph. The procession provides me with an opportunity to renew friendships and relationships, as I ritualistically take my place as a modern-day character in this Biblical pageant.

The ebb and flow of the memories I relive are anchored within me through the secure perch of my camera. For it is through my camera that I have met the people who *make* the event, who strive to mix ancient religious traditions with the communal expression of spirituality in the streets of a modern city. Photography and immigration have been "inextricably linked in my life", and personal expression through the camera helped me come to terms with the issues of identity and integration that I faced in the 1960s as a young immigrant from a small rural town in Calabria, southern Italy.[1] My lifelong documentation of the Good Friday procession has been a formative component of both my immigrant experience and my evolution as a photographer.

During our first two years in Canada my family and I lived on Grace Street, across from St Agnes Church, where I received the Sacrament of First Communion, an important rite of Catholic childhood. Later we moved a few blocks away, but within the same parish. I grew up in a strongly religious family, attended the local Catholic elementary school, and was exposed to the ritual of Good Friday long before I became interested in photography. Religious imagery and icons were abundant in my home, as were oral stories from the Gospels. I was also familiar with the notion of people praying in the streets, influenced by my early childhood days in Italy, where processions on a public street or piazza are a crucial part of tradition and spiritual expression and are embedded in the cultural psyche of the people. Witnessing the procession in Toronto reinforced a feeling of comfort in me and my family, but paradoxically, it had the effect of reminding us that we were in fact, immigrants, a transplanted community, and therefore different from mainstream Canadians. Not only was the language that we spoke at home different, but our names were foreign-sounding and utterly unpronounceable by English speakers. And likewise, as the procession revealed, our customs were quite unusual in the context of a conservative city that in the 1960s and 1970s was a bastion of Protestant culture.

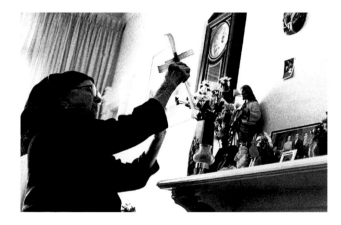

Maria Carmela Spanò, the author's mother, arranges a cross made from palms on the mantelpiece of her living room in preparation for Good Friday. Toronto, 1997.

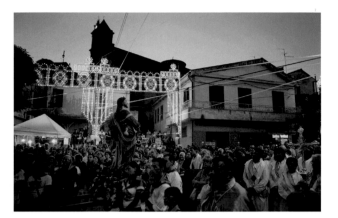

As a young photographer, I turned to the Good Friday procession as a concept that I could understand from the inside. The procession became my unofficial training ground. Since I was photographing for myself, and not for the approval of a magazine editor, I felt free to explore my own community in whatever way I could muster, unconsciously hoping to come to terms with conflicting values that arise through the uprooting process of immigration. I recognized the humble, raw features of the faithful in the procession—the working class or "salt of the earth", as *Toronto Life* described my subjects in 1977—to be the same hard working men and women whom I photographed, at about the same time, on construction sites and in factories all over Toronto.[2] I would come to see the similarities between the men who solemnly carried the recumbent *Cristo Morto* (Dead Christ) on their shoulders to the strain of funeral dirges and the men who boldly carried placards at the Legislative Building demanding social justice and reform of the province of Ontario's antiquated workers' compensation legislation; or the similar features in the women who carried the richly embroidered banner of the Sacred Heart of Jesus with those who toiled in the bowels of the garment industry on Spadina Avenue in the 1970s, long before the area became a coveted niche of art galleries and fashionable condominiums. Later, in the 1990s as I photographed

The feast of St Rocco, a major saint of Maierato, Calabria, Italy, is held at twilight in the main piazza of the author's native town, 2011.

labour and social protest movements, the similarities between the religious banners of Good Friday and the political banners of the activists as they marched on University Avenue, Toronto's premiere boulevard, were too striking to ignore. In using my camera as a tool for exploring my community and my own identity as an immigrant, it was transformed into a tool for activism.

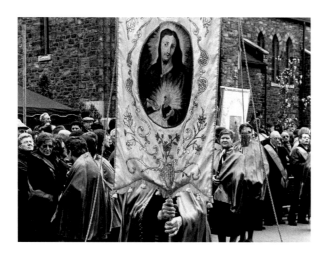

An Ancient Tradition

The procession offered me a source of constancy, and slowly I realized that the ritualistic appeal that it had for me was not only grounded in religiosity, but also in documentary photography, a medium that offered me the possibility to become an aspiring artist. In 1994, Good Friday coincided with a work trip to Mexico to photograph migrant farm workers. I realized quickly how strong the ritualistic appeal was embedded in me: I sought out a procession to photograph in the city of Zacatecas, Mexico. Although *La Procesión del Silencio* (Procession of Silence) was culturally different from Toronto, the essence and solemnity were eerily familiar to me.

On a recent trip to my hometown of Maierato, I was once again reminded of the fundamental importance of the religious procession to my cultural roots; on the evening of my arrival, I happened upon a procession that was underway in midsummer, and I felt a surge of emotion that took me back to Good Friday in Toronto. Virtually every

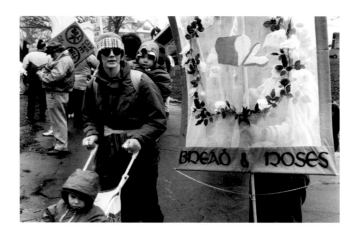

town in Italy has a procession uniquely dedicated to its own patron saint—the townspeople's protector saint, one of many venerated in the Roman Catholic Church. A patron saint is venerated through a *festa,* or feast, that consists of a spiritual component that includes a religious service and street procession, plus a secular component that is a celebratory street party with food, folkloric music and dance and games. Good Friday, however, is markedly different from the *festa* of a patron saint. Liturgically it is the most important day in the Christian calendar, and it is the one procession that is common to every sizable town in Italy. Its essence is of a symbolic funeral procession, expressed through the reenactment of the *Via Crucis* (Way of the Cross), the journey of Jesus Christ to his Crucifixion, known in the Liturgy as the Passion of Christ.

Embroidered banner commemorating the Sacred Heart of Jesus, at the Good Friday procession, Toronto, 2003 (detail).

The "Bread & Roses" banner commemorates the historic strike of mostly women immigrant workers, in Massachusetts, USA, 1912, which was immortalized as a labour hymn. Photographed at Days of Action Protest in Hamilton, Ontario, 1996.

In Toronto, more than 200 amateur actors, all volunteers, portray a myriad of tableaux vivants from Holy Week interspersed with banners of prayer groups like the Circle of the Sacred Heart of Jesus, and social clubs representing specific towns in Italy, which symbolically proclaim their presence in the procession. There are scenes of young girls in

Morto lying supine on an open *bara* (bier), a funeral platform carried on men's shoulders with dignity and solemnity, accompanied by an honour guard provided by veterans of the Italian *carabinieri* police in dress uniforms and plumed hats; and finally, an immensely sad-looking statue of Mary, the *Addolorata*, who follows behind the

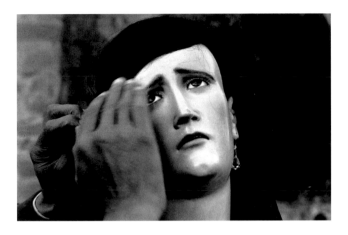

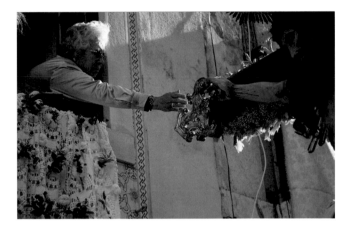

bride-like First Communion dresses carrying palms; the Flagellation of Christ by Roman soldiers who taunt and torture the shackled Jesus; a man solemnly carrying a heavy wooden cross on his shoulders; a woman dressed in a long black robe as *Addolorata* (Our Lady of Sorrows); women carrying accoutrements of the Crucifixion like nails, hammer and a crown of thorns, delicately laid out on soft, purple pillows like jewels—purple being the liturgical colour of mourning; numerous Biblical scenes such as the Pious Women dressed in long robes, with their heads and faces partially covered; Veronica displaying a veil on which Christ's facial features were imprinted in blood after she wiped the sweat off his face; various statues representing Biblical scenes such as Pontius Pilate passing sentence on Christ; a tall plaster statue of Jesus nailed to the Cross; a statue of *Cristo*

body of her son, grief-stricken. A throng of faithful worshippers trails for blocks, alternately led in prayer or mournful chant by priests and Franciscan monks. It matters little if some of the raspy and untrained voices wander off-key sometimes, for the worshippers feel secure in the familiar chords played by the brass bands. The plaintive strains of funeral marches and dirges such as *Mater Dolorosa* (Sorrowful Mother) and *Tristezza Eterna* (Eternal Sadness) attest to the funereal atmosphere of the event.

One of the principal participants is Giuseppe (Joe) Rauti, a maintenance worker in a home for the aged, now retired. He has portrayed Jesus Christ continuously for 48 years (except for one year due to a work injury), adhering to a vow that he made as a result of a life

La Dolorosa, a statue of Our Lady of Sorrows, or *La Procesiòn del Silencio* (Procession of Silence), on Good Friday in Zacatecas, Mexico, 1994.

The annual procession of *Senhor Jesus das Chagas* (Lord Jesus of Chagas) in the narrow streets of the city of Sesimbra, Portugal, 2008.

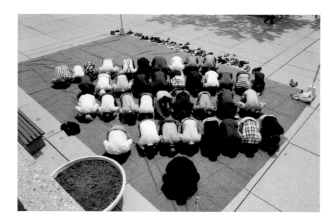

picture-taking. He had been portraying Jesus Christ for so many years... and I had been photographing him for just as long.[3]

At the outset of the procession Joe used to whisper in my ear the exact spots where he was going to fall with his cross, so that I could be ready with my camera. He was giving me the proverbial scoop as an insider, though it mattered little since he performed his three falls at exactly the same spots every year.

A Canadian Tradition

changing miracle in his family. Every year, he and I meet and exchange pleasantries about our families as we wish each other a "Happy Easter". A man who professes to carry a metaphorical cross in his daily life as a result of a child born with severe physical and intellectual disabilities whom he and his wife opted to look after at home for all her life, Rauti has dedicated himself to bearing a second cross, a wooden cross, on the streets of the city in atonement for a moment of doubt in his faith. He devotedly believes that this is his fate, or his "luck", as he now puts it. Over the years, I have been privileged to watch him as he transforms himself from Giuseppe the worker to Jesus the Saviour. He first takes a vow of silence in the weeks prior to Good Friday, then fasts during Holy Week, completing his transformation by donning a theatrical costume in the church basement complete with convincing—if exaggerated—makeup. In a magazine article some years ago I mused about how,

> I went to the men's room with Jesus. Well, not exactly Jesus, but Giuseppe Rauti. Already in his biblical robes and wearing a crown of thorns, Giuseppe wanted a second opinion—"Do you think I put too much blood on my face?"—and felt comfortable enough to interrupt my

It is curious that a now elderly gentleman in his 70s would continue to portray Jesus, who died at age 33. But this is the nature of the procession, where the community recognizes the man's need to fulfil his vow, as long as "God gives me the strength to do it". Others have similarly portrayed their characters for many years, including Isabel Mazzotta who becomes Veronica, Fabio Gesufatto who portrays the pillaged Jesus, and the late Filomena Maneli, who not only was a key organizer for many years, but also portrayed *Addolorata*, and was buried in the robes of her character.

These amateur actors have become unofficial celebrities in the community, for they perform in a complex and elaborate event that sometimes attracts crowds of more than 100,000. Although it is acknowledged by many media reports as the largest Good Friday procession in Canada and the United States, its beginnings were inauspicious, and can be traced to an unusual occurrence in 1962. According to accounts by the original organizers of the procession, it was Vito Telesa, a then-recent immigrant from Calabria, Italy and the sacristan of St Agnes Church, who in the course of doing some repairs in the basement of the church discovered a hollow space

Muslim faithful praying in the direction of Mecca, in Toronto's Nathan Phillips Square, during the Ashura Day procession, 1995.

behind a wall. The pastor, Rev Riccardo Polticchia, agreed that the false wall should be opened up. They were astonished to discover a plaster statue of the *Cristo Morto* sealed in a hidden closet behind the false wall.

The statue was scratched and discoloured, but none the worse for wear. Telesa, who had rudimentary experience in the art of gesso restoration, repaired it as best he could. With the help of community members like Giuseppe Simonetta and Luigi Ariganello, and with the support of the parish priest, an informal committee was organized, which took the initiative of holding the first Good Friday procession. They timidly embarked with their prized statue and walked in the form of a procession along Plymouth Avenue, a narrow laneway next to the church with little or no vehicular traffic that could have been disrupted. In so doing, they "tested the waters", and successfully so, for some 500 to 600 members of the parish attended. It was a bold move for the small Italian Catholic community in a Protestant city that eschewed ethnic expressions on the street; but the seeds of what would grow into one of Toronto's major street festivals had been sown. The procession has come to represent the affirmation of an immigrant community's identity. The evolution of the procession reflects the community's transformation from its humble working class beginnings to the dynamic role that it now enjoys in mainstream society—economically, socially and culturally.

As I follow the procession along its 8-kilometre route, I can see many characteristics that attest to its "Canadianness". It is to be found in the way that people move, with order and tidiness, careful not to take more personal space than necessary in the public street. It is in the context of the physical setting: Victorian semi-detached homes dwarfed by towering maple trees, quintessential Toronto. It is in the sometimes biting cold weather of late March, when everyone is forced to wear heavy winter clothing. It is the perceived need to carry the flags of three sovereign states at the beginning of the procession, proclaiming in turn the immigrant community's patriotism for their adopted Canadian homeland, nostalgia for their native Italian homeland left behind, and their spiritual allegiance to the Catholic Church ruled by the state of the Vatican. These symbols are prevalent in immigrant-based communities, and illustrates the pragmatism of the Canadian way of doing things.

As the procession grew, statues were procured from other churches in eastern Canada. Whenever a church was torn down due to redevelopment or as a result of a fire, arrangements were made to repurpose the statues for the procession. This is how the statues of *La Pietà*, Mary Magdalene and *Ecce Homo* (Behold the Man) were added. The latter was picked up from a seminary in Quebec City by two parishioners, who drove it to its new home in the back of their pick-up truck. When the Cultural Association of Castelliri, a social club named for a town near Rome, expressed a desire to join the procession with their patron saint, *Santa Maria Salomè*, a new tradition began whereby every year the saint is trucked in and out on the same day.

Spiritual and Secular Dimensions

By 1998, the procession had attracted significant international attention. The town of Recco, near Genoa, home to an eighteenth-century Baroque sculpture of the Crucifixion, requested permission to make a one-time appearance in the procession with their prized heritage art-piece. The valuable work required the approval of the government of Italy as well as Vatican City in order to leave the country. Toronto was treated to an historic and awe-inspiring display, as the gigantic sculpture was carried through the streets by only one man, who balanced it upright on a special harness attached to his shoulders and waist—without the use of his hands, which he kept clasped behind his back, in accordance with tradition.

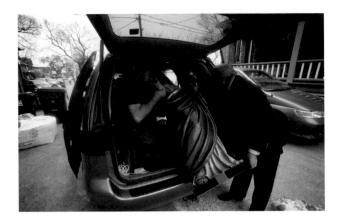

One of the key moments for the procession's growth occurred in the late 1980s when College Street was fully closed to vehicular traffic, including streetcars. Prior to that, the procession was permitted only on the south side of the street, with traffic flowing unimpeded on the north side, and streetcars operating in both directions. It was a chaotic situation, but this reflected the informality and casualness with which the procession became entrenched in the fabric of the city. It took more than two decades, but the success of the procession finally persuaded the authorities that both College Street and Dundas Street West, two of the most important transit corridors in the west end of the city, should be closed to streetcars.[4] The area today becomes flooded with automobiles as people drive to it from the outer suburbs of the Greater Toronto Area, such as Vaughan, where much of the Italian community has resettled. Organized bus tours come from as far away as Buffalo and Rochester, New York, as well as from many other towns around southern Ontario.

Not surprisingly, the procession keeps evolving with little changes every year, reflecting the tastes and priorities of newer generations. One year, the plethora of real flowers that adorned the statues was replaced with artificial flowers. It was "less of a mess", someone said, and "more practical", because it saved on the cleaning time afterward, said another. Another year, the platforms on which the statues were carried, were retrofitted with table legs and wheels or coasters; now they could be easily rolled through the streets. However, the effect of the solemnity created by the physical burden of mostly men and occasionally women carrying the statues on their shoulders was now gone, replaced with the kind of casualness that one associates with entertaining displays in secular parades. It is interesting that this "improvement" has not been applied to the statue of *Cristo Morto*, and the sense of gravitas that the central statue suffuses on the street is still as evident as it was in earlier days. Another year, the eight torches which burned in large black urns carried aloft dramatically on 2-metre wooden poles beside *Cristo Morto*, flames ablaze and blowing uncontrollably in the wind, were deemed a potential hazard, and they are no longer part of the event. I miss the odour of burning wax—the torches evoked a church smell and along with the visual play of the bright orange flames dancing above the crowds, they served to underscore the ceremony of the procession. In years past, it was not uncommon to see people fall on their knees in veneration as the holy relic carried by the priest passed by. The crowds were more humble, and they dressed more respectfully in their Sunday best reflecting not only the newness of the immigrant community in their adopted country, but also their devotion to the traditions they had left behind. Today, "casual" seems to be the preferred mode of attire, suggesting an informality not present in the earlier days of the procession.

Walking in the procession is an intrinsic part of the devotional ritual, a form of active participation in the ritual of celebrating Good Friday. But as the procession evolves into an increasingly showy and theatrical affair, it inevitably takes on attributes of a secular parade, and as a result it attracts more observers than walkers. It's as if the procession has mutated from a purely humble event of communal prayer to one that is decidedly mixed in spiritual and secular character. In part, it is the result of the organizers' desire to popularize the procession by introducing

The statue of *Santa Maria di Salomè* (St Mary of Salomè) is squeezed into a mini van for the return trip home in North York following its annual appearance in the procession, 2010.

highly dramatic scenes like the reenactment of the Flagellation of Christ, but it is also a natural outcome of the procession's widespread exposure in television, radio and print media, and in social media as well.

As a documentary photographer, I have watched the neighbourhood change dramatically in the past four and a half decades. The area has become highly gentrified as many of the working class families have moved away, or simply passed on. Victorian homes that once housed up to five families now have now been sandblasted and renovated and provide accommodation for two or three individuals (and maybe as many pets). The elementary school that I attended when I first moved to Canada, St Francis of Assisi School, has been redeveloped into townhouses. Many of the stately trees that lined the residential streets have succumbed to disease and have been cut down. Family-owned grocery stores, iconic symbols of ethnicity, have been replaced by boutiques and restaurants, though a few of the original cafes from the 1960s remain. The majority of the population is no longer Italian; Little Italy is largely Italian in name only. Where once I was virtually the only photographer, there is now a large contingent of professional newspaper photographers and videographers, and of course in the digital age, virtually everyone carries a smartphone with which they can take pictures usually destined for social media networks.

At the end of the procession, with the plaintive chords of the band still reverberating in my mind, I am drawn to memories of the iconic photographs that have been a lifelong source of inspiration for me. If the act of photographing this event is a personal ritual of photography, it is because my spiritual fathers and mothers are to be found within documentary photography itself. The plaster *Pietà* that I just photographed in the streets of Little Italy evokes the human *Pietà* created by Eugene Smith, when he photographed Tomoko Uemura in the arms of her mother in the village of Minamata, Japan, a photograph that became a rallying cry for social justice;[5] or Dorothea Lange's photograph of Florence Owens Thompson, better known as the "Migrant Mother",[6] to which I have always attributed a spiritual quality as the "Madonna" of farm workers, an image that is entwined with the humanistic perspective of my own documentation of Ontario farm workers, the harvest "pilgrims".[7]

Photography today is ubiquitous and pervades virtually every facet of our lives and possesses a fundamental influence on our social behaviour. Therefore, the practice of social documentary photography comes with the burden of social responsibility, perhaps more so today than ever before. To be a social documentary photographer means to have a commitment. It means the ability to recognize the historical context of the moment witnessed, and conversely, to be accepting of the ensuing political meaning that the act of photographing will produce. My role has been not merely to witness and record: I have committed myself to re-telling a story of my community through photography, in a work that I am hopeful transcends the visual religiosity and theatricality of the Good Friday event. Further, as a historical researcher, I am aware that it is a chapter of working class culture and immigrant history that has long been overlooked, sometimes dismissively, for its surface colour and ethnic flavour. But herein lies the power of photography: to help you bear witness and in so doing, becoming empowered to write a history of one's own.

NOTES

1 Pietropaolo, Vincenzo, *Not Paved With Gold*, Toronto: Between the Lines, 2006, p 1.
2 de Villiers, Marc, "Farewell to Little Italy", *Toronto Life*, June 1977, p 46.
3 Pietropaolo, Vincenzo, "The Good Friday Ritual", *This Country Canada*, Spring, no 10, 1996, p 66.
4 Although College Street is usually associated with the Good Friday procession and is the heart of Little Italy, Dundas Street West is also part of the event's route. Historically, Dundas was a central part of the Italian community, concentrated around St Agnes church, the site of the first procession.
5 Smith, W Eugene and Aileen Smith, *Minamata*, New York: Holt, Rinehart and Winston, 1975, pp 138–139.
6 Stryker, Roy Emerson and Nancy Wood, *In This Proud Land*, Greenwich, Connecticut: New York Graphic Society, 1973, cover.
7 Pietropaolo, Vincenzo, *Harvest Pilgrims*, Toronto: Between the Lines, 2009.

RITUAL: FOUR DECADES OF GOOD FRIDAY PHOTOGRAPHS

DON SNYDER

It is actually five decades since Vincenzo Pietropaolo joined his high school camera club and made his first prints in the school darkroom, but his enthusiasm makes it seem like this was only a brief moment ago:

> I would borrow a Pentax SV that my eldest brother had, or a small rangefinder called Halina 35X that he had also been given.... But that was only for a short time. I couldn't wait to get my own personal camera.... I purchased my first camera in 1968, with the help of my father. It was a Canon FT-QL with a 50mm 1.8 lens. I remember the circumstances well, and also the price: $219.95 plus tax.

> I looked in my records, and I found a letter dated 31 August 1970, addressed to *Impressions Magazine*, in which I wrote, "I am 18 years old, and in my last year of high school. I have pursued photography seriously for almost three years...." That would take me back to 1966–1967. It's an interesting letter, since it shows that I was making submissions to magazines, and freely stating my opinions about photography....

Pietropaolo recalls those years vividly, not only for the depth of his excitement to learn this new medium, but also for the intensity of the questions that were pulling him towards it in the first place, which he says arose as early as grade seven: "Who am I? Where am I going?"

These questions oriented his work towards the spiritual right from the start. An early memory of his father coming home from work and always taking his boots off at the back of the house is recalled with photographic precision and recounted with an intuitive, deeply sensed awareness of the value and meaning of everyday ritual; many descriptions of his upbringing in the Italian-Canadian community, with its strong sense of identity and faith, give another indication of this same appreciation. Discussing photographers who first influenced him—Alfred Stieglitz, Lewis Hine, Walker Evans, Dorothea

Lange, Eugene Smith, Paul Strand—Pietropaolo speaks of his "spiritual parents" in the medium, and talking about the issues that preoccupy him now, Pietropaolo comes back again and again to matters of the spirit: the photographer's responsibility for truthfulness, the tensions necessary for good image-making—"you can never rest while you are shooting"—and photography's potential to show the spiritual aspects of human experience, which he says are universally experienced but seldom represented. "We think of cities as secular, but spiritual expression is everywhere... why aren't there more images of the spiritual in the history of photography? Why such emphasis on ethnic representation, and so much less on spirituality?"

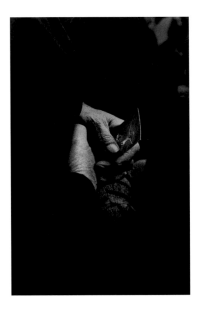

He continues:

> Certain images [from painting and film].... Michelangelo, Caravaggio, Pasolini... you see these images throughout

history, and they come back again and again... there is even a Sacred Heart of Jesus Tattoo Shop! But photography also is a very spiritual form of expression.... It gets at the spiritual essence of things, it helps you see them.... In one way, I learned about this first-hand from photographing the Good Friday procession over a period of years, gradually coming to understand its humanism and sense of community. My pictures are not 'off the wall' or 'in your face'—people will always know if your intentions are not honorable. I don't embellish, I don't crop, and my images are not about power... the story is more important than the individual pictures. Like John Berger in *The Seventh Man*, I'm trying to tell stories of ordinary people, in a way that makes them spiritual and extraordinary.... The camera has given me a ticket—almost an obligation—to look at the world.

This sense of the spiritual in photography—especially in work, community and ritual—and his personal conviction that the story is more important than the individual image are motifs that run through virtually all of Pietropaolo's work, in both exhibition and book forms. Three projects in particular exemplify this: *Not Paved with Gold: Italian-Canadian Immigrants in the 1970s* (published 2006), *Canadians at Work* (commissioned by the Canadian Auto Workers Union and published in 2000) and *Harvest Pilgrims: Mexican and Caribbean Migrant Farm Workers in Canada* (published in 2009). Made during the same decades as *Ritual,* these projects reinforce the viewer's appreciation for what Pietropaolo has accomplished in this volume, his most recent book. Looking into the faces of his subjects, and watching them appear to look back, their gaze meeting one's own, there is a sense, over and over, of encountering strength of purpose, humility, conviction, tenacity and faith, both revealed and reinforced by Pietropaolo's impeccable sequencing.

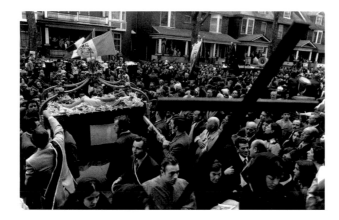

The photographs here are arranged by decade, giving Pietropaolo the opportunity to show both change and constancy over time, and giving the reader a chance to reflect on the cumulative meaning of a ritual procession that has taken place in Toronto annually for more than a half-century. The first sequence, from the 1970s, begins with a simple image of clasped hands, *Hands in prayer during all-night vigil in church, after the Good Friday procession*, 1972, (page 29), and concludes with a complex and angular crowd scene, in which the statue of the fallen Christ is preceded up the church stairs by a large cross (page 57). The entire sequence of photographs moves us through this complex narrative, defines the key themes of the ritual—prayer, vigil, faith across generations, preparation and procession, the cumulative drama of the Passion—and also defines photojournalism in the 70s: an art of black and white, careful framing and expressive printing driven by a humanistic perspective, and design considerations tailored to the printed page.

The 1970s in Canada saw the founding of both *OVO Magazine* and *Photo Communique*, a proliferation of galleries across the country devoted to photography, and conferences and publications such as

Canadian Perspectives, held in Toronto in 1978. Less-remembered, but no less valuable, were publications such as *The Globe and Mail*'s *Weekend Magazine*, which used photography effectively and well: the 5 October 1974 issue ran one of Pietropaolo's photographs on the cover, and devoted the lead story to "The Italians in Canada: Builders of a New Life", which reproduced the opening image of this book on its first page.

In the 1980s, colour overtook black and white, in both the fine arts and in the fields of journalism and documentary: this was the decade of Sally Eauclaire's trilogy of books on the emergence of colour photography (*The New Color Photography*, 1981, *New Color/New Work*, 1984, and *American Independents: 18 Color Photographers*, 1989), and of attendant changes in photographic education, critical writing and exhibition practice. Of the 34 photographs in this section of *Ritual*, only seven are in black and white, and they are printed to utilize the tone scale in a more open, naturalistic way. While the outlines of ritual and drama remain constant, in this section of the book Pietropaolo sequences his images to emphasize the public, the outdoor and the colourful, expanding the scope of his reportage to show a more varied crowd, with a much greater awareness of the camera. Some subjects openly pose, and everyone seems to know when the camera is observing them, even though few other photographers appear. This particular mix of self-awareness contrasted with self-abjuration is vividly shown in two photographs on pages 90–91: both figures carry crosses, but the younger subject questions the camera, while the older casts his gaze downward, still clinging to ritual and devotion.

Pietropaolo's third sequence, from the final decade of the twentieth century, returns to black and white, and includes image sequences that fold out, making it the visual centre of the book. The ritual procession now attracts a larger audience, and is becoming more widely known:

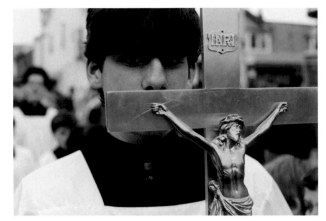

page 90

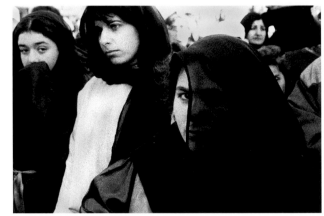

page 109

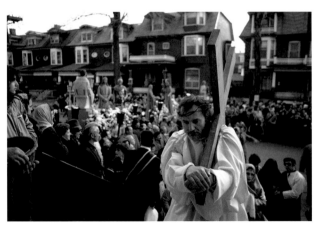

page 91

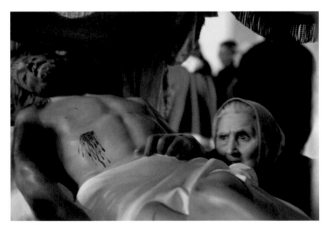

page 187

statuary figures and participants now arrive from outside Toronto, even outside Canada. In 1998, the Italian town of Recco lent its Baroque crucifix to the event, providing a new form of recognition to Toronto's Italian community. Police direct the crowds, stanchions line the streets and other photographers are seen more frequently. Working at close range and primarily with wider-angle lenses, Pietropaolo brings the viewer fully into the event; this section reads like a film, foreshadowing the era in which cameras produce both still photographs and video with equal facility. Certain photographs arrest this seemingly filmic quality, and confront the viewer with a variation of the questions Pietropaolo has been asking himself since grade seven; on page 109, a partially veiled figure seems to ask the photographer, "Who am I? What do I believe?"

Toronto has changed in the millennial years, yet the ritual continues. Participants take selfies; a newscaster comments as Christ stumbles to the pavement, and a camera from CHIN, a community cable television station, records the prone, fallen figure. We even see Christ being made up, blood applied to his face, and signs on local businesses say "Now Open Sunday Brunch" or "Happy Easter". It feels as if the ritual is more diffused, more varied, more mediated, but at the same time it feels more inclusive, even somewhat less formal. Remixing colour and black and white, interior and exterior, Pietropaolo has found a way to depict these changes, without ever veering away from his deep engagement with, and respect for, the figures who annually stage this ritual. The final photograph in the book shows an almost shocking intensity of devotion, as a scarfed woman gazes at the statue of Christ, her eyes slightly out of focus, but burning with intensity.

What does it mean for our own era, that in a time of global ideological conflict people still come together to re-enact rituals of faith? I think it means a lot; the photographs show this, over and over, and

the interview texts reaffirm it: in the words of Giuseppe Simonetta, a founding member of the Lay Committee of the Good Friday procession, "Without faith, you can't do anything."

Don Snyder is a professor at The School of Image Arts, Ryerson University.

RITUAL: THE PHOTOGRAPHS

THE SEVENTIES

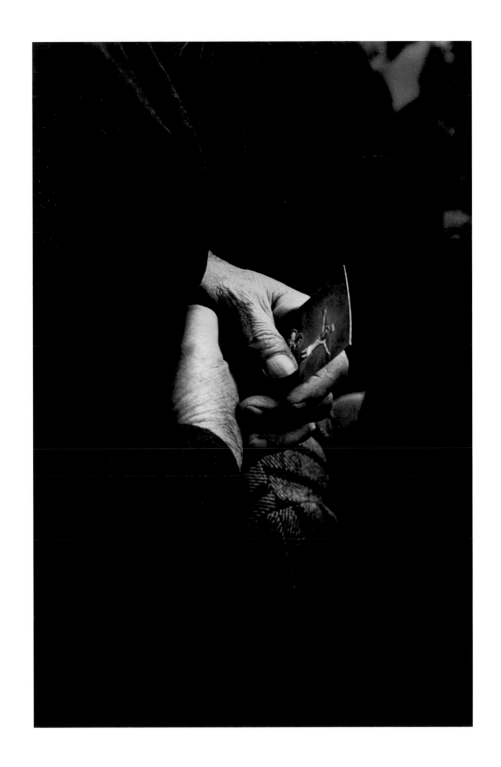

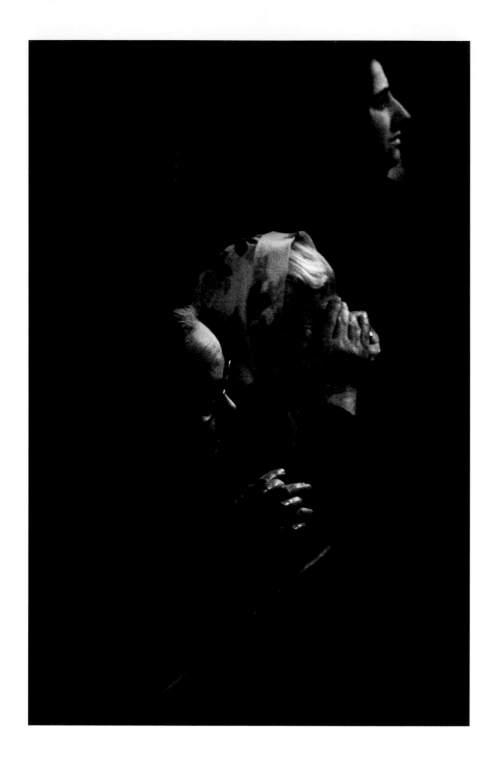

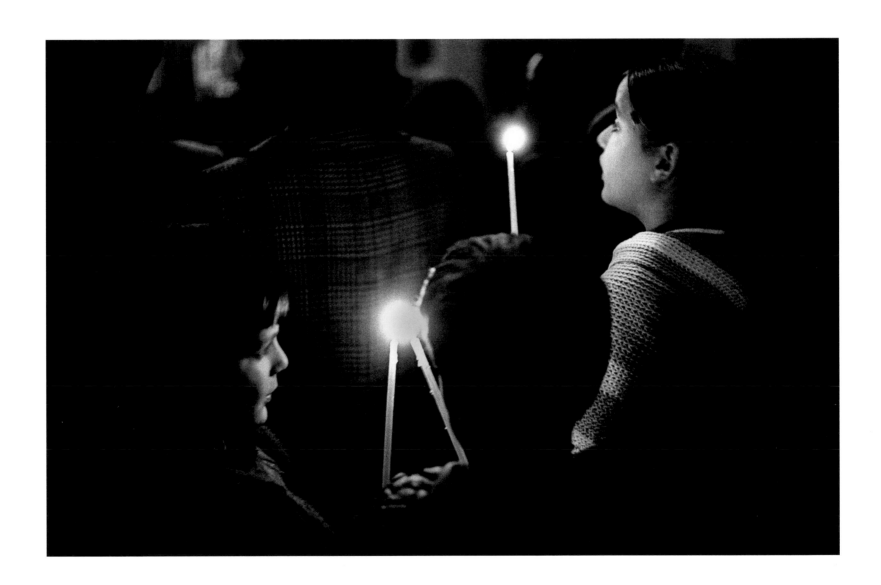

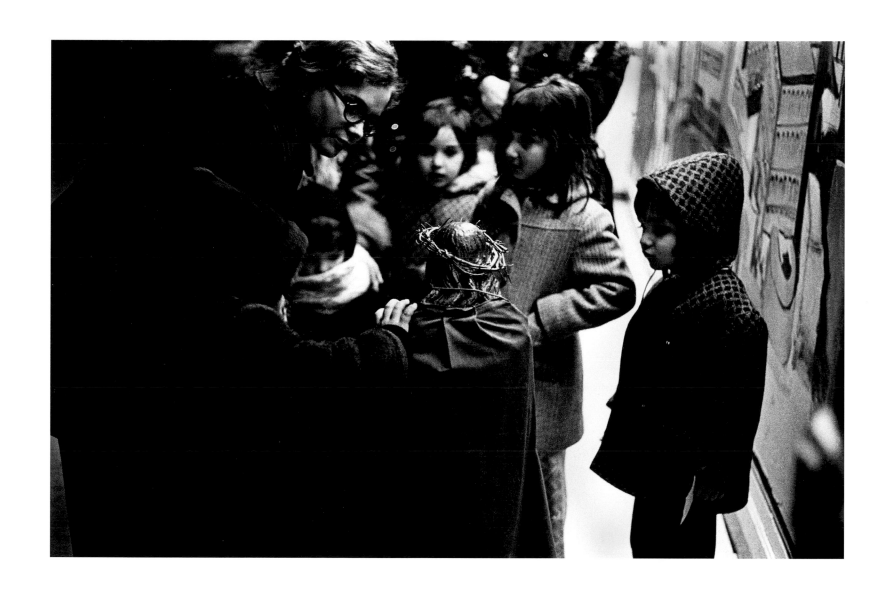

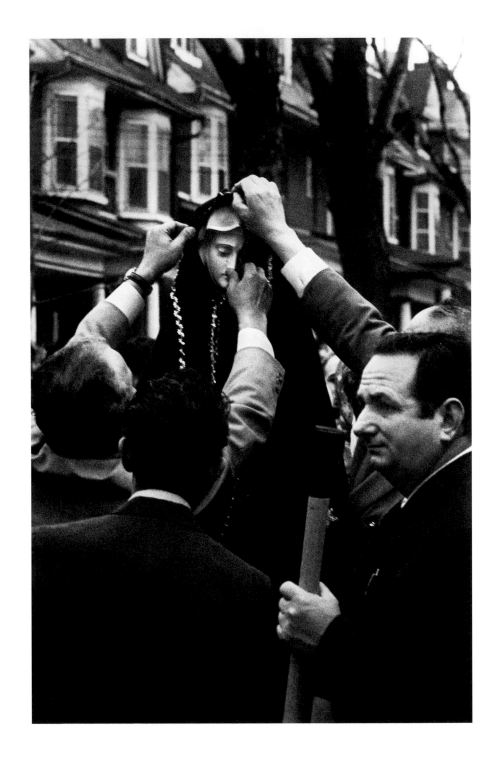

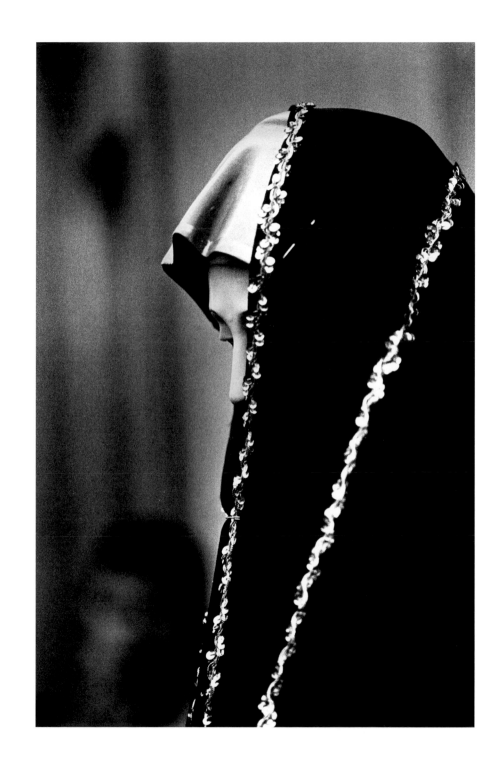

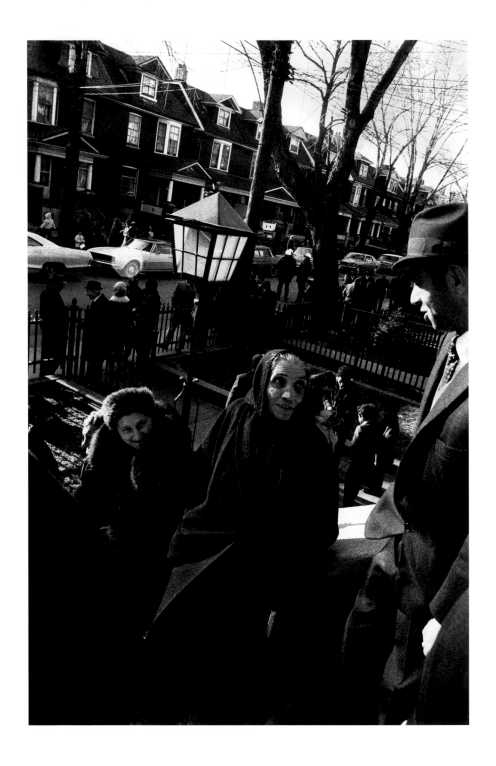

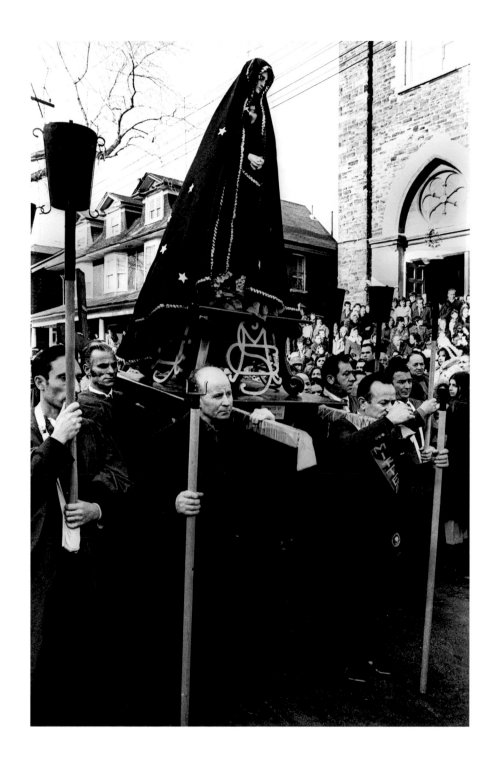

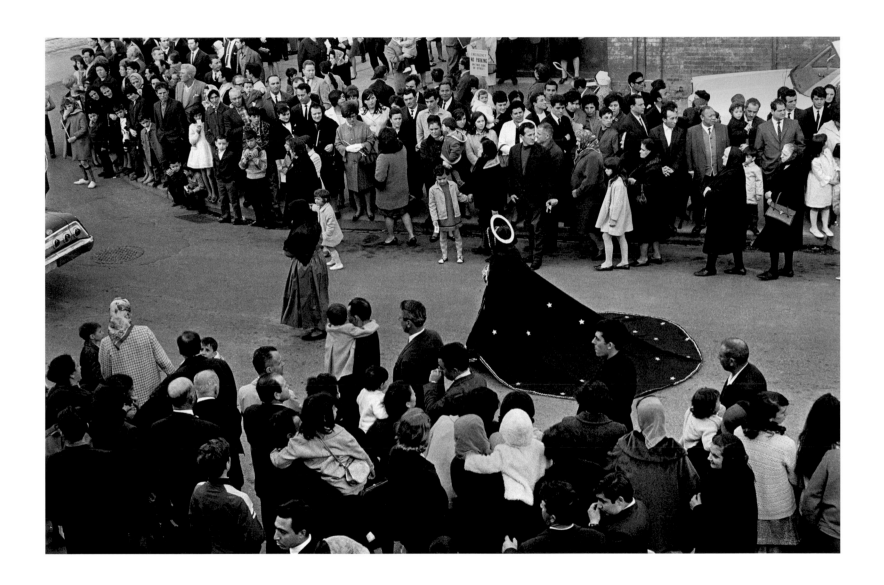

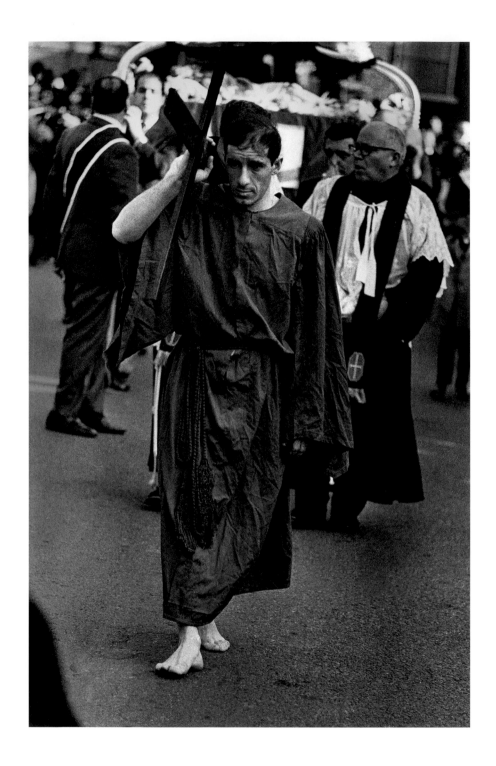

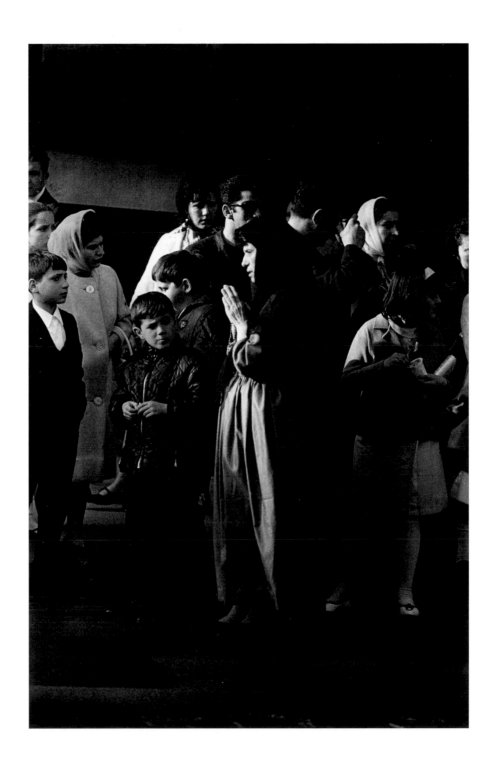

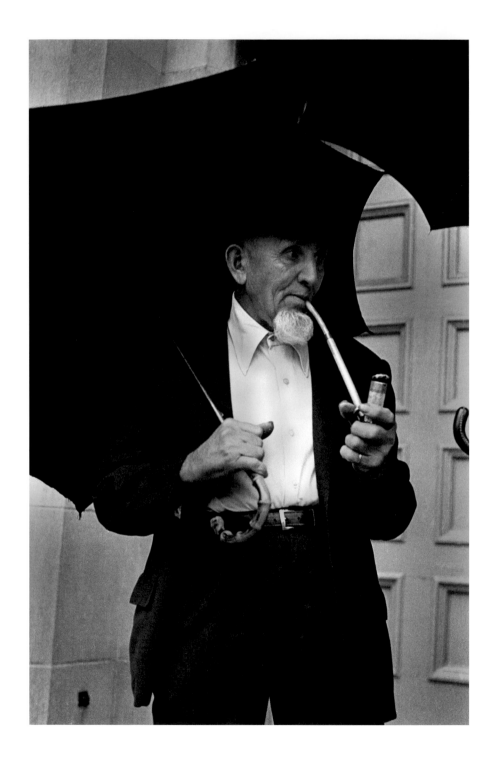

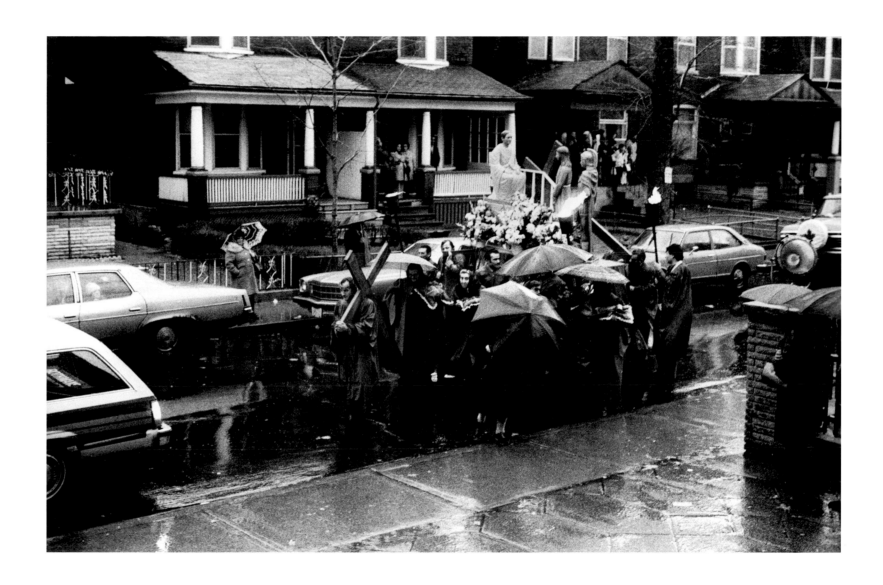

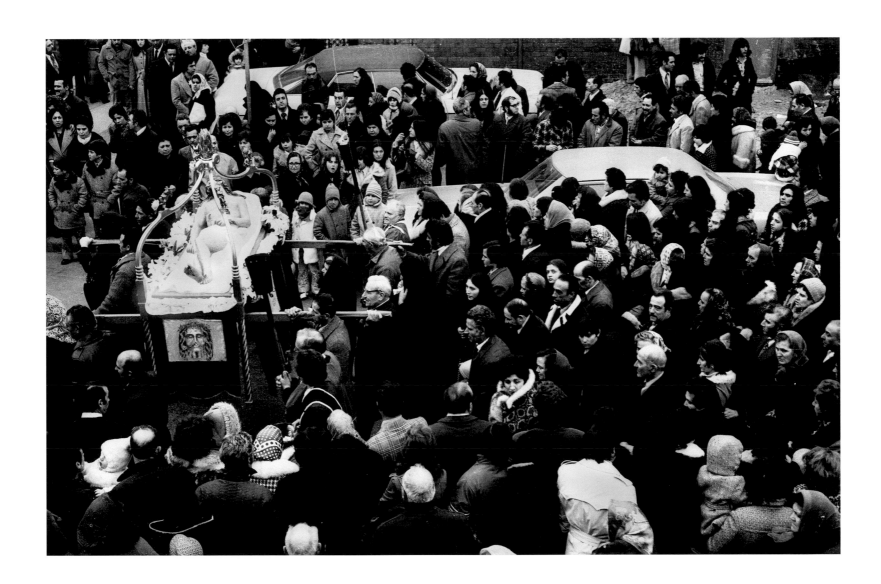

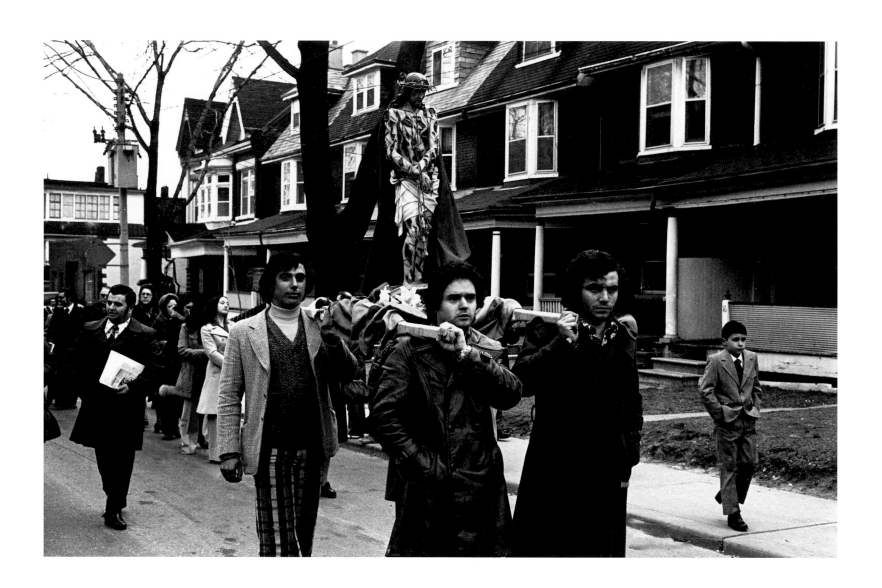

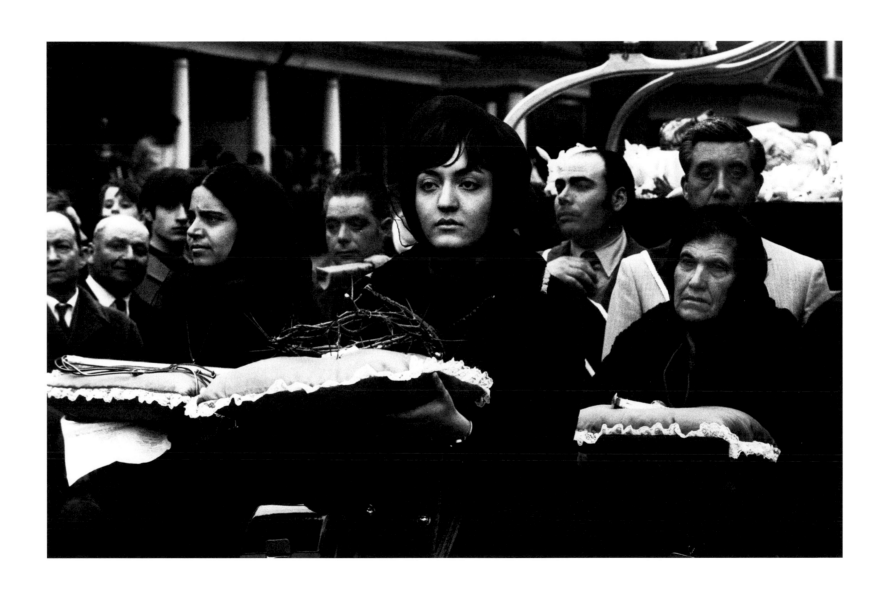

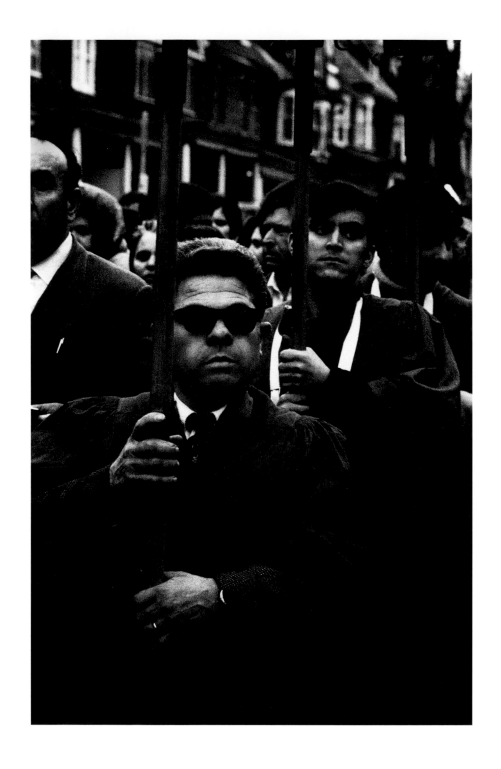

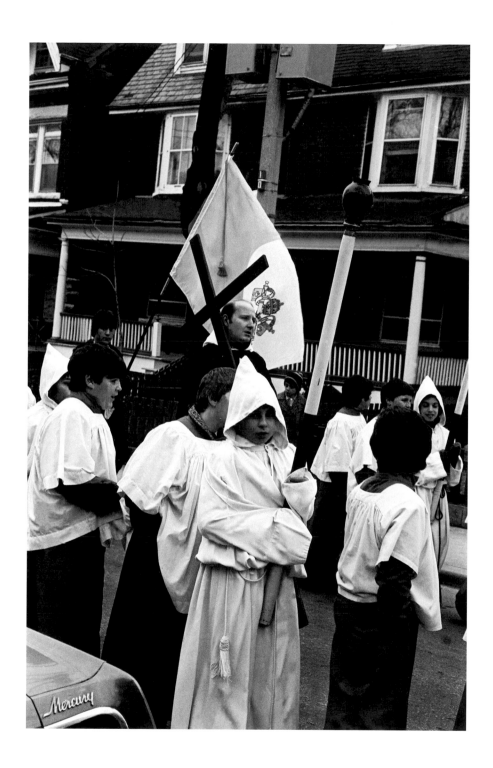

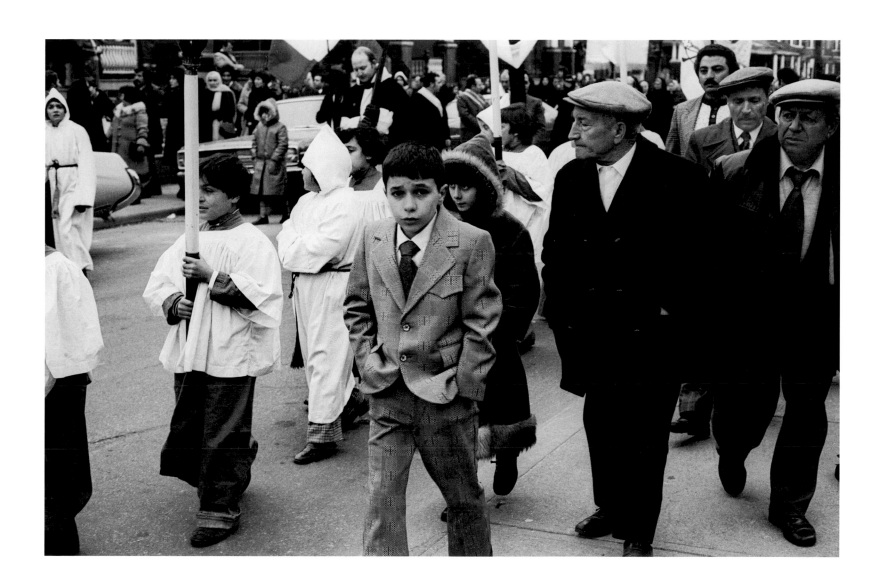

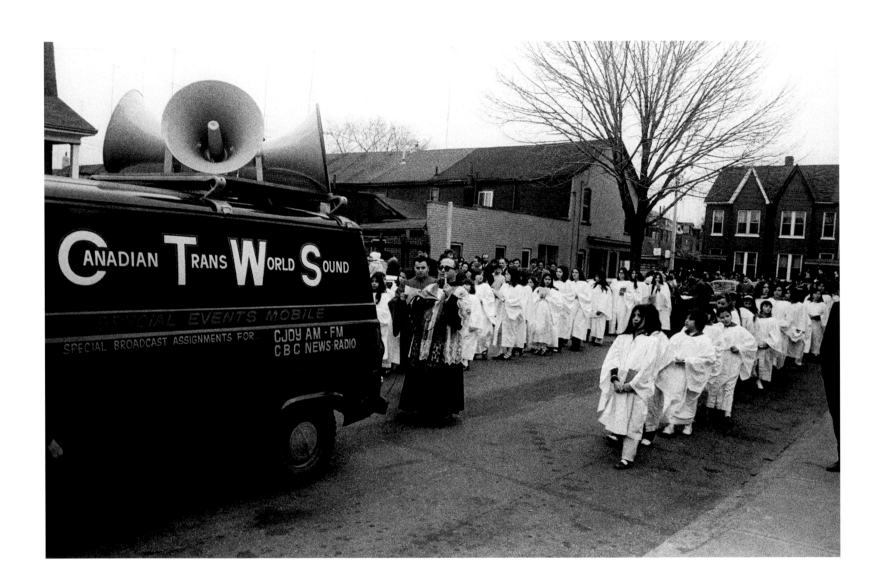

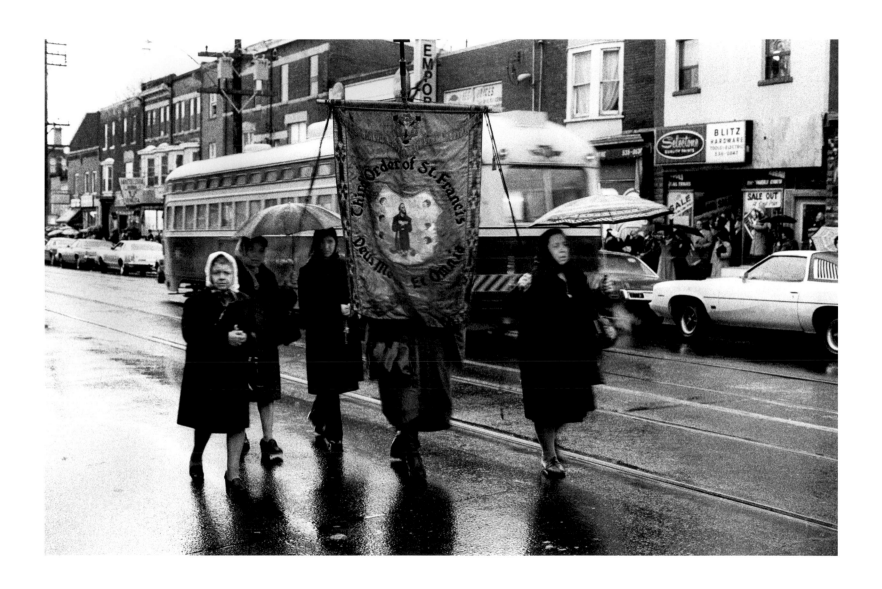

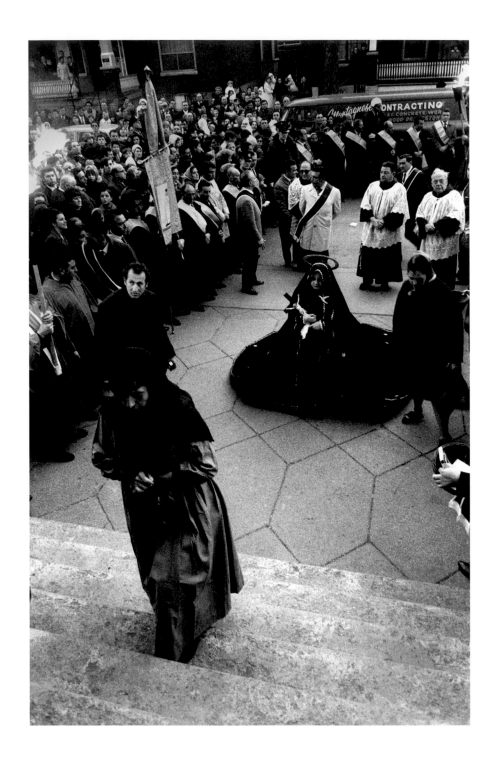

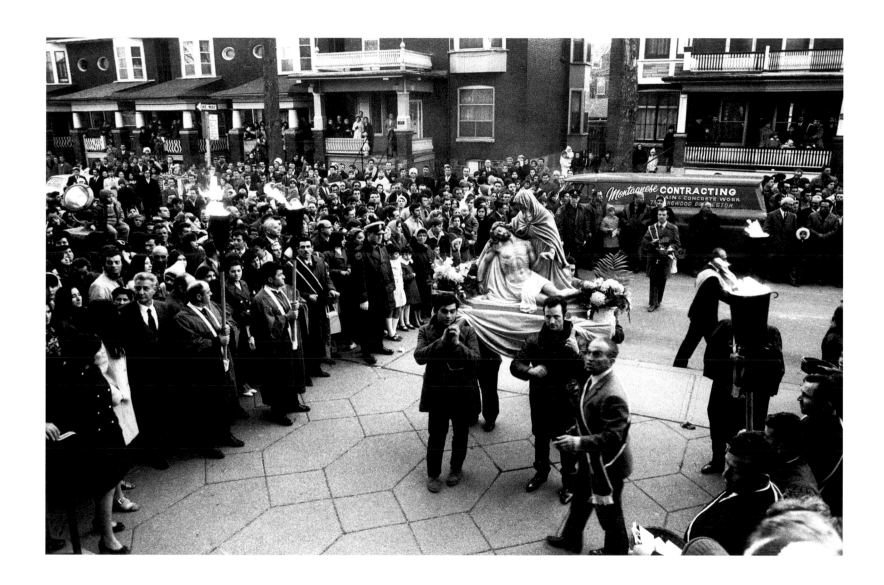

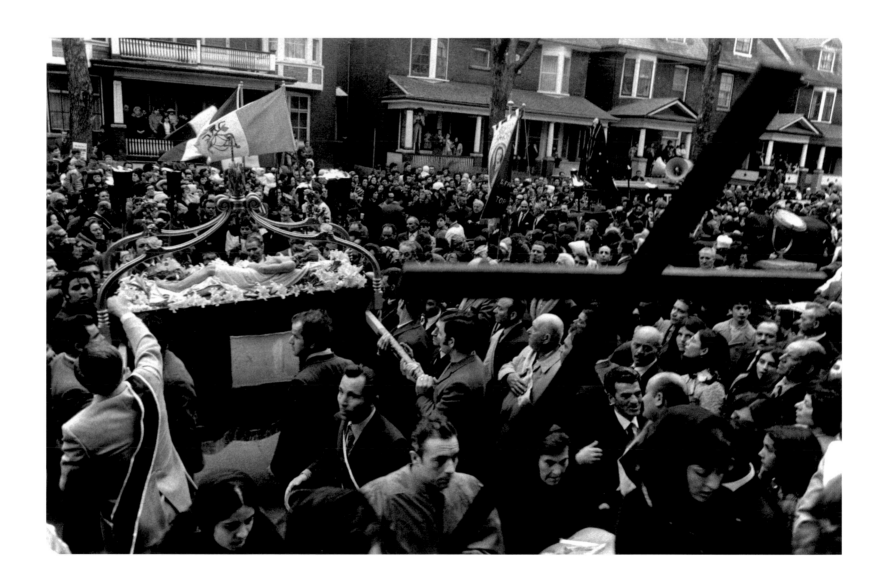

THE EIGHTIES

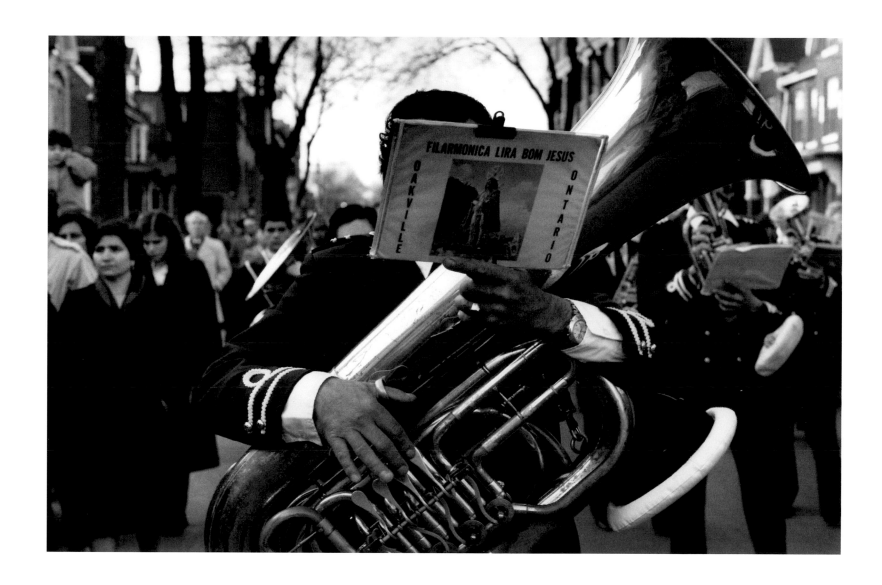

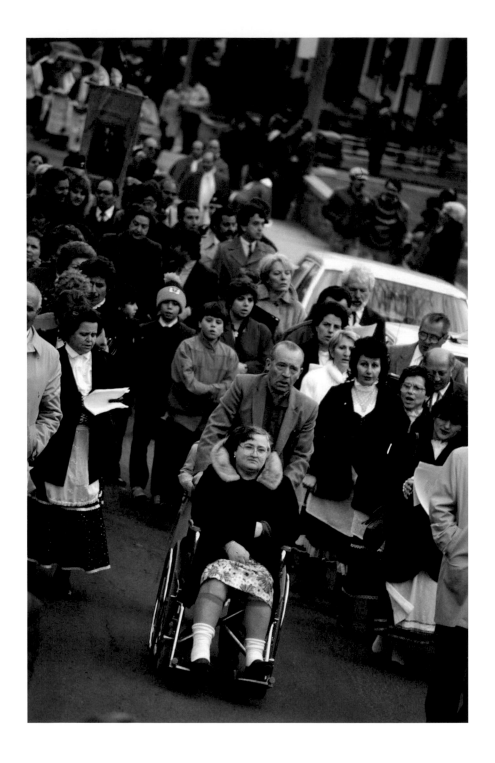

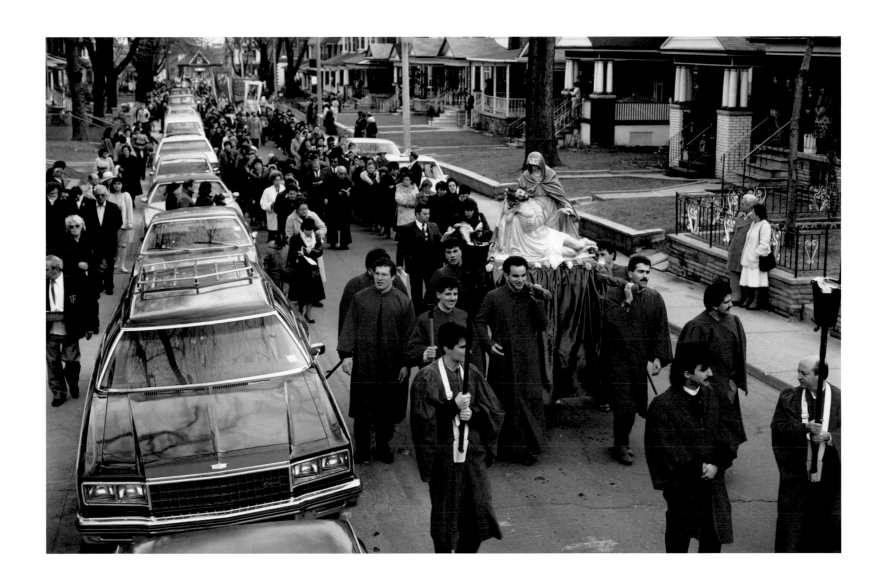

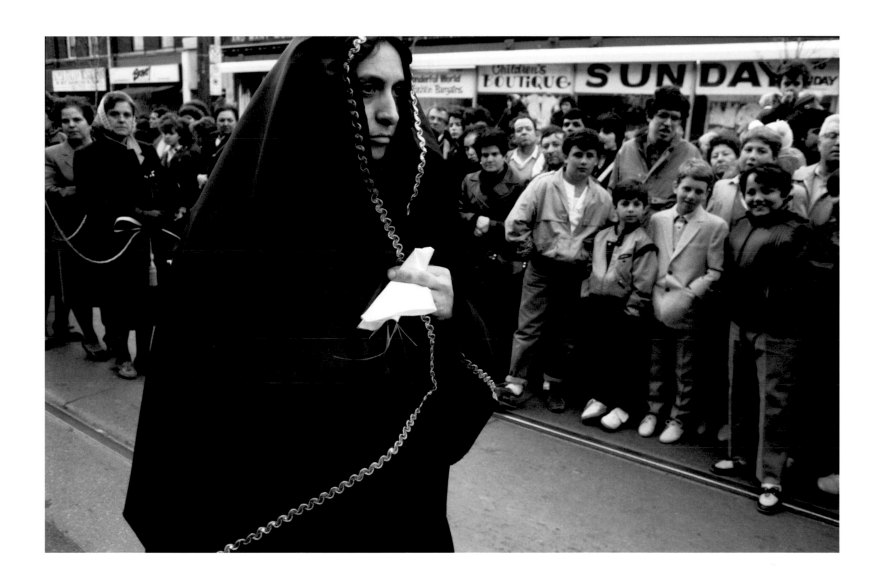

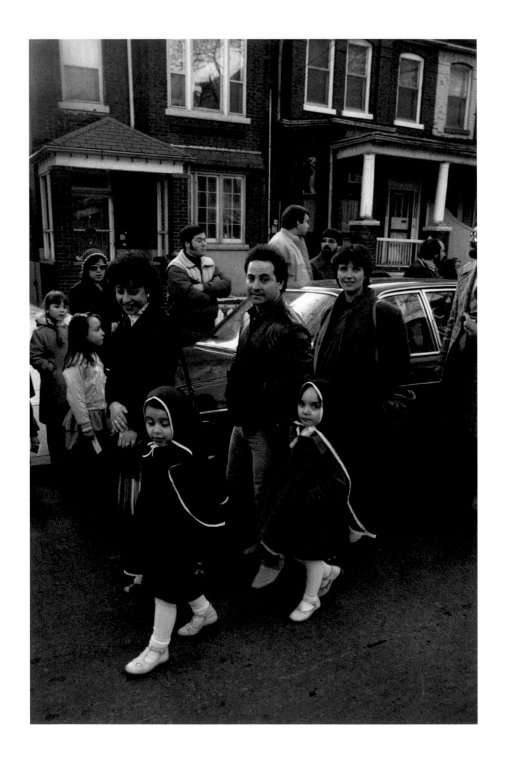

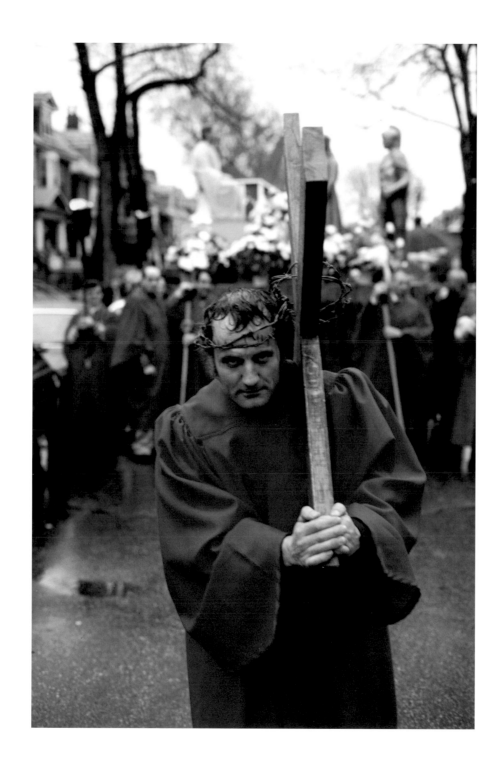

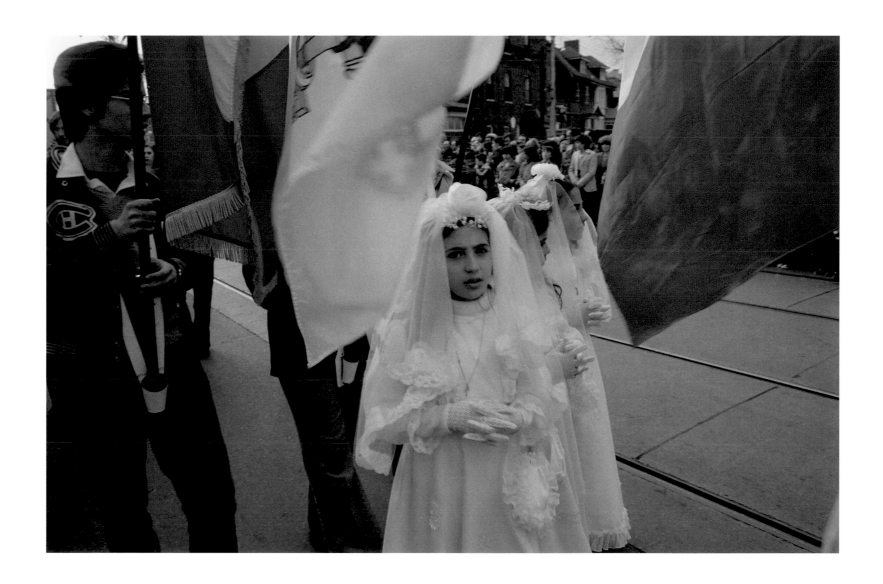

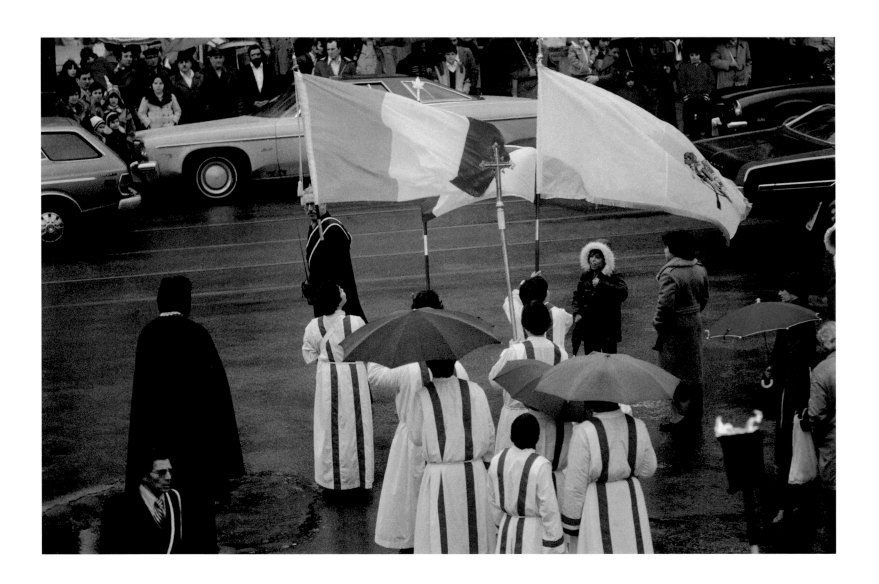

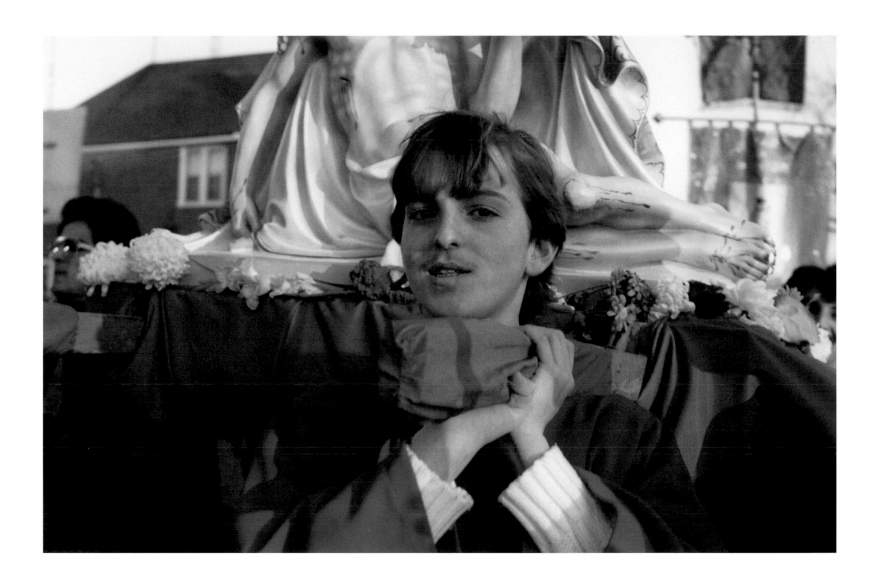

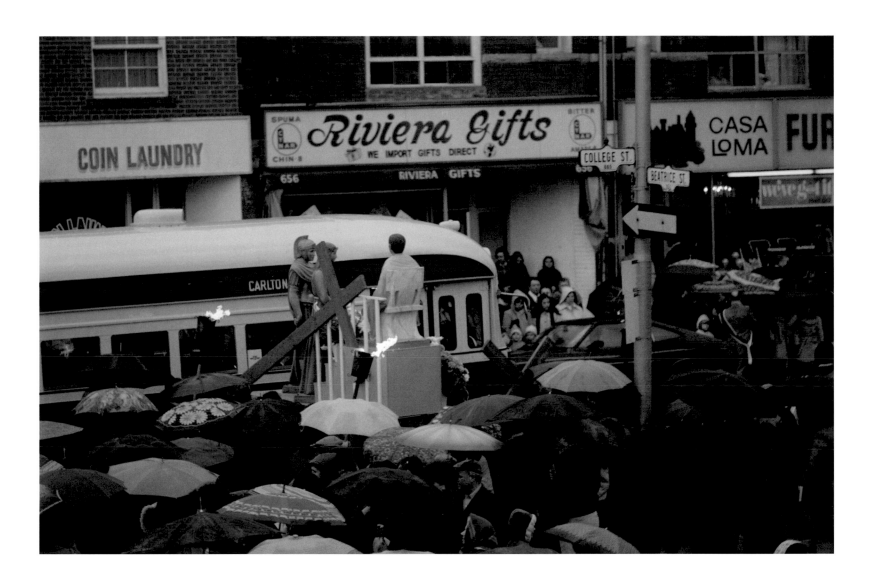

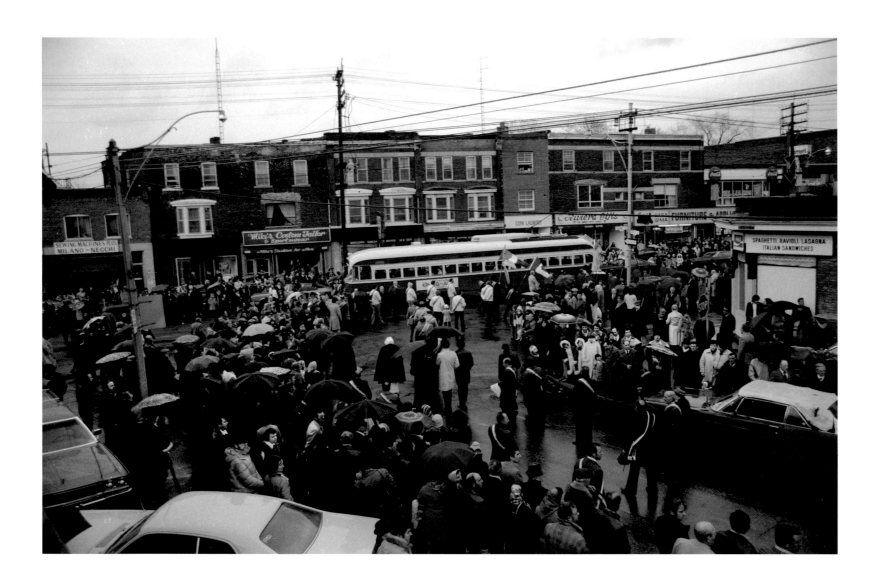

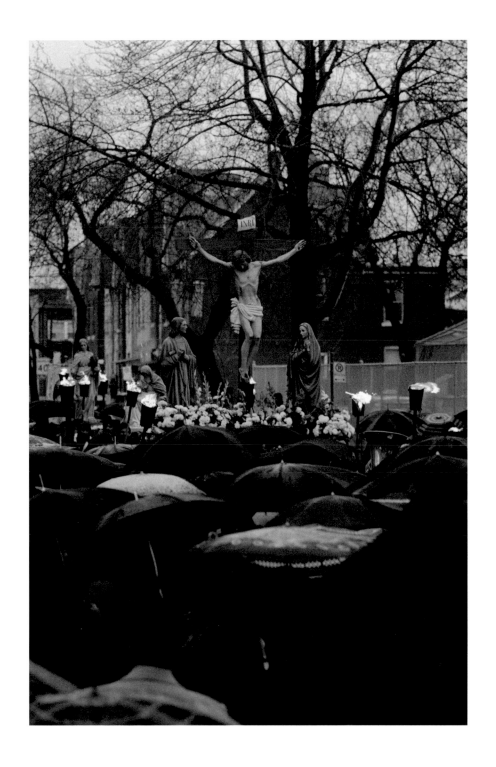

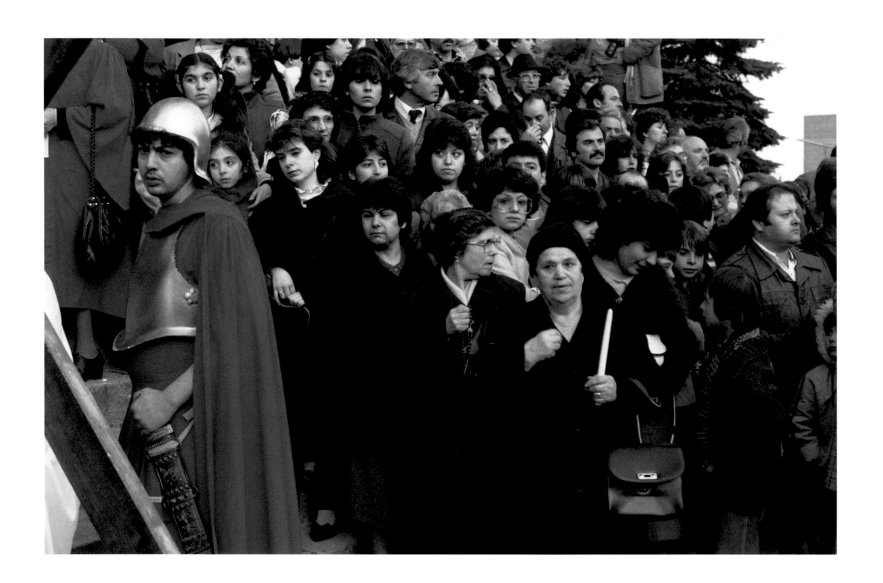

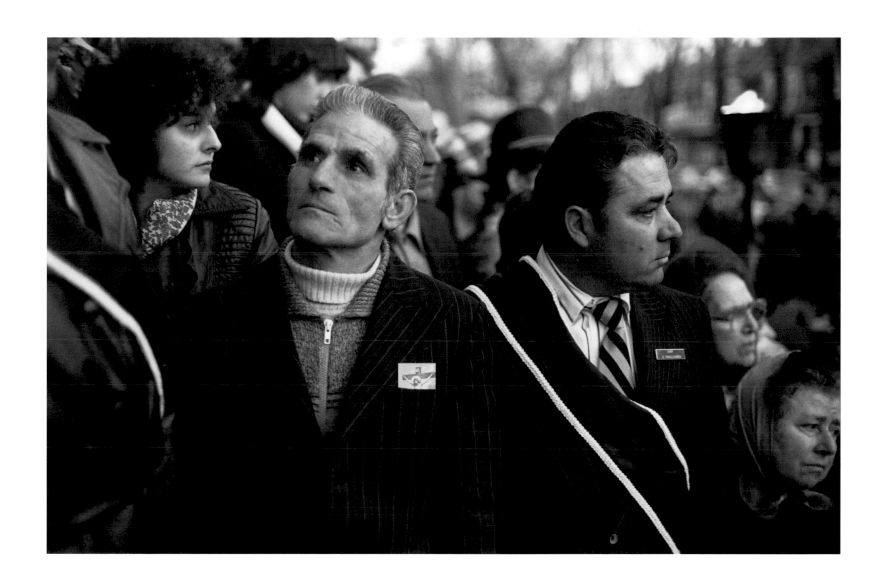

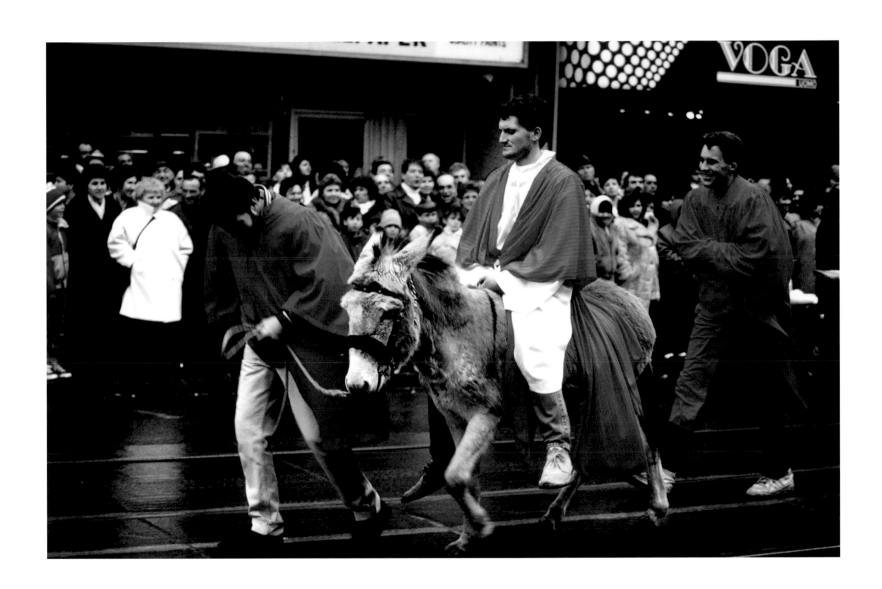

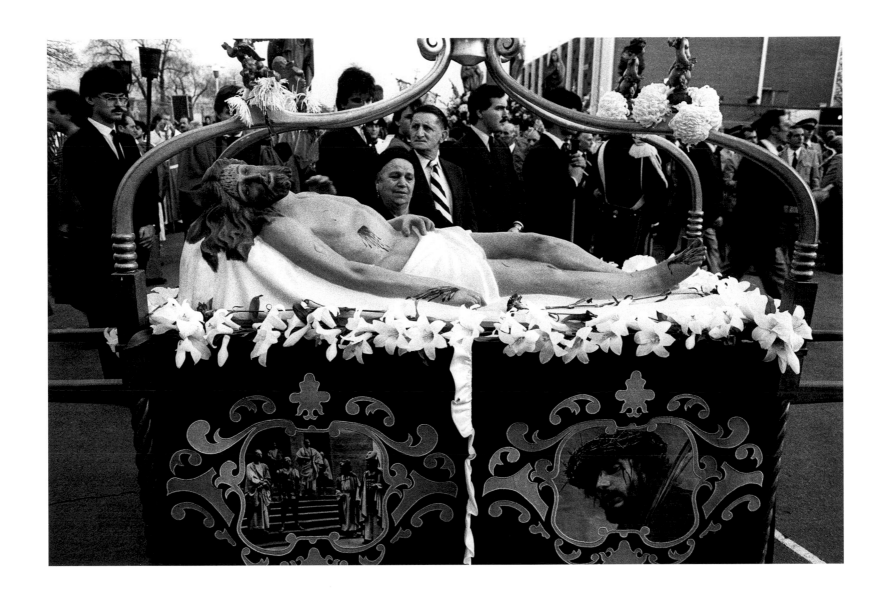

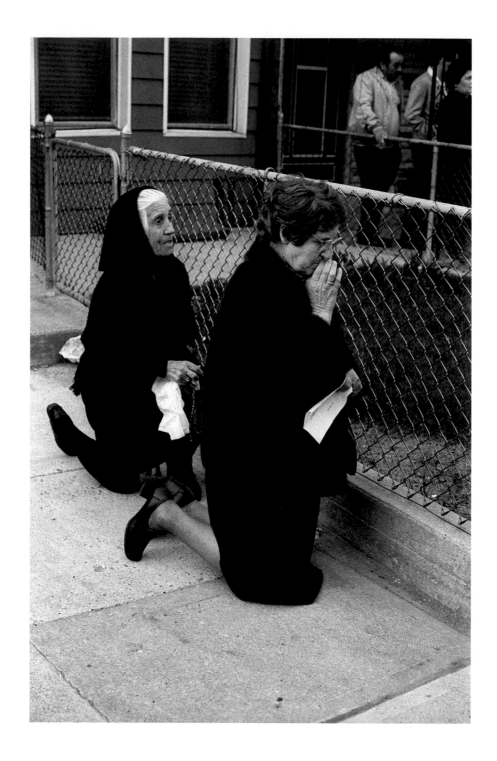

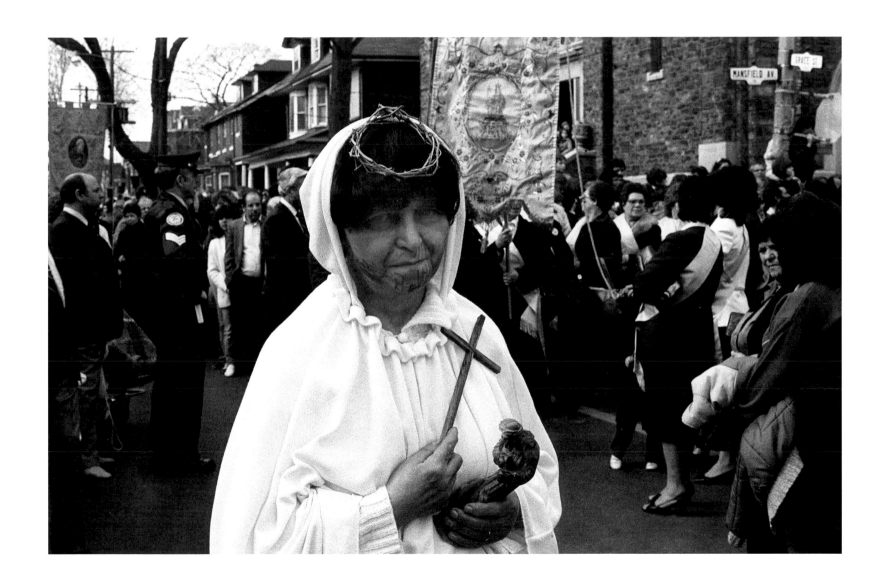

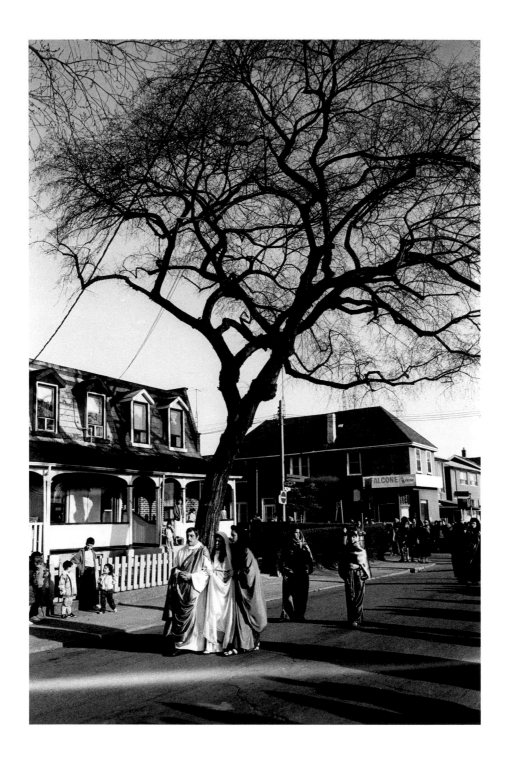

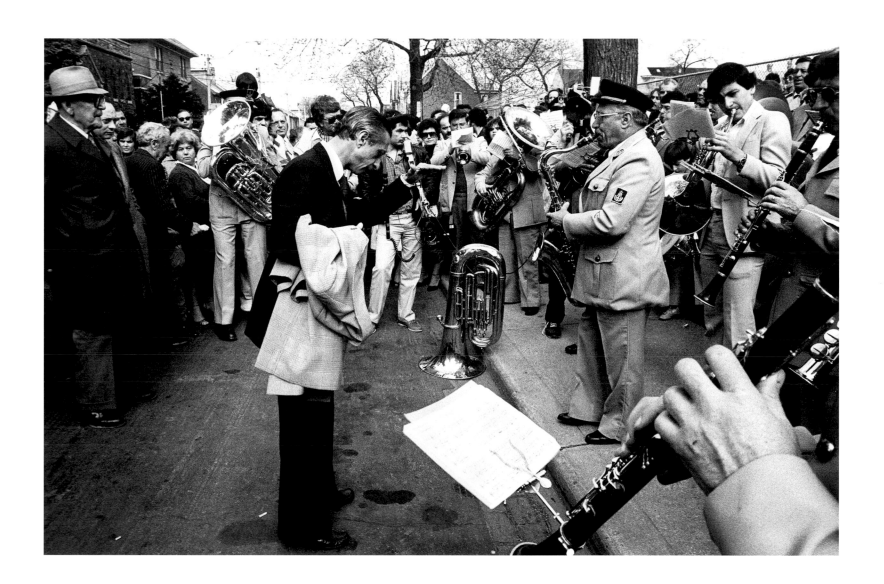

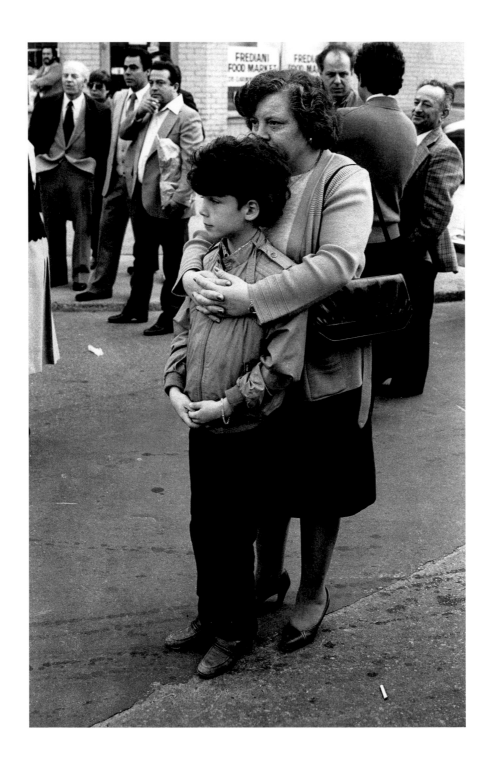

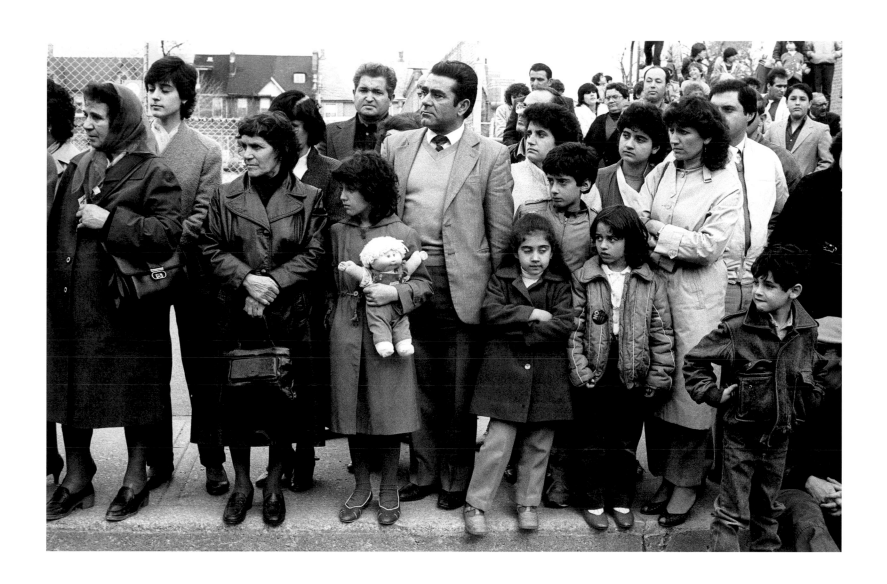

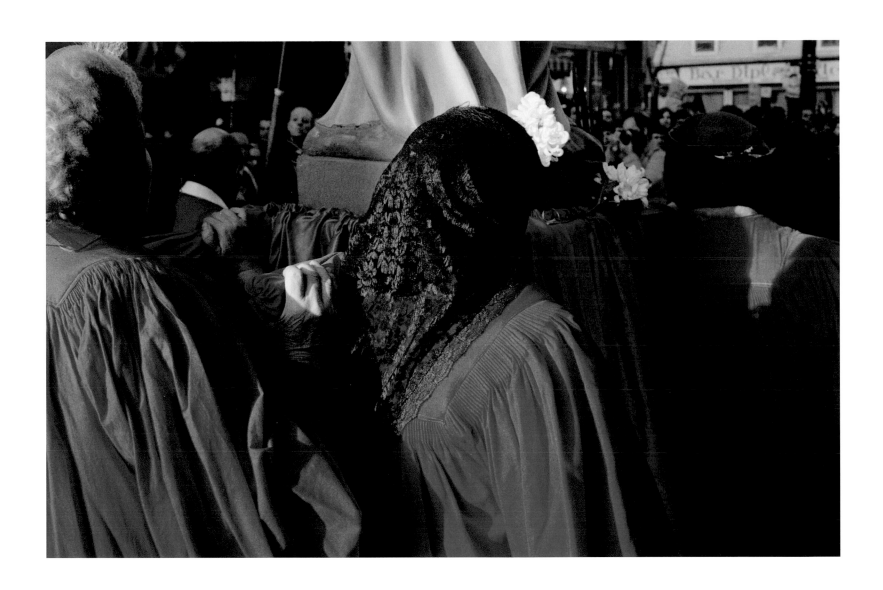

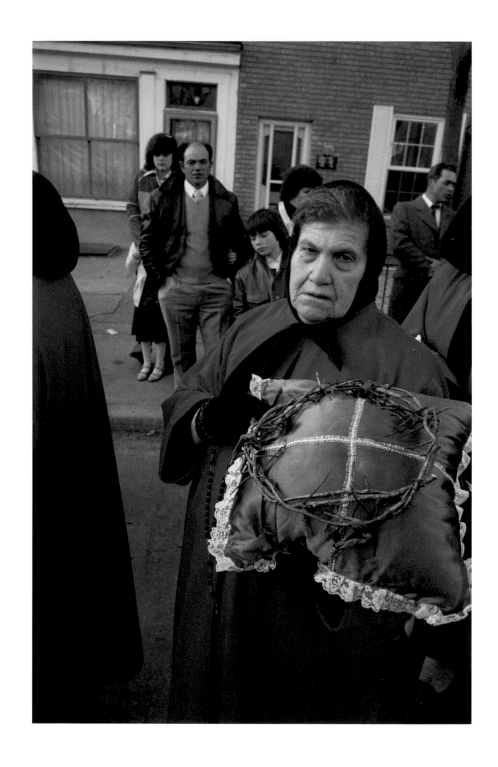

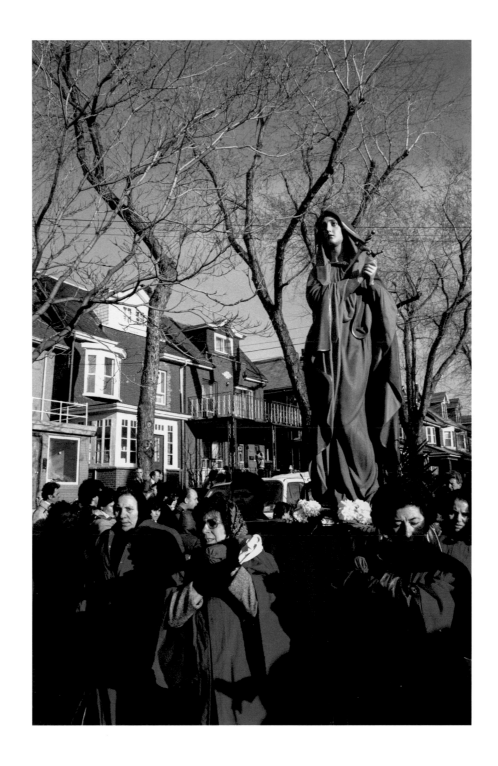

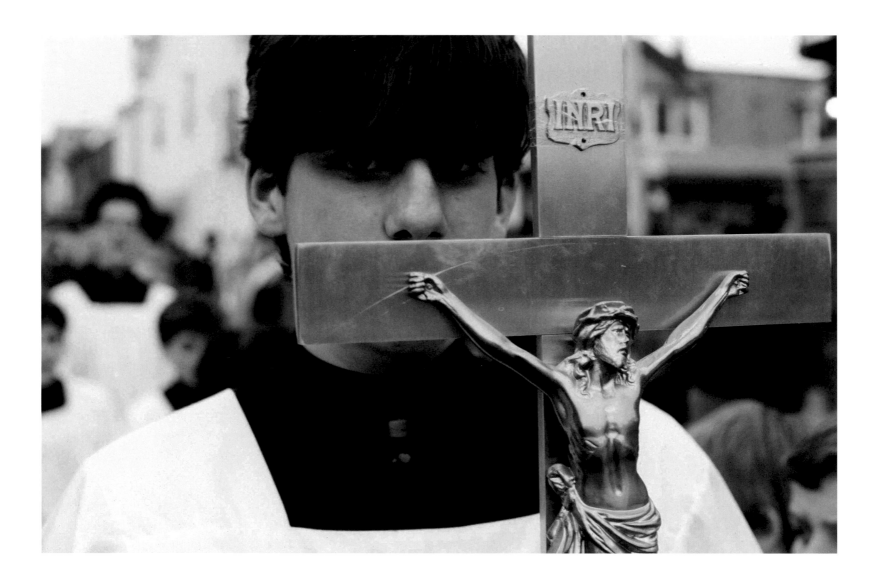

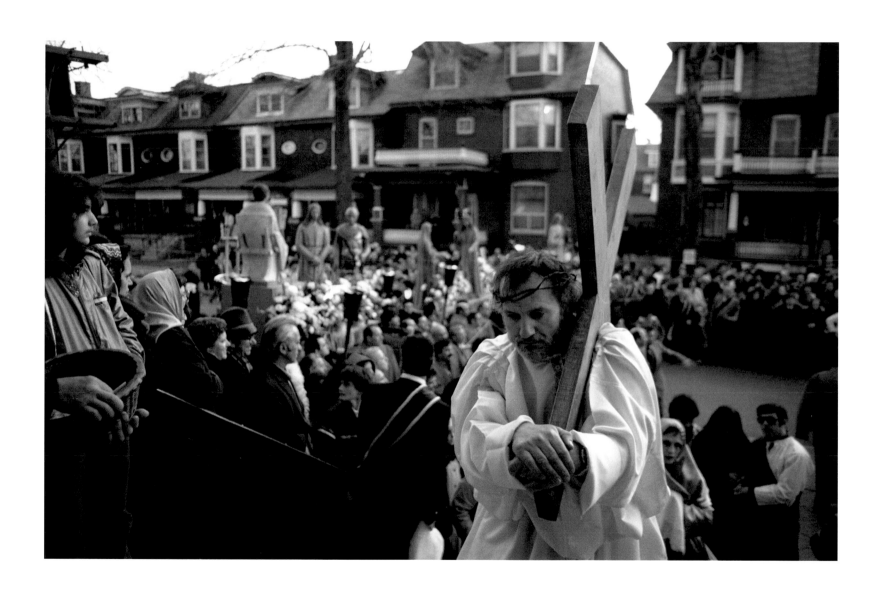

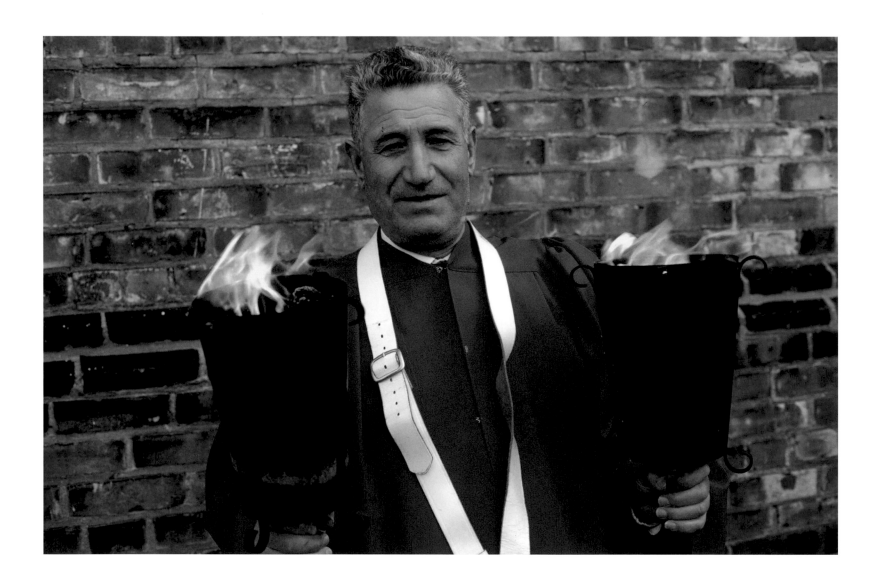

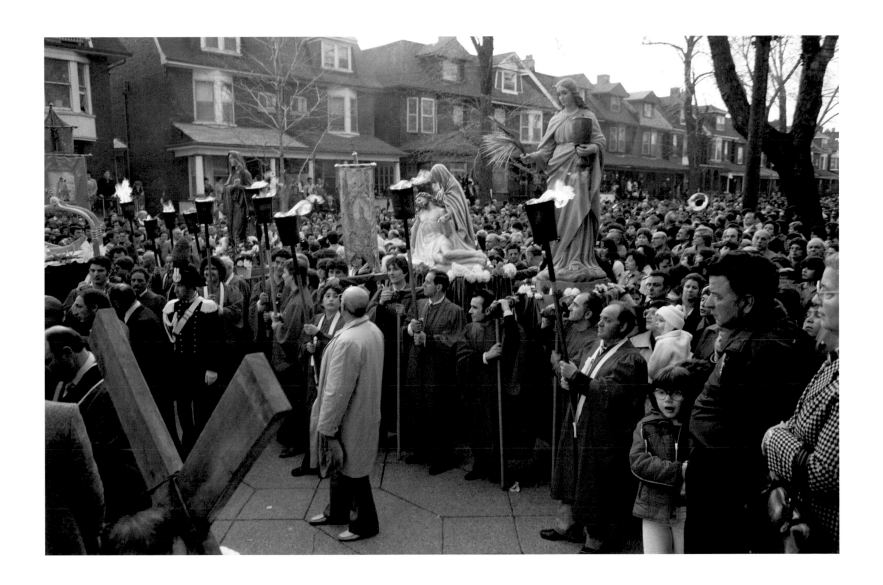

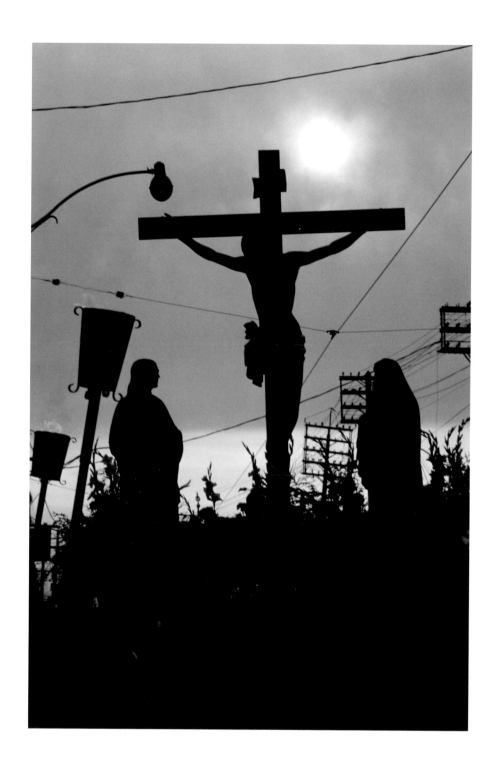

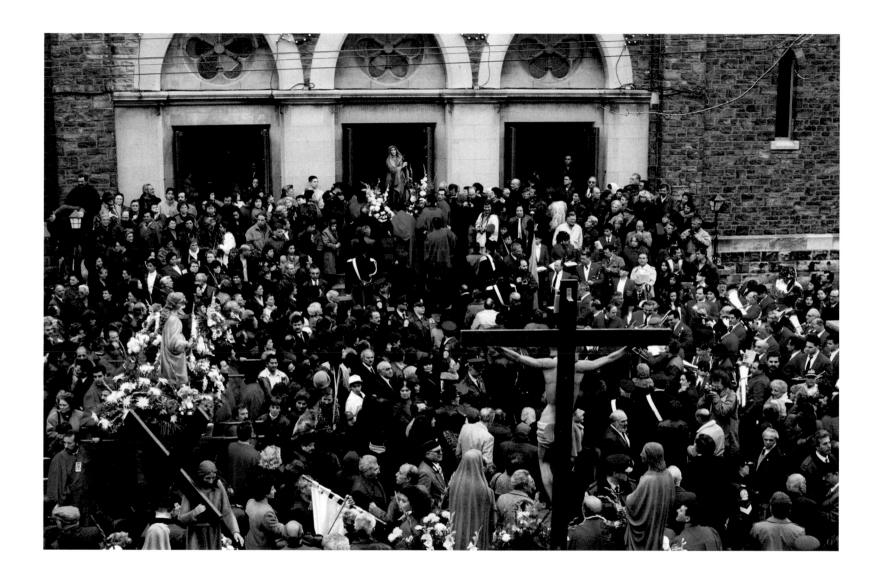

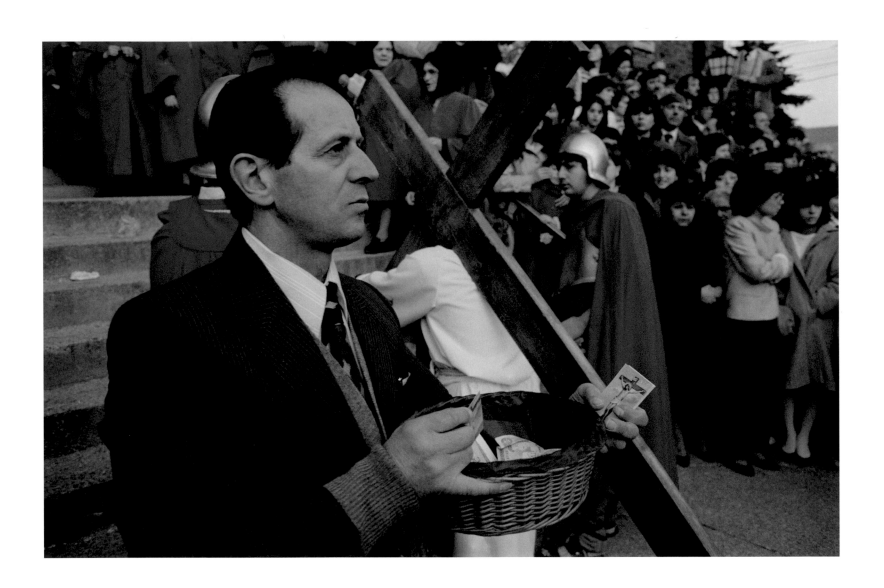

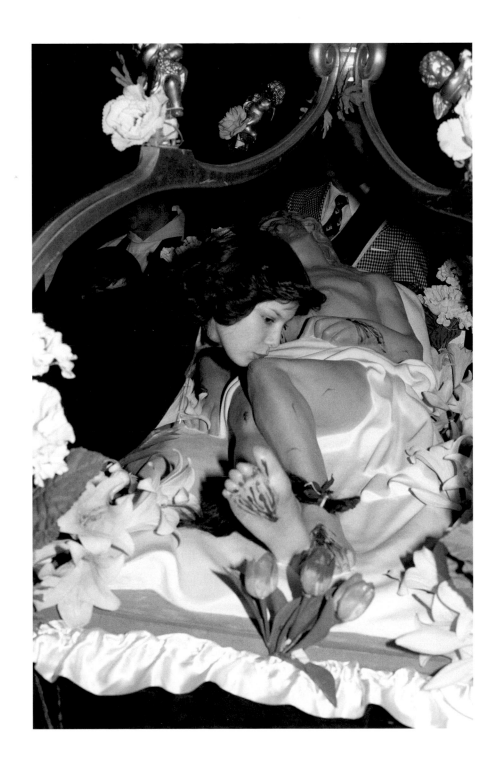

THE NINETIES

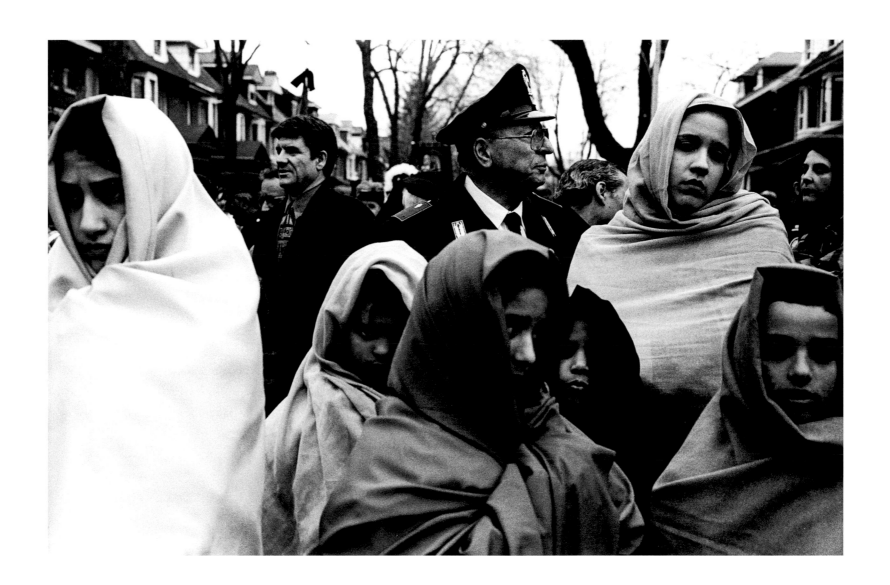

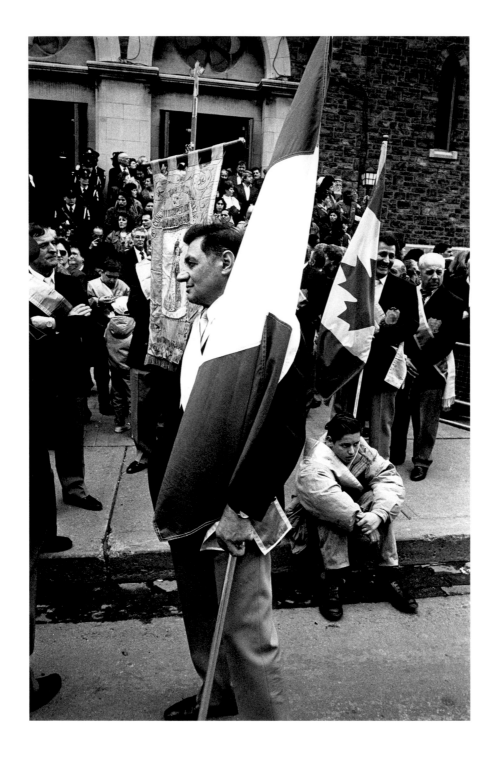

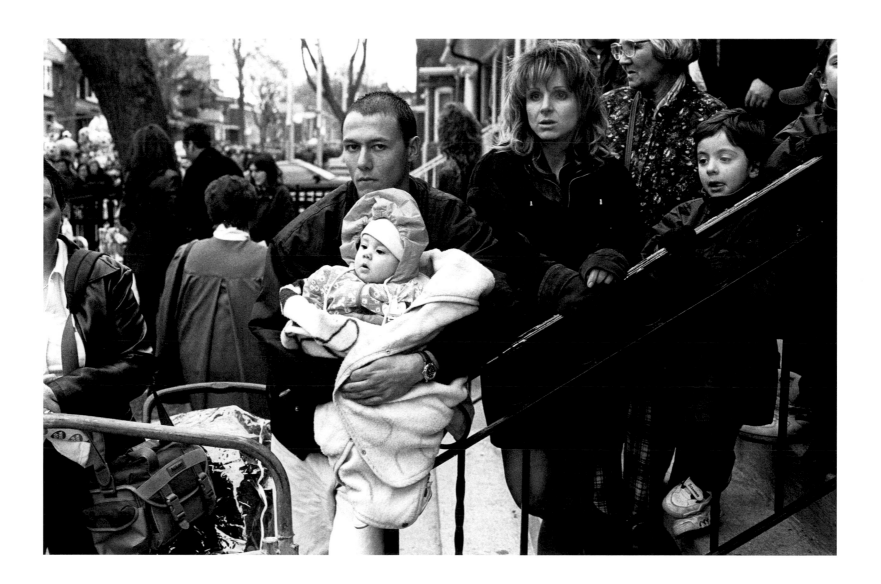

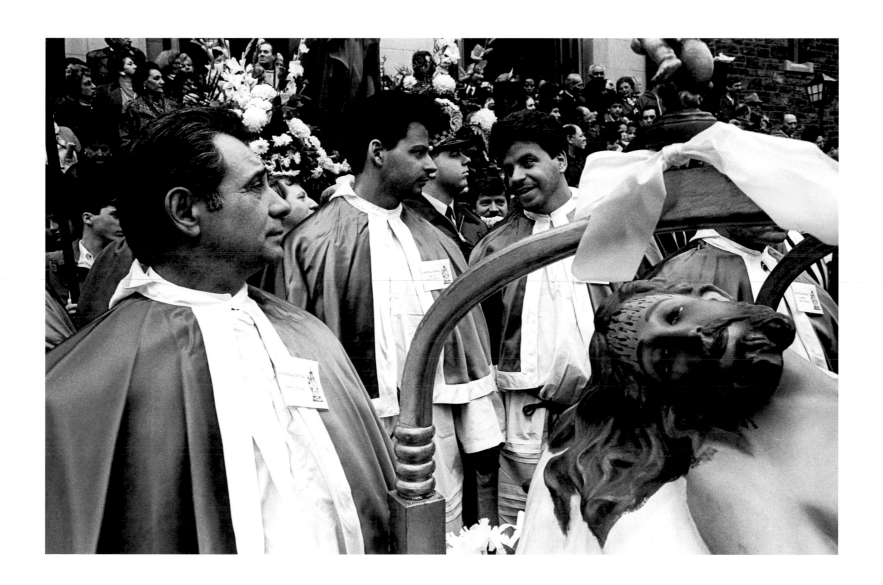

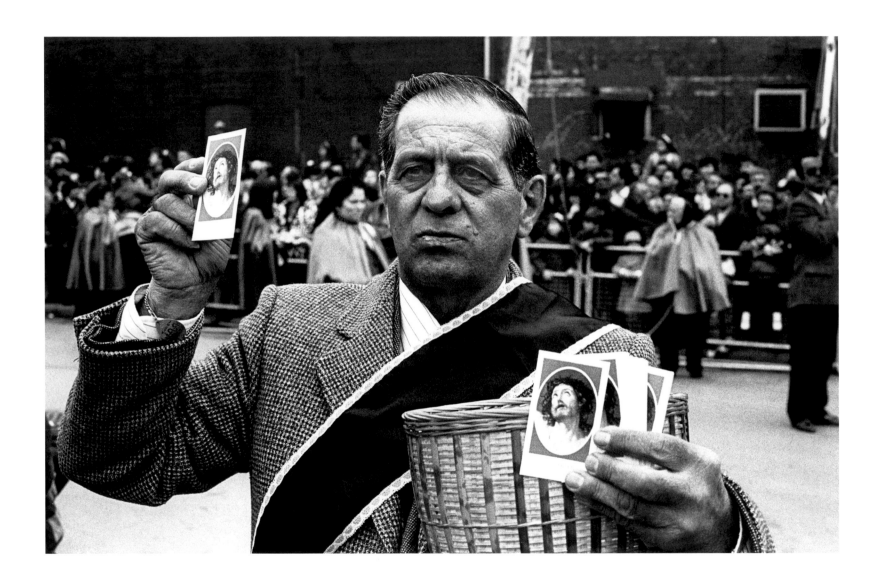

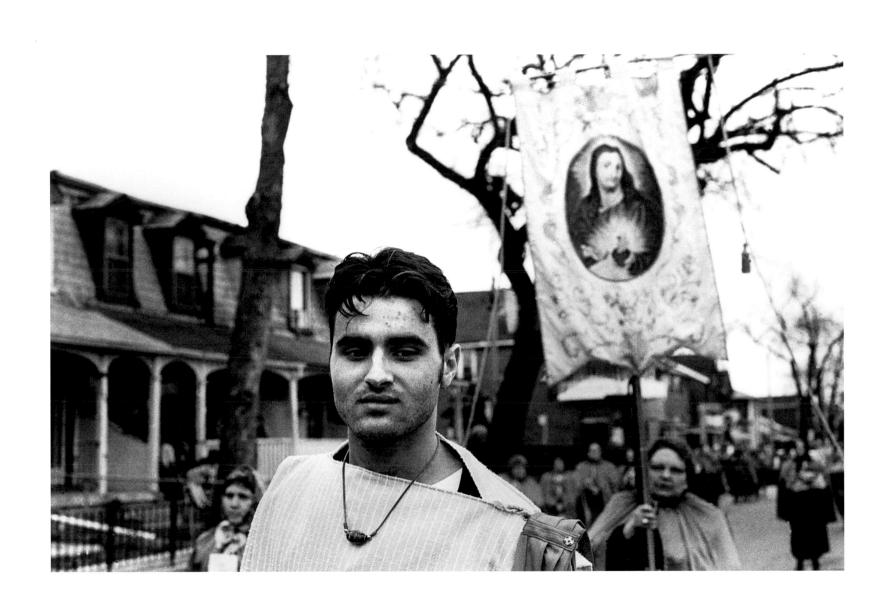

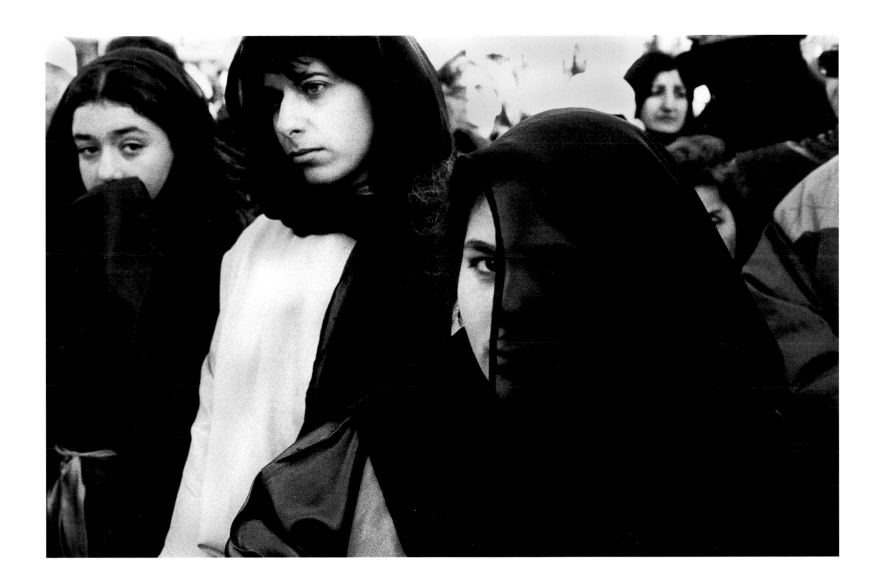

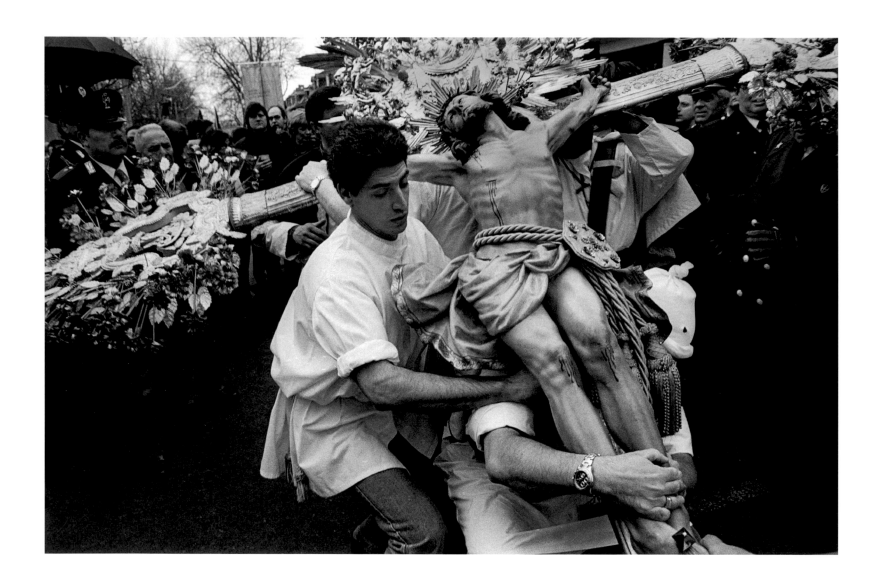

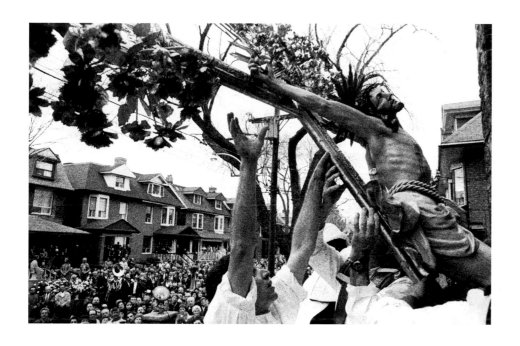

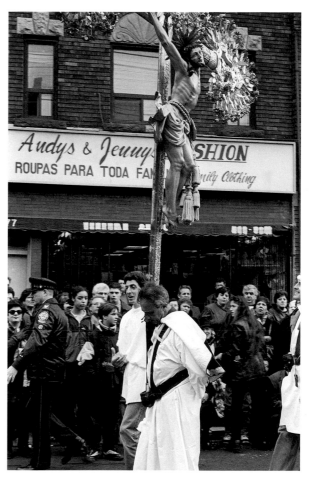

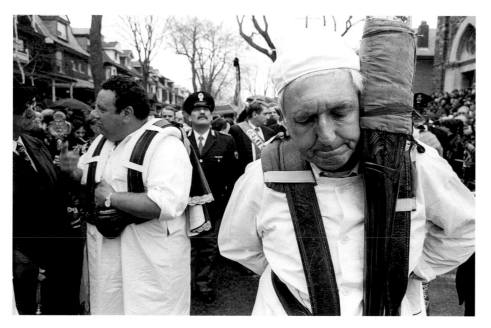

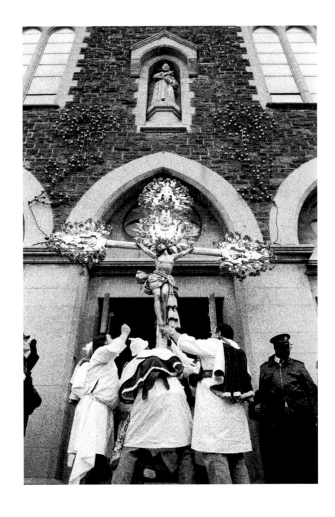

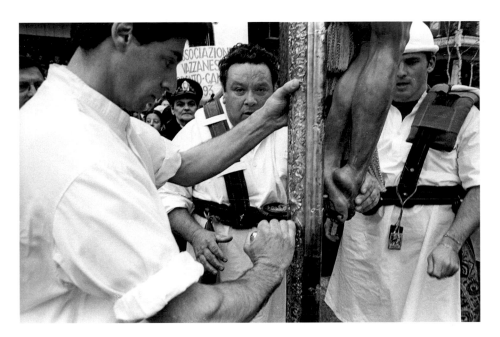

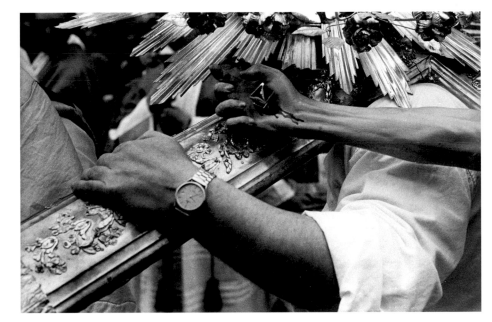

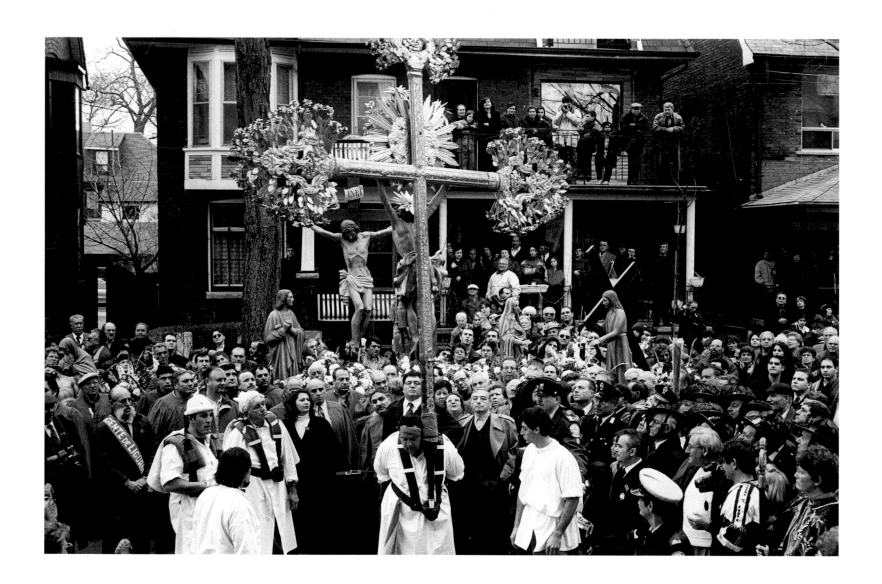

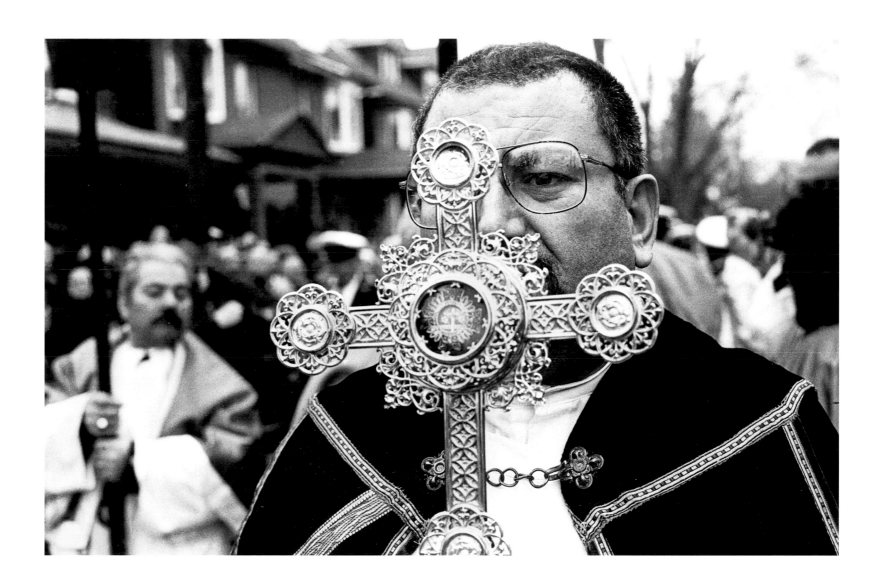

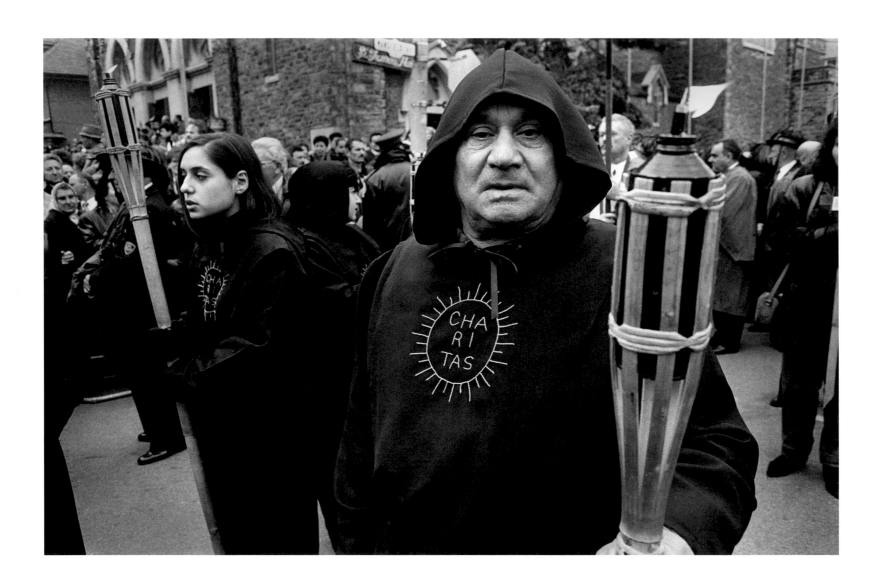

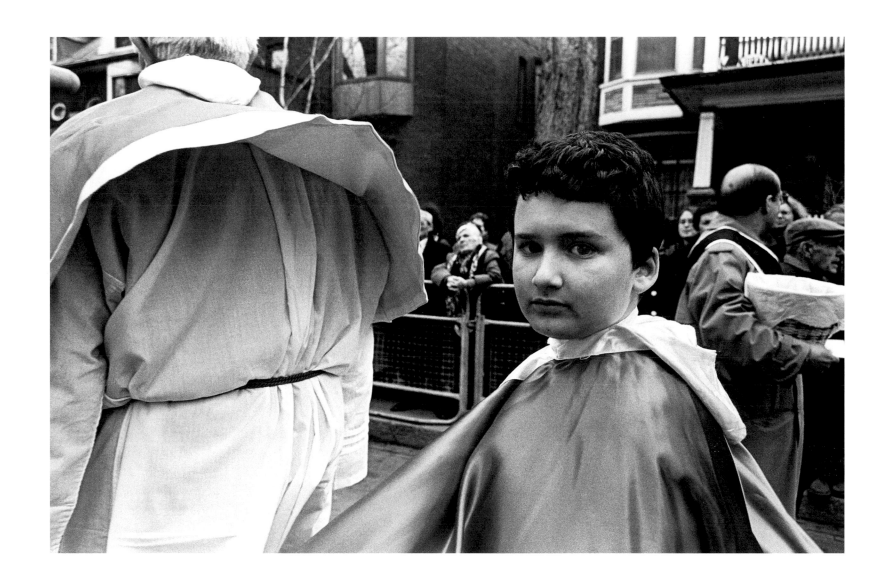

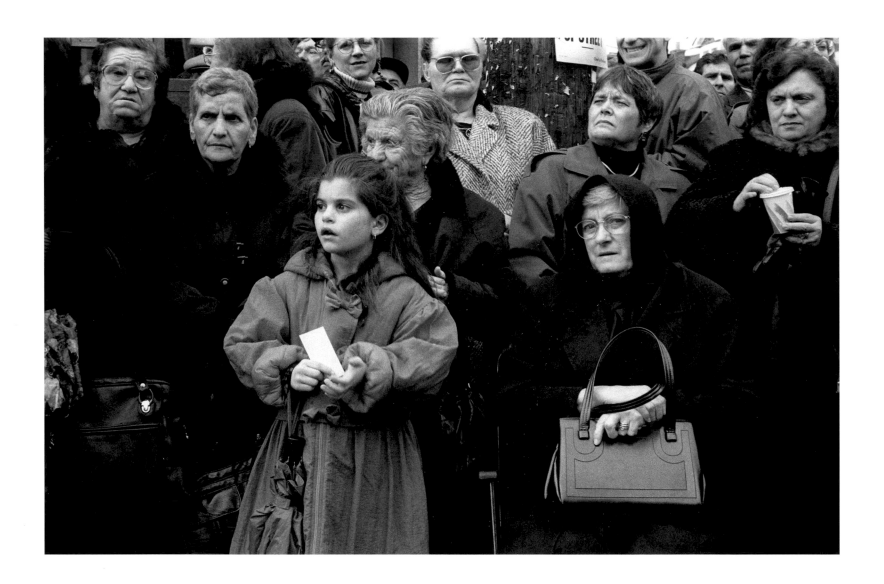

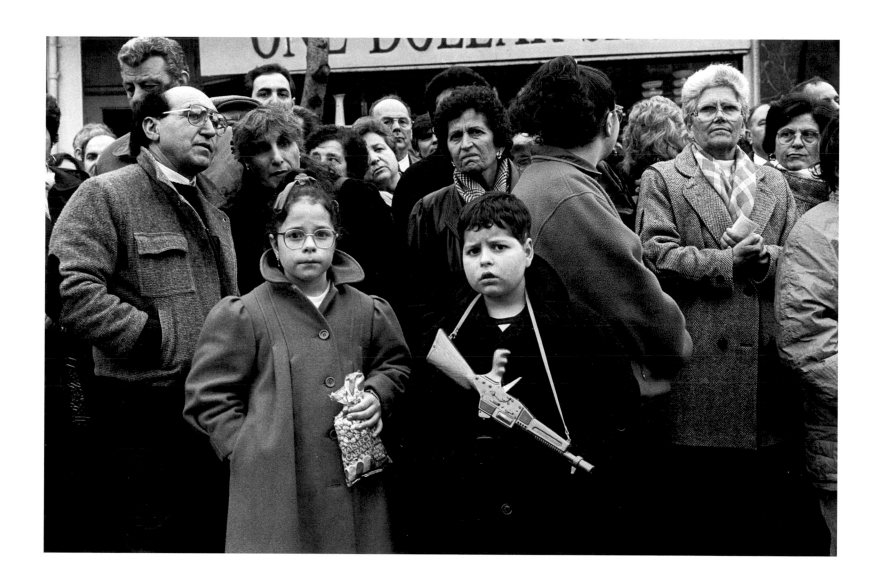

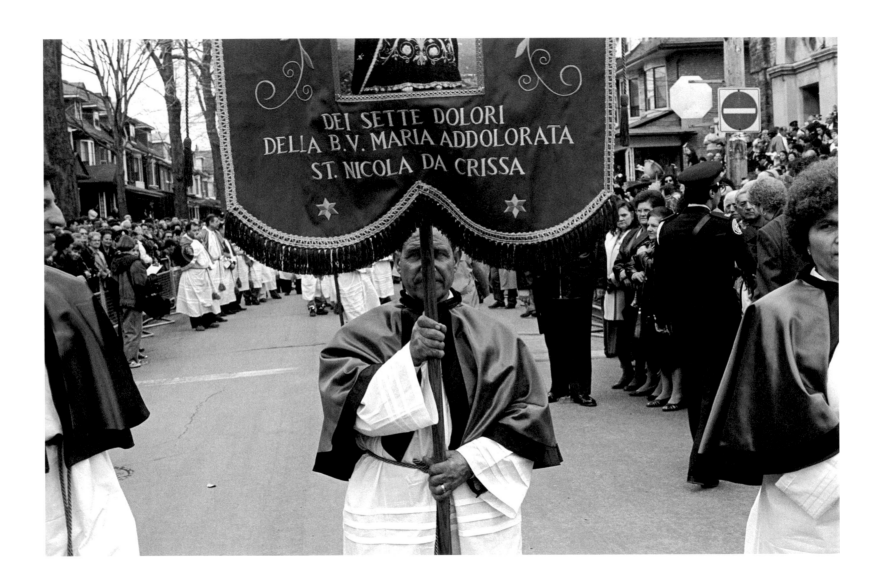

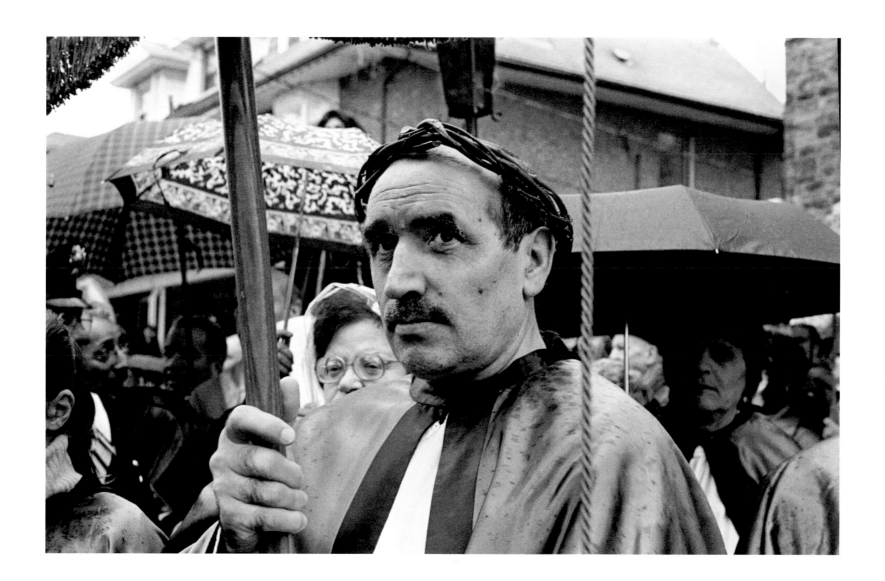

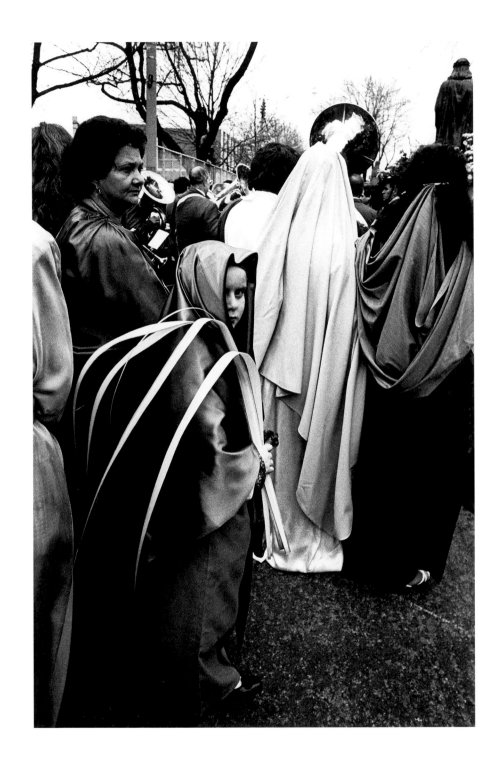

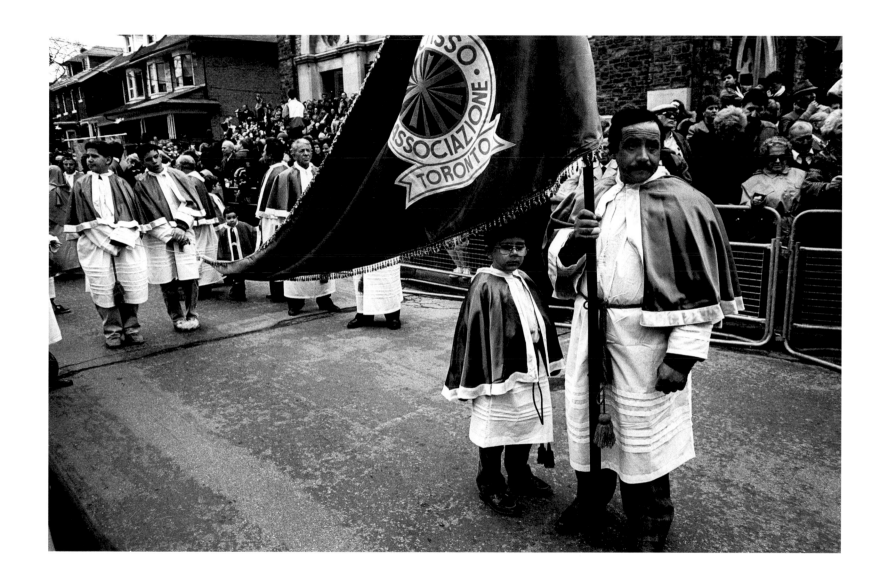

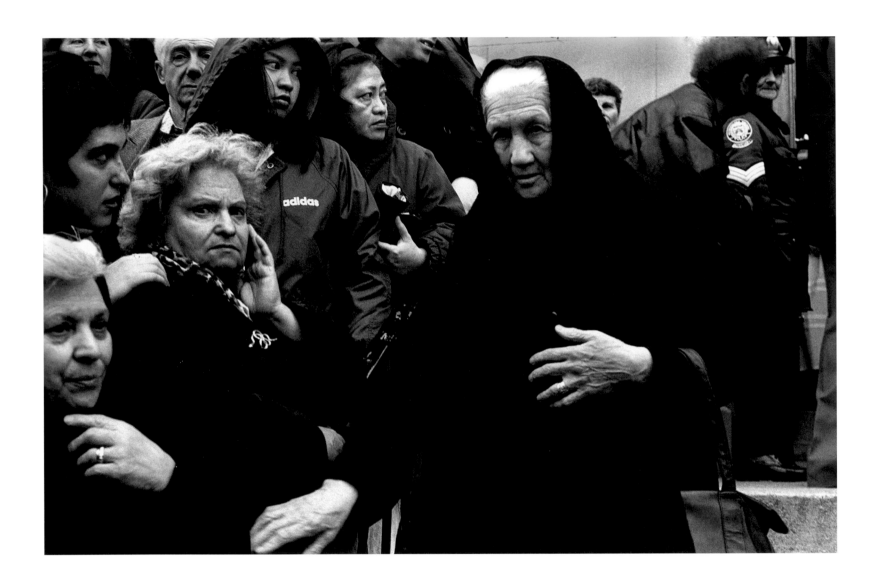

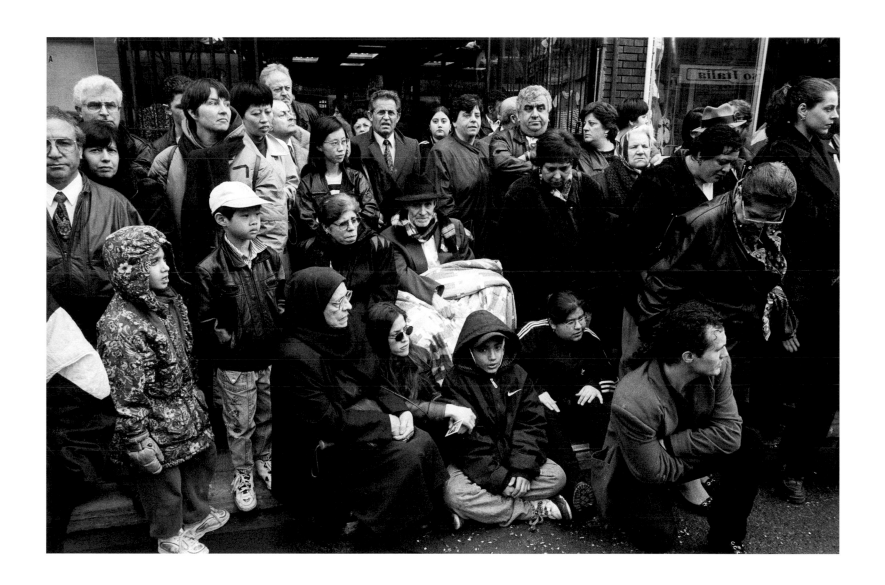

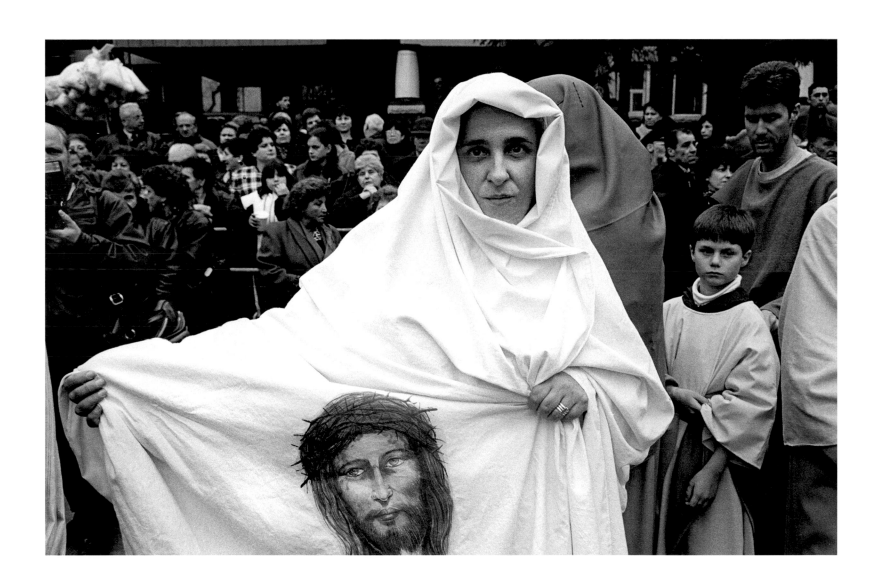

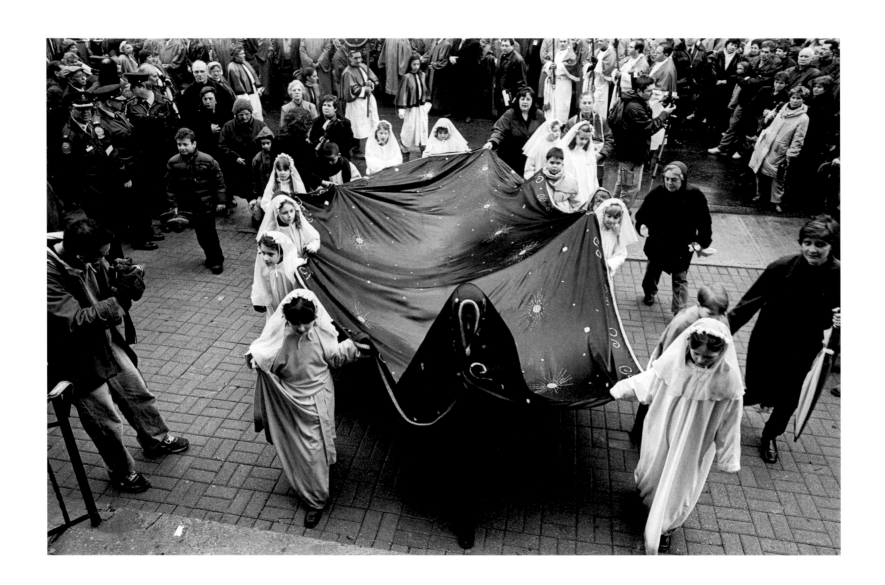

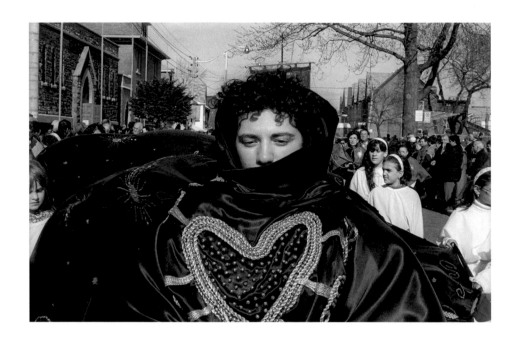

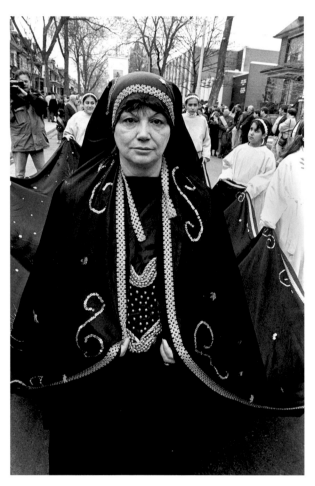

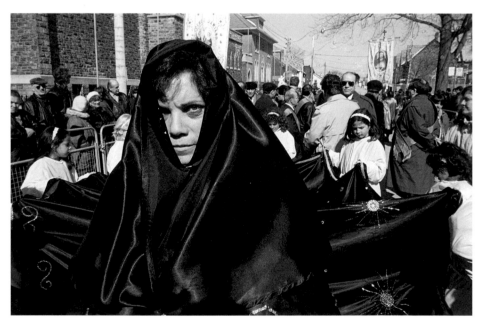

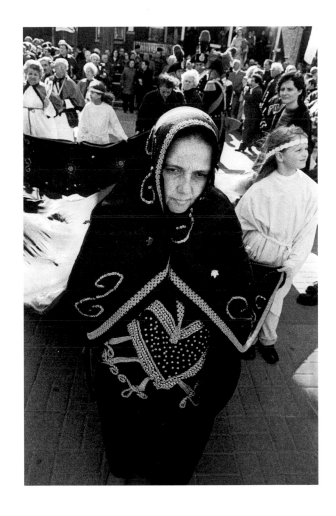

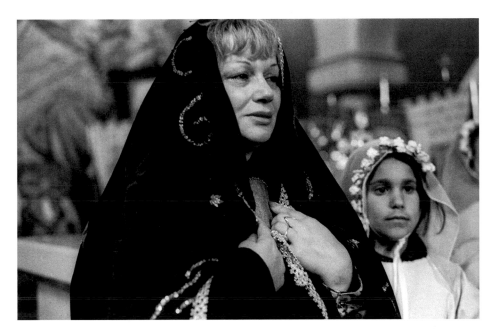

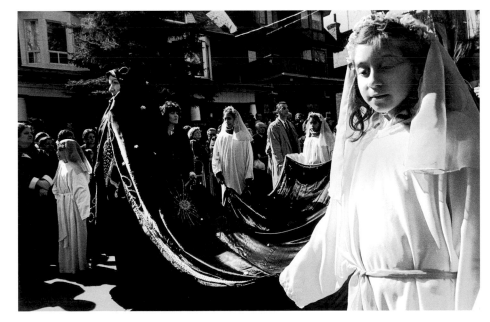

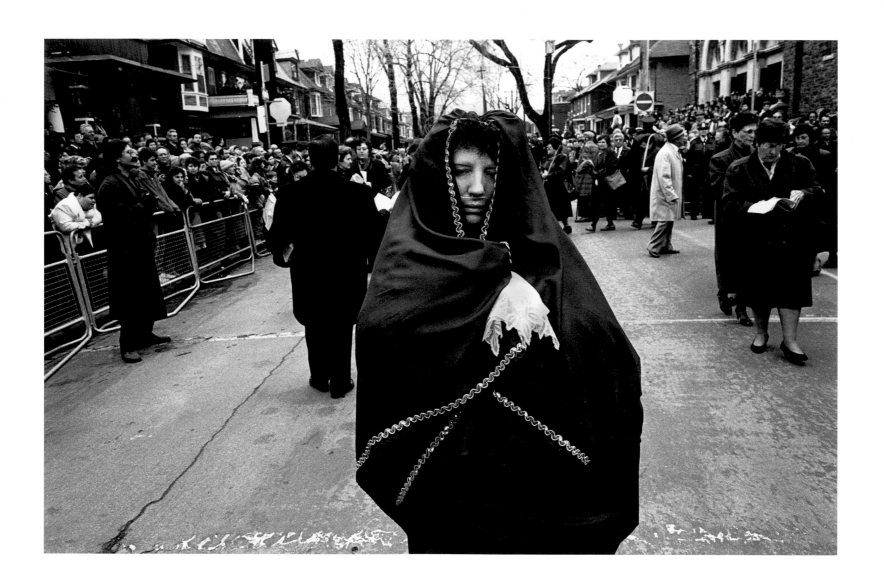

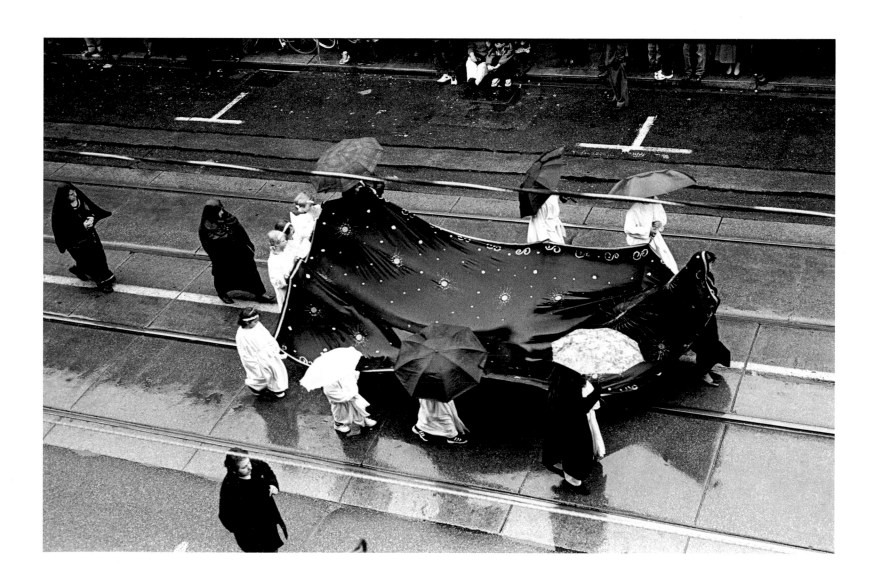

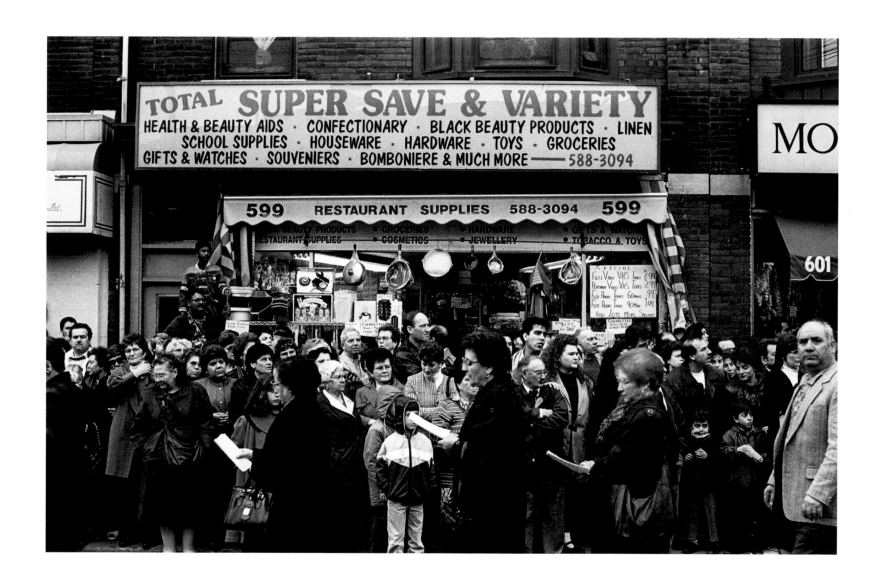

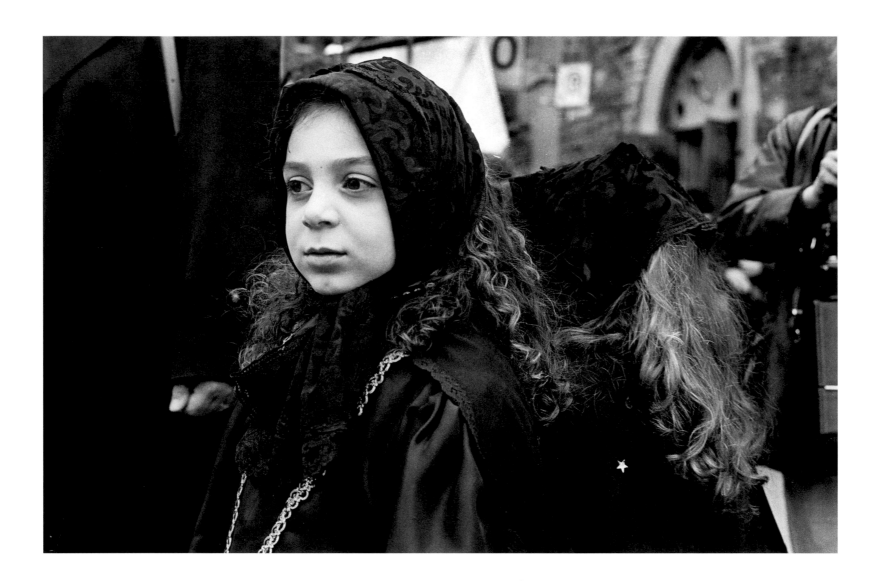

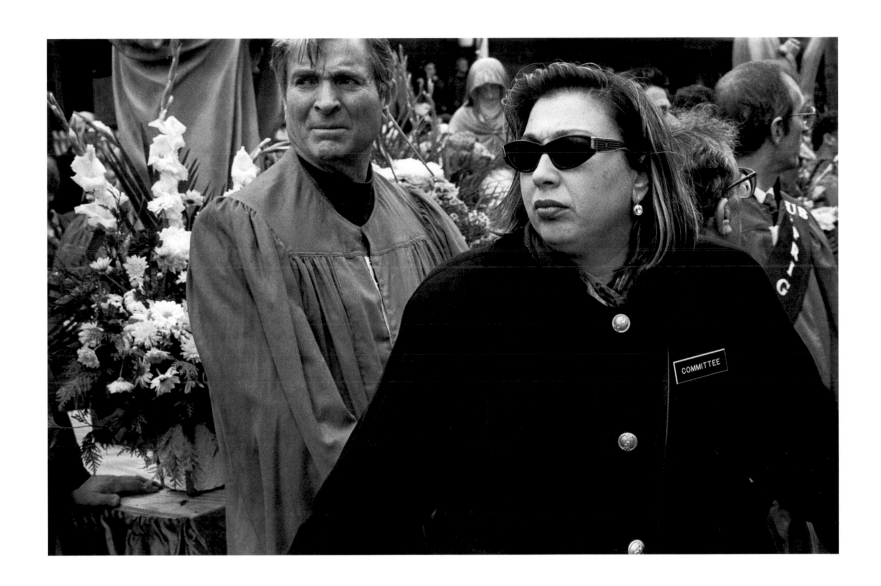

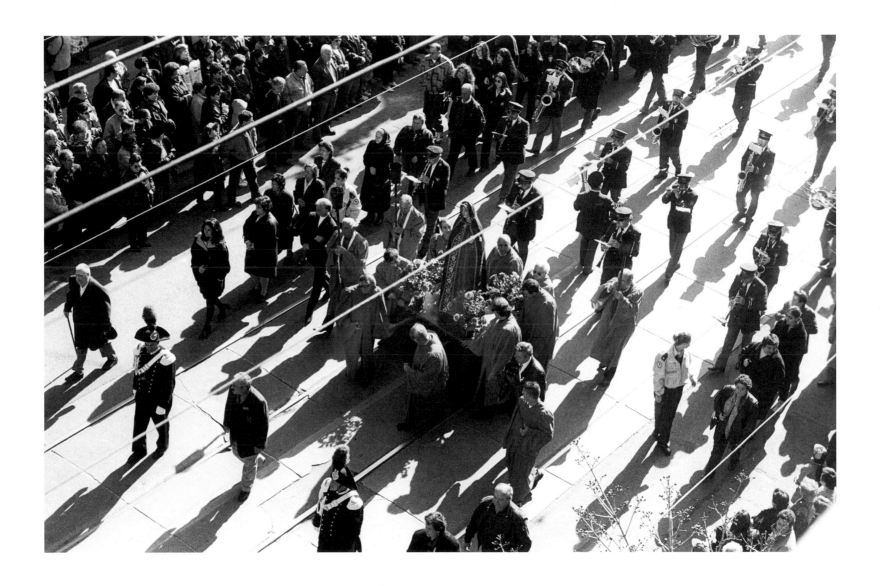

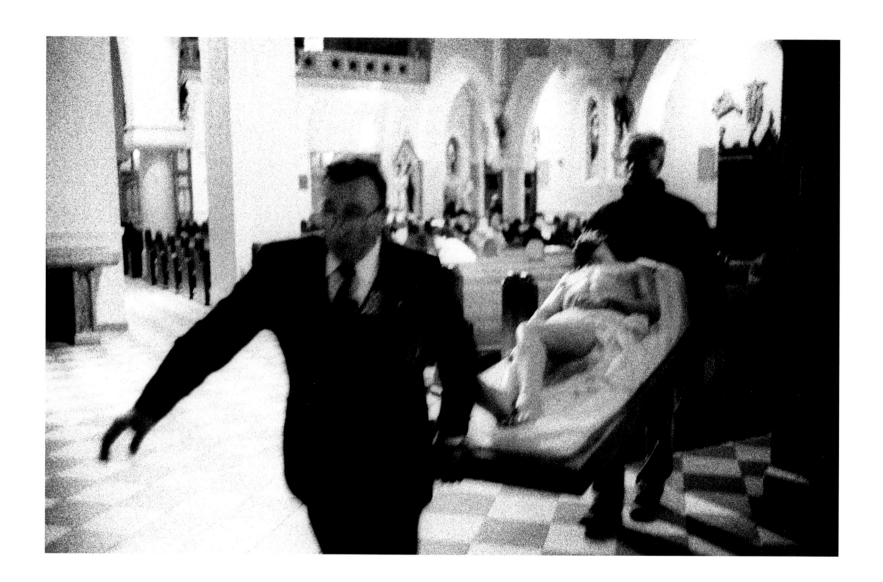

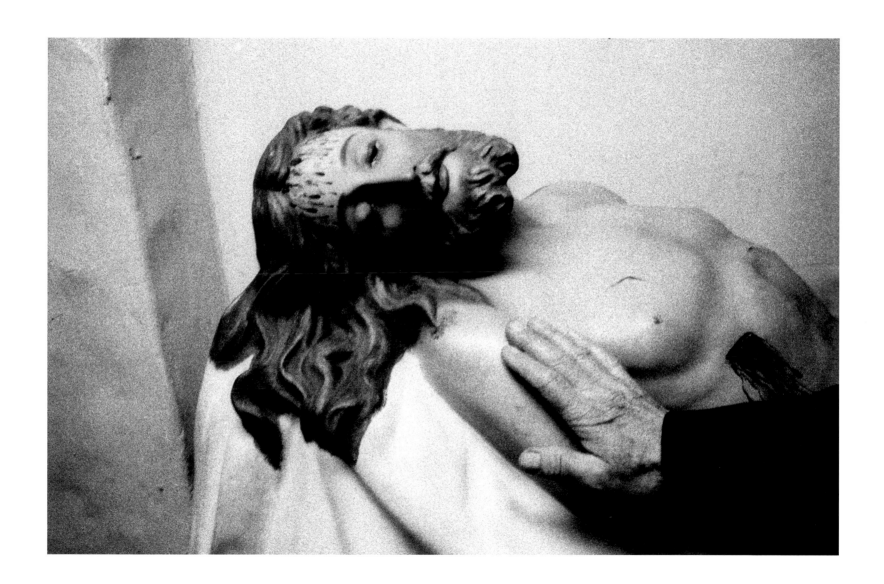

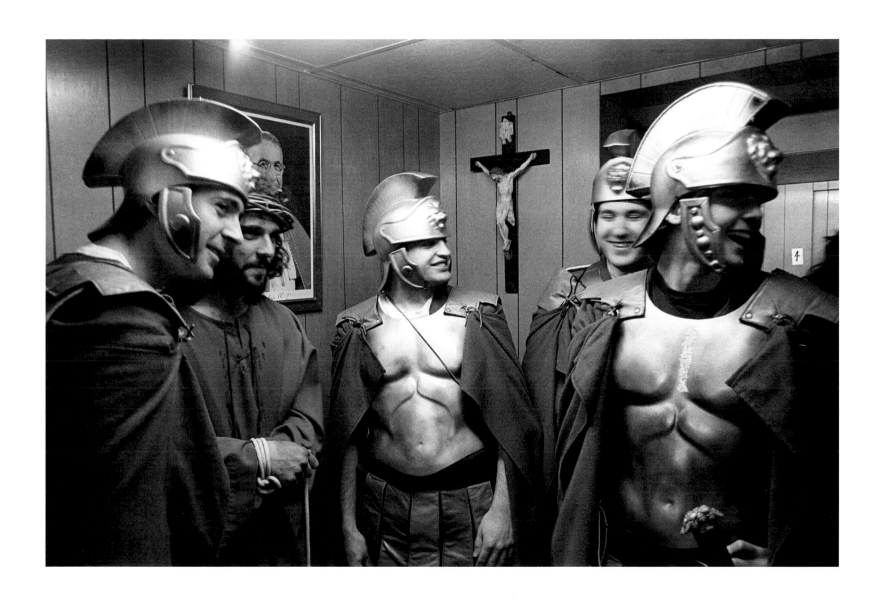

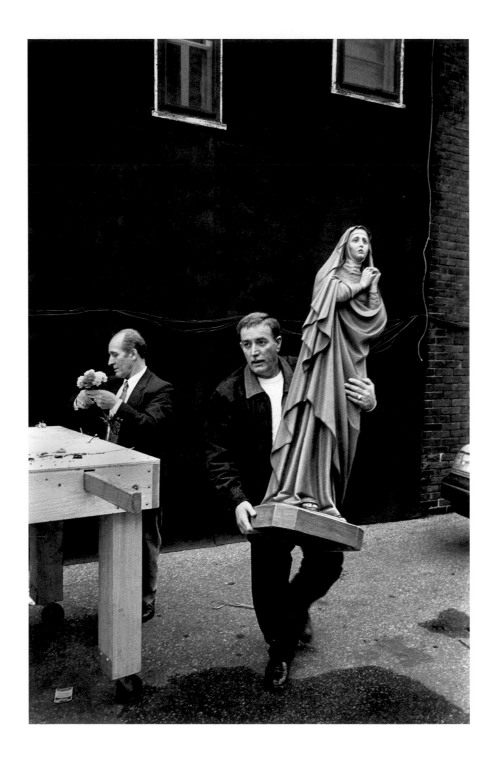

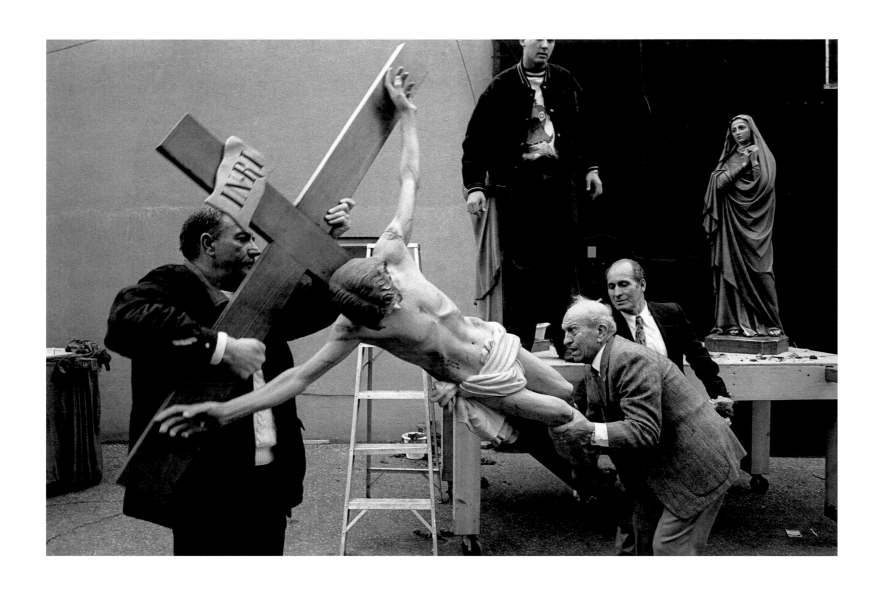

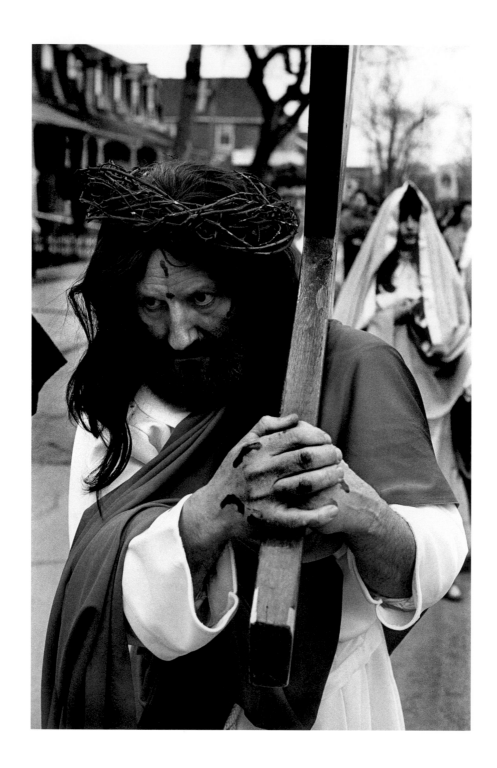

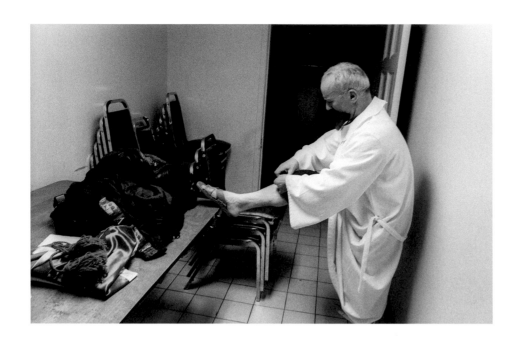

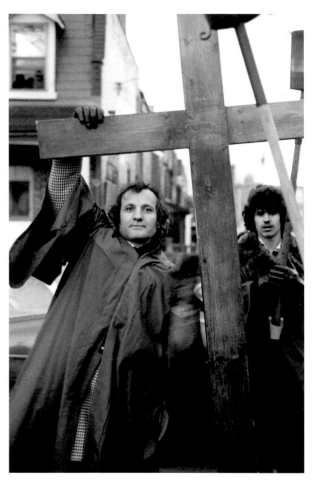

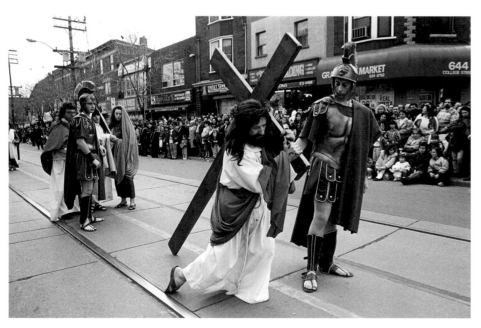

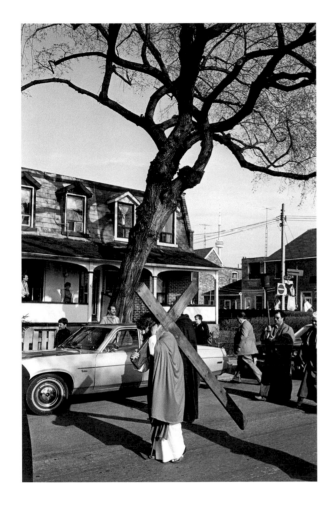

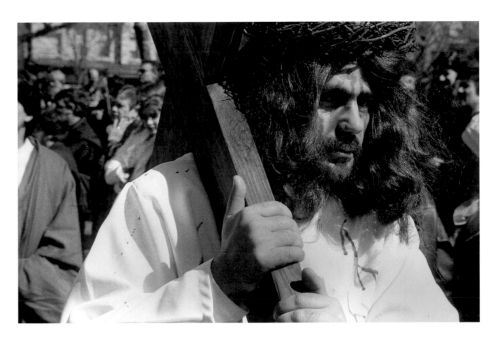

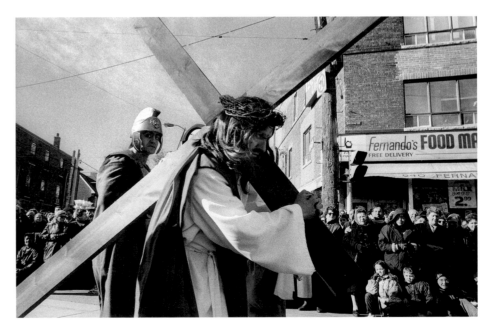

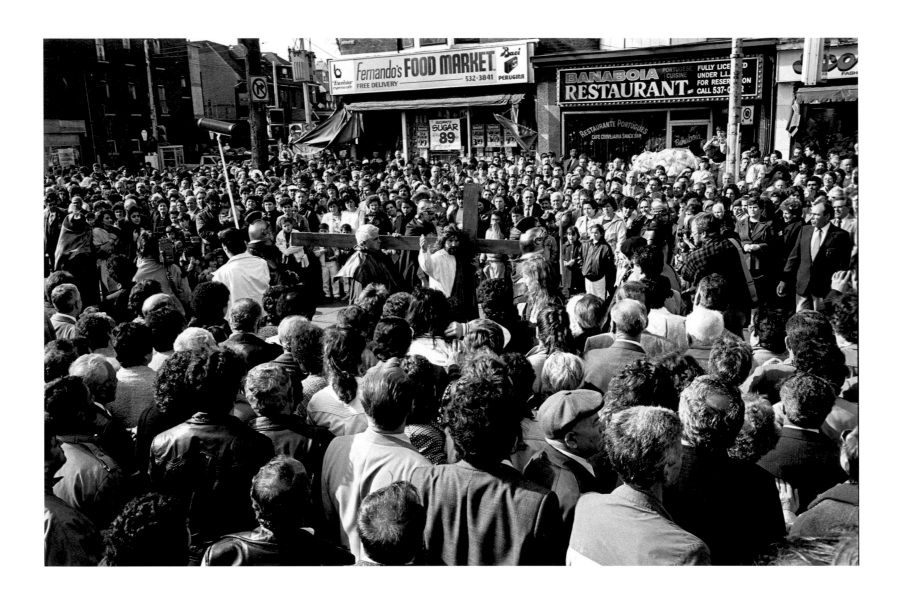

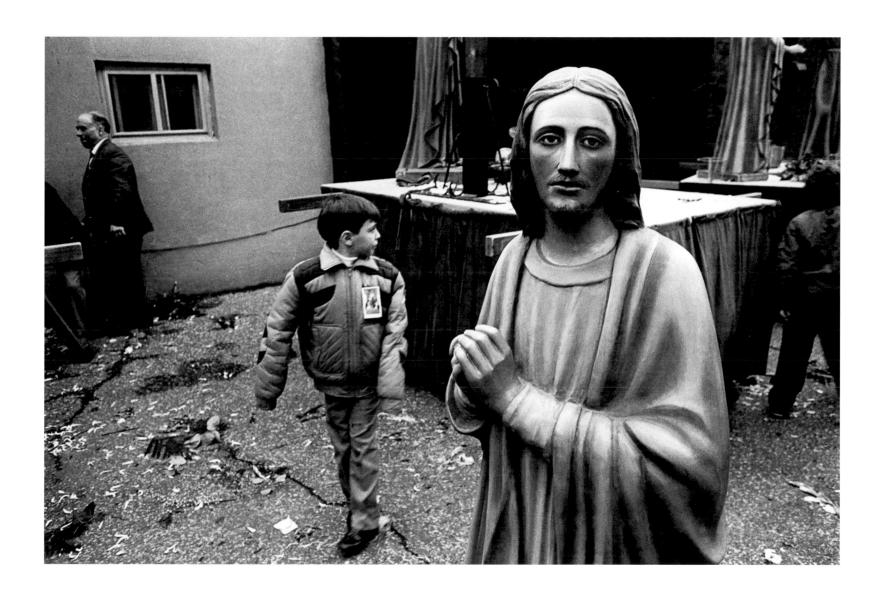

THE MILLENNIAL YEARS

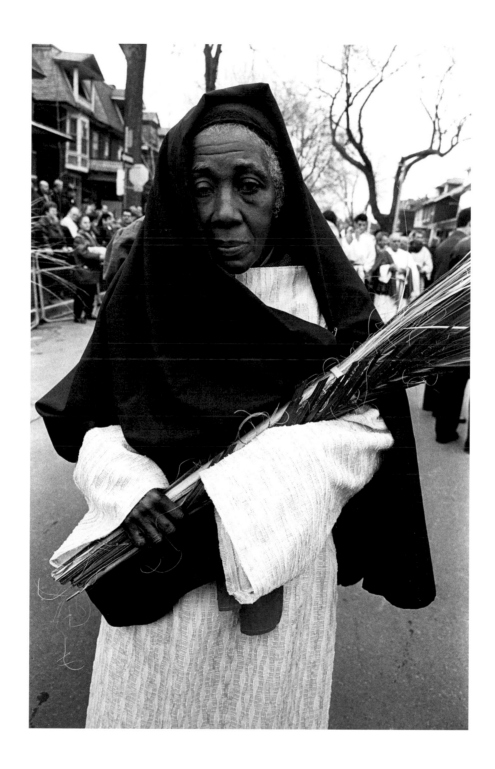

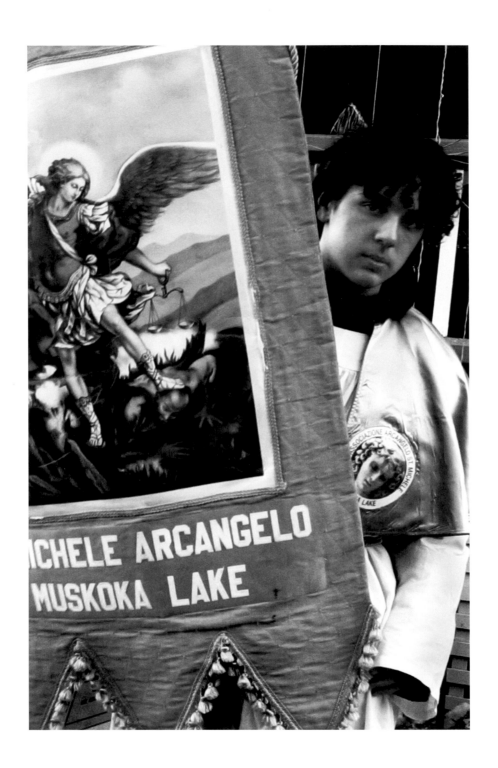

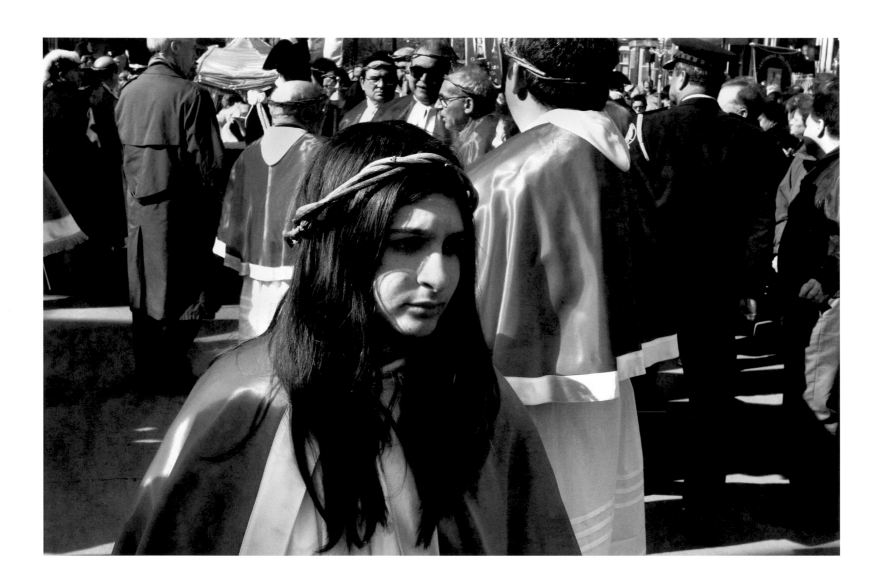

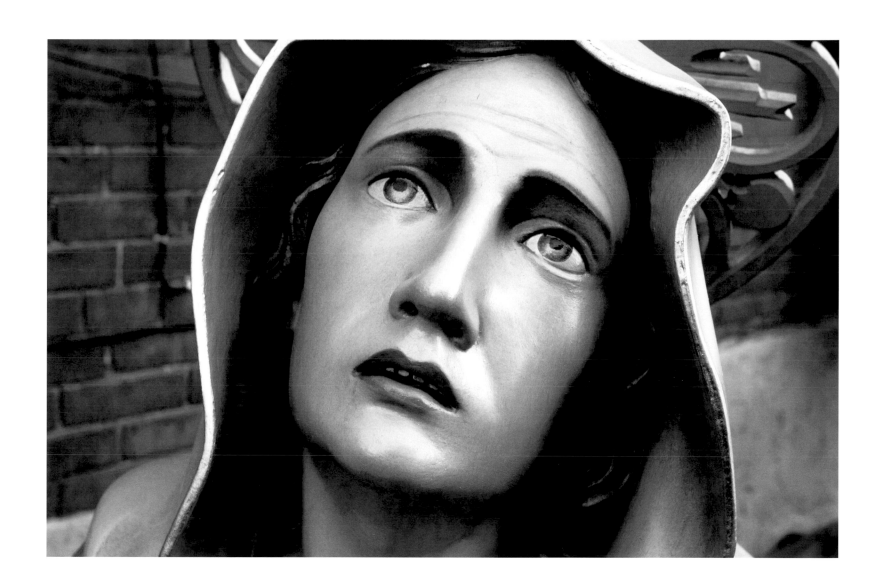

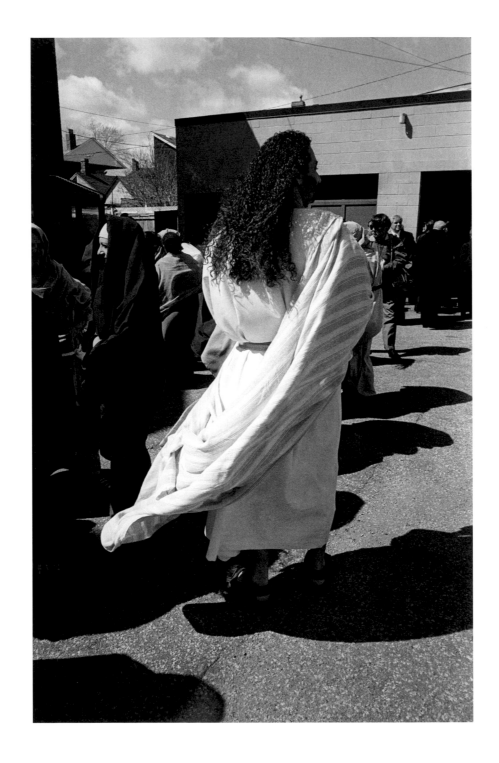

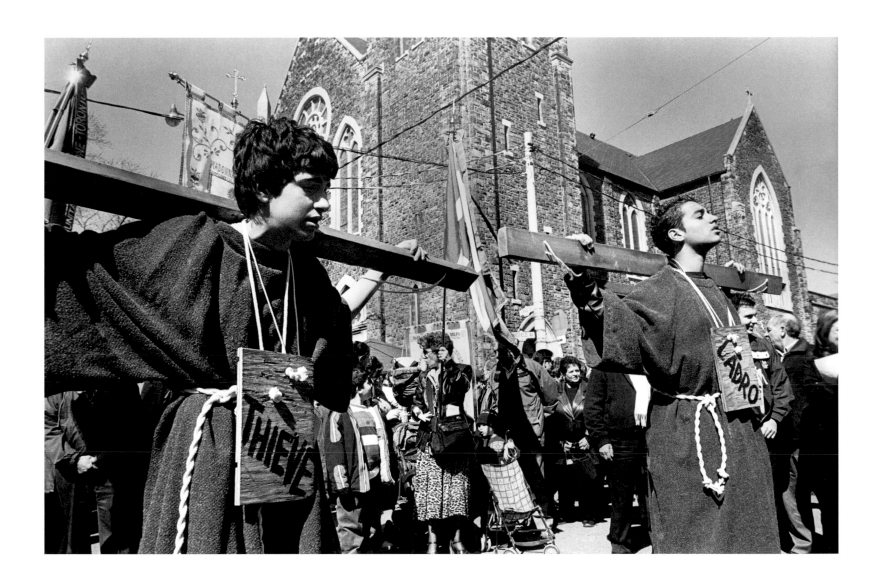

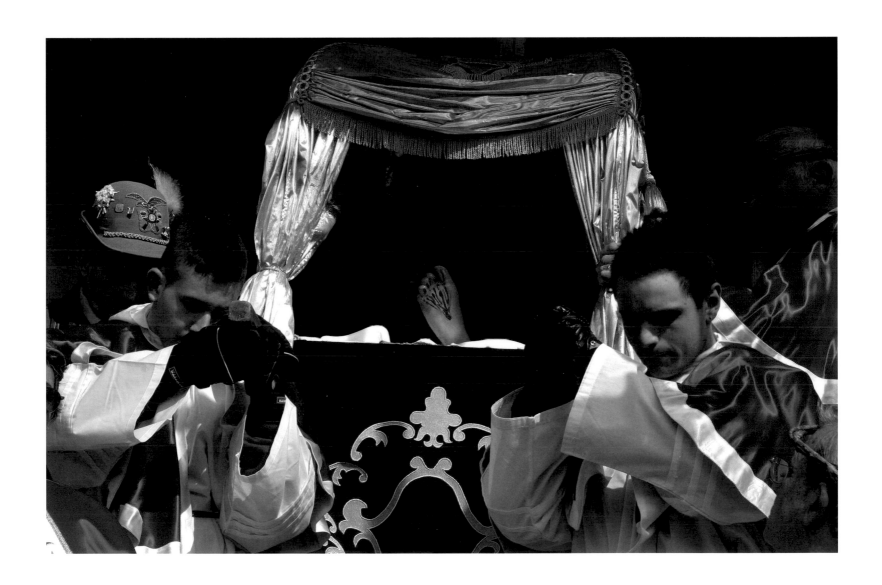

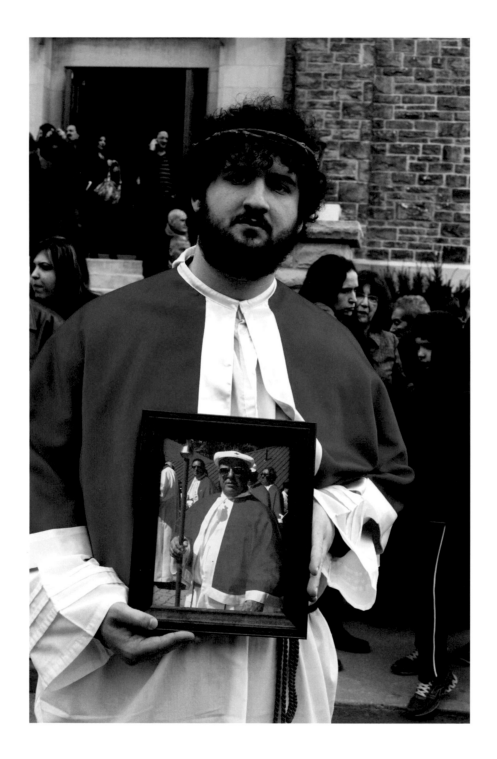

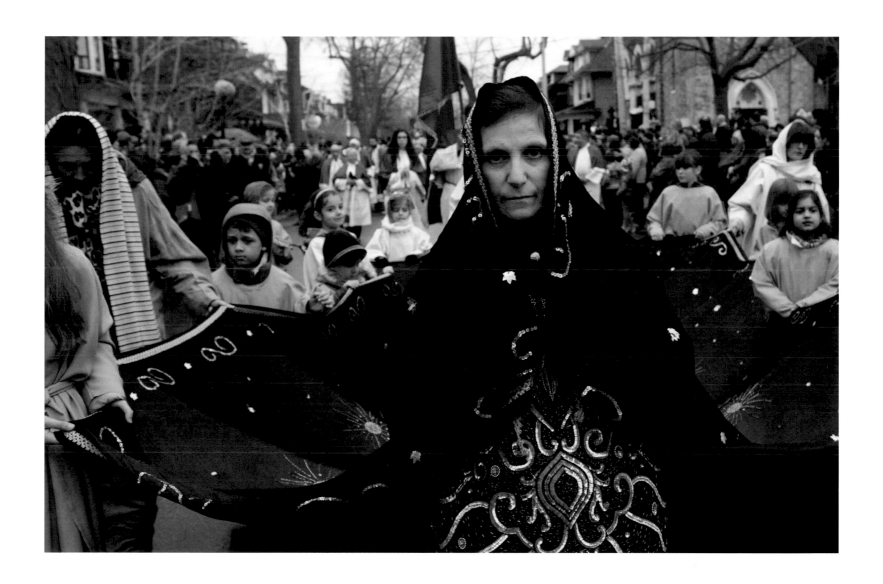

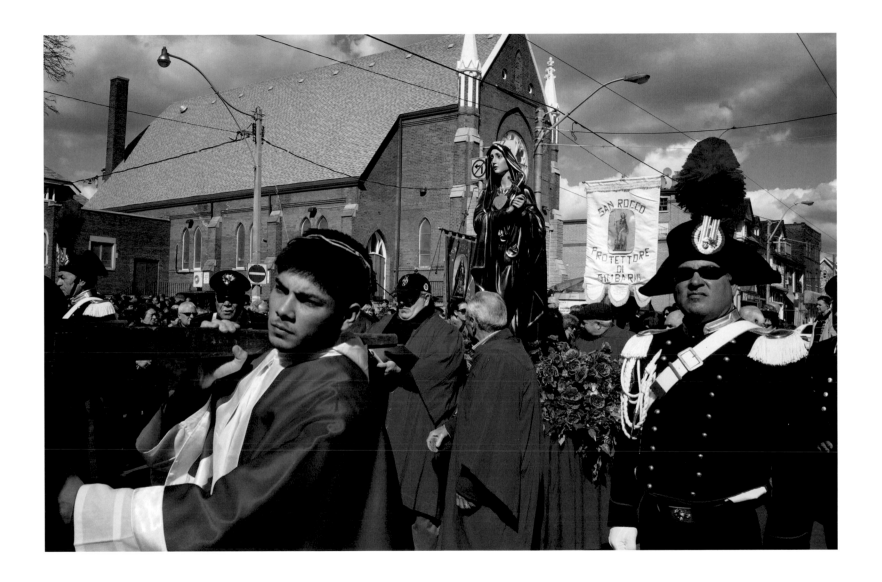

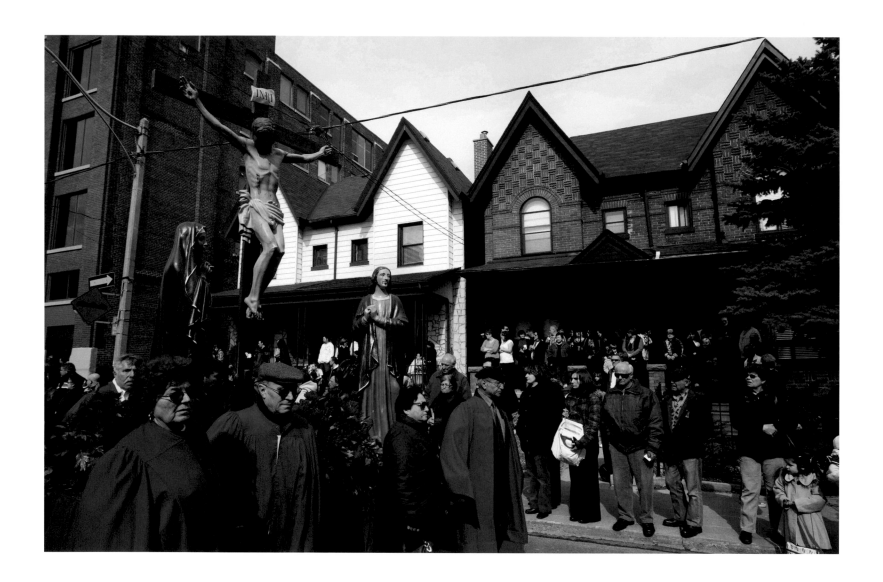

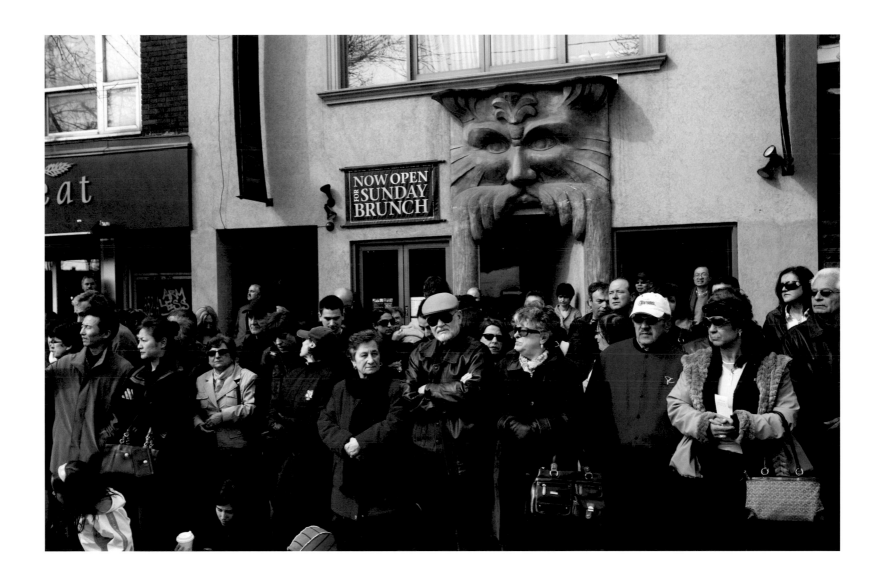

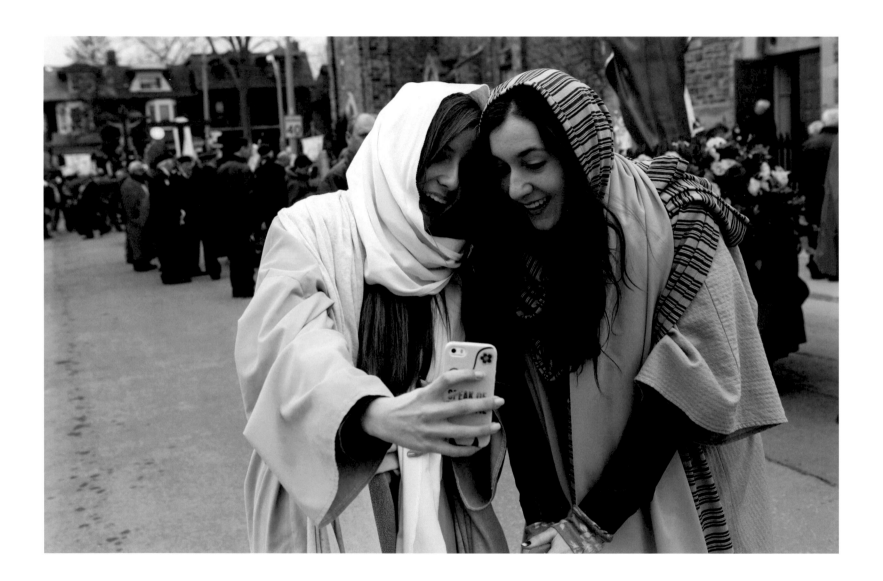

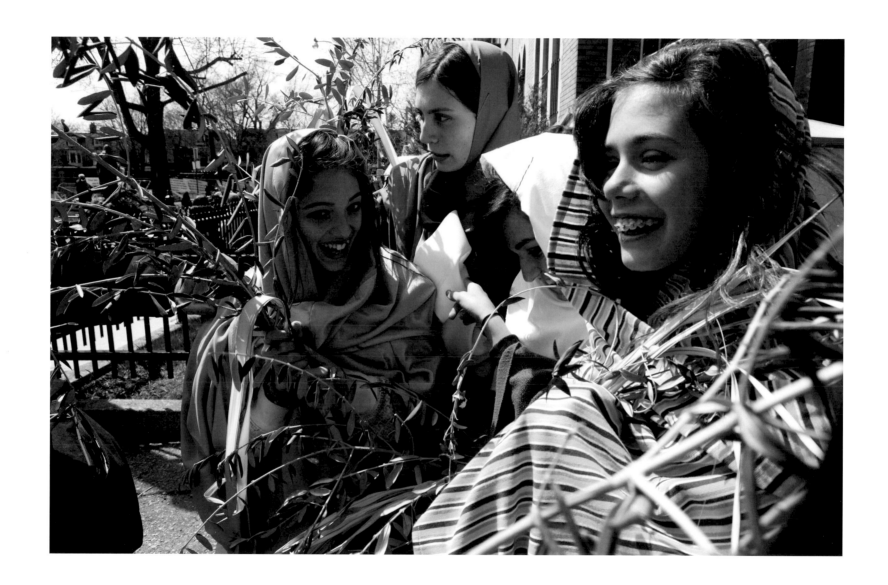

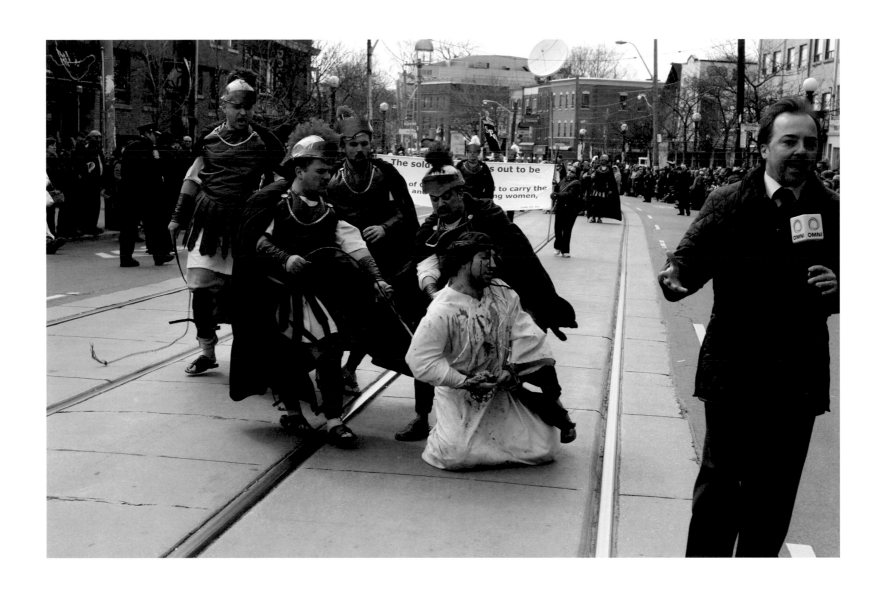

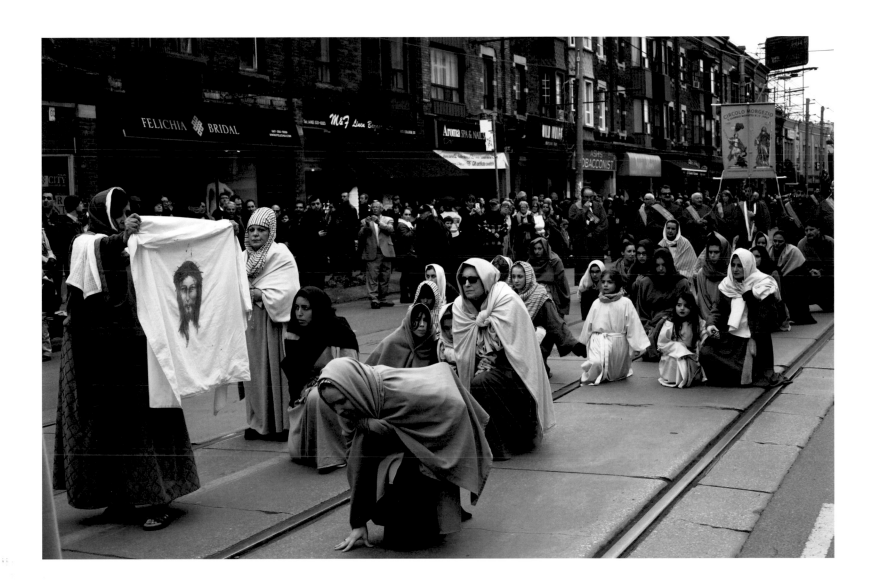

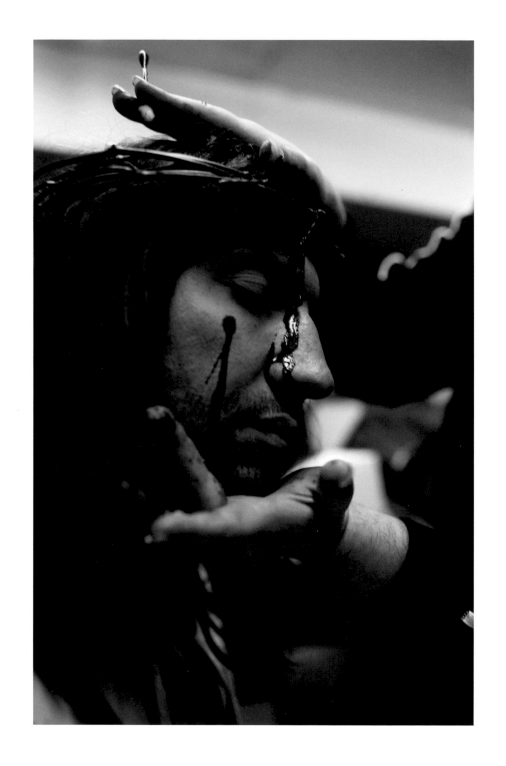

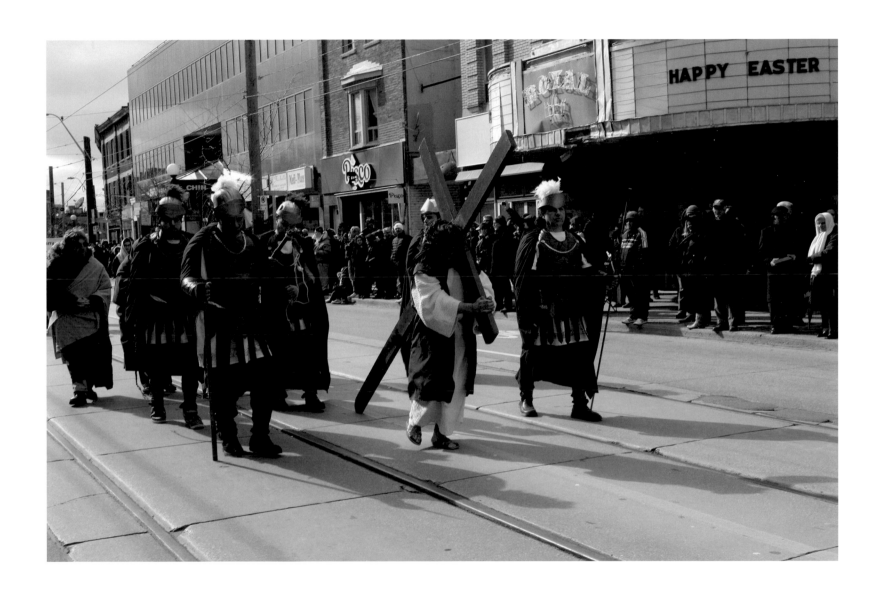

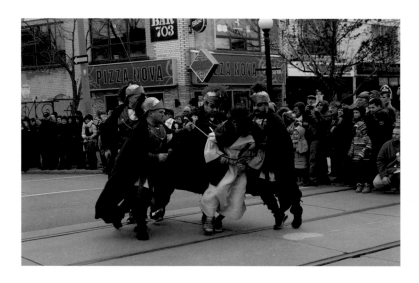

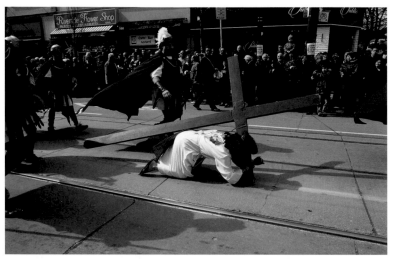

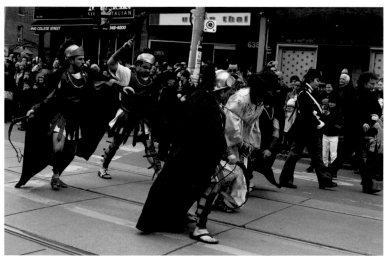

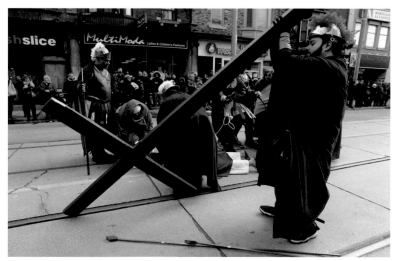

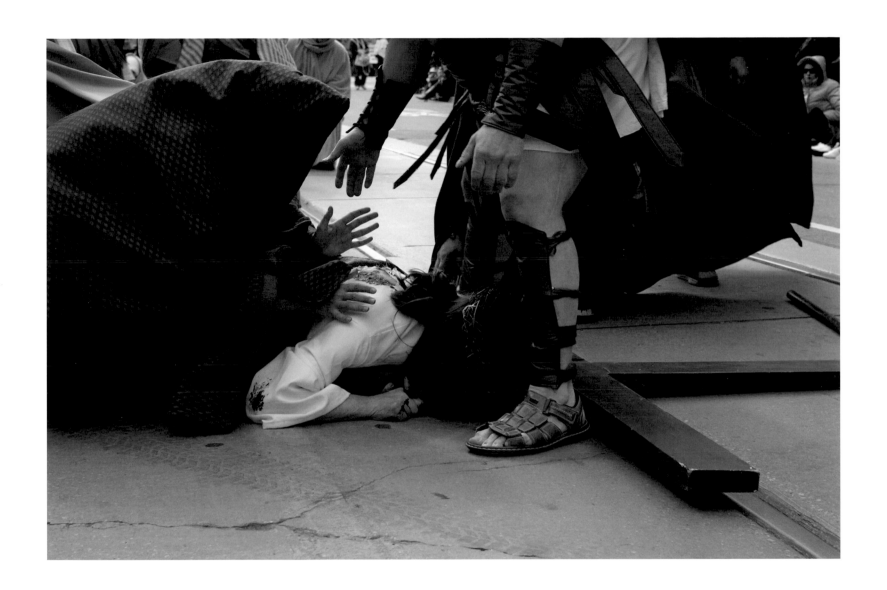

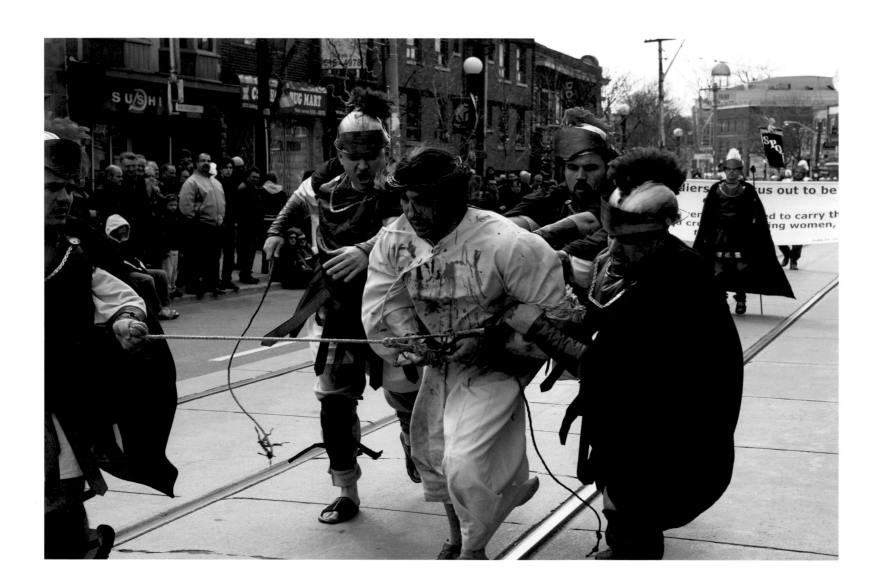

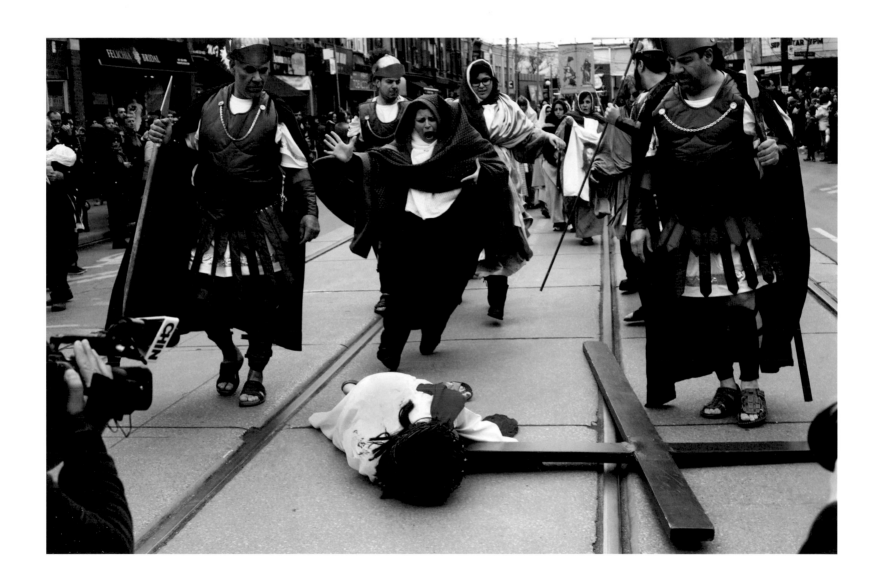

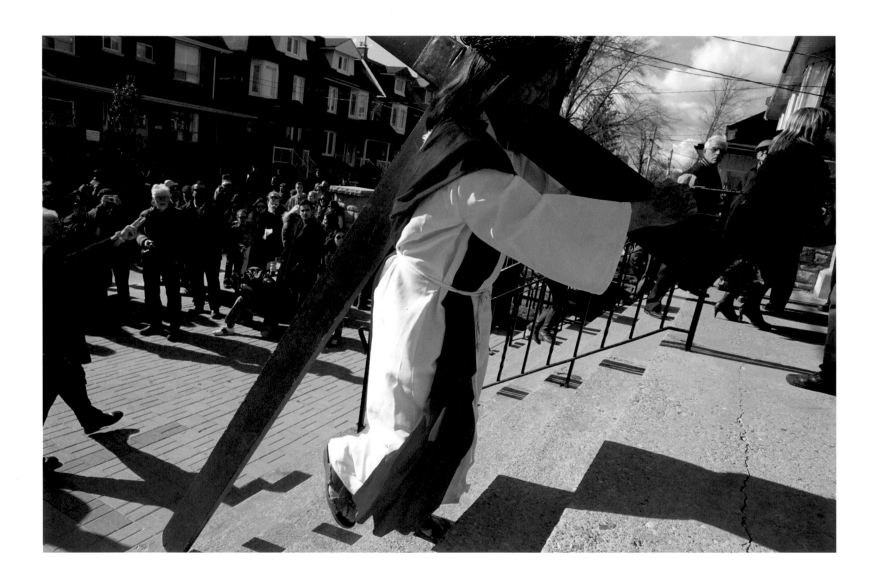

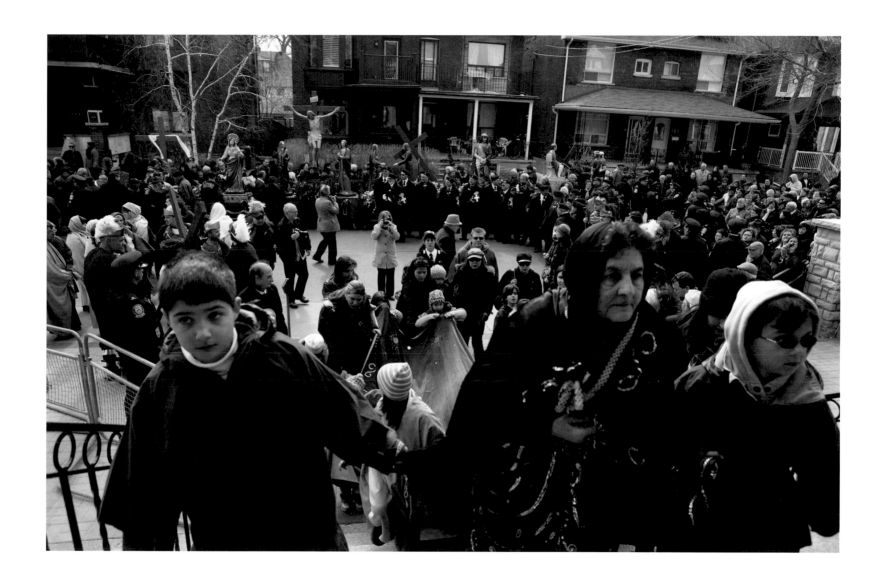

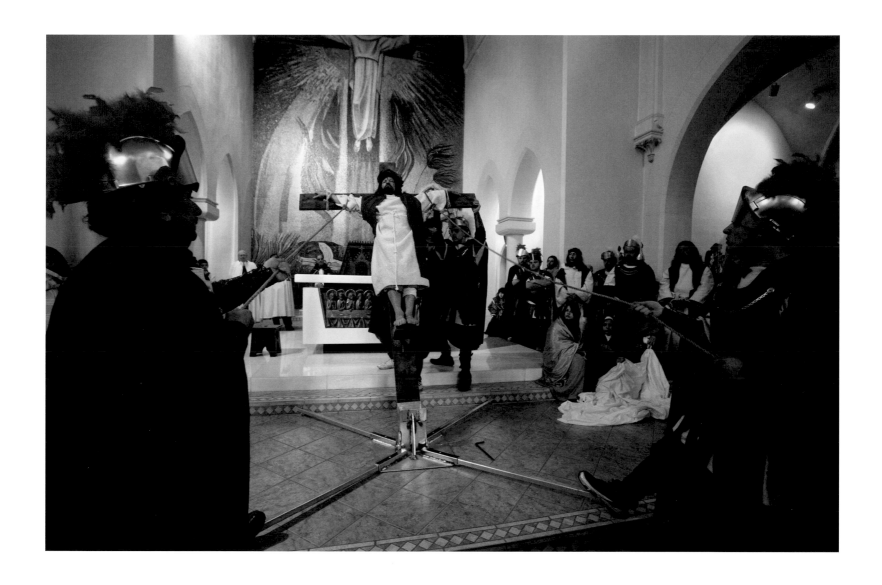

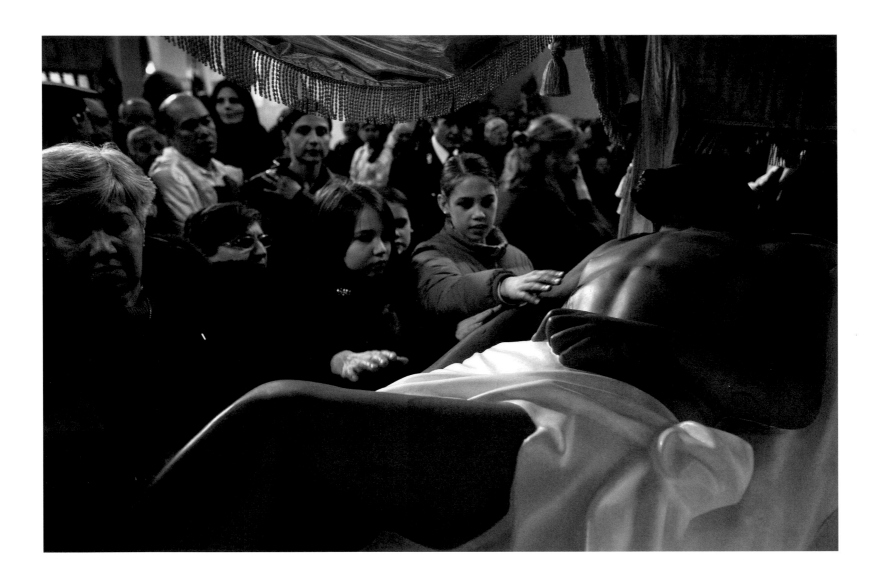

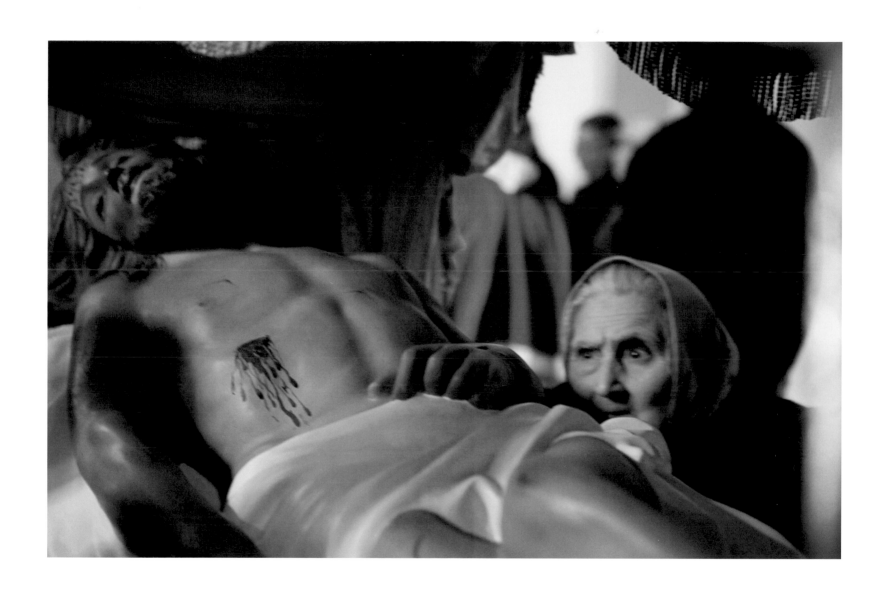

IN THEIR OWN WORDS:
CONVERSATIONS AND INTERVIEWS

I held a number of informal conversations and interviews with some of the key organizers and participants in the procession. Aside from my annual encounters in the process of documenting the procession, I was already familiar with most of them through other channels. I made my selection with a view to provide as wide a range of experiences and perspectives as possible focusing the discussions on history, immigrant identity, spirituality and personal fulfilment.

GIUSEPPE SIMONETTA

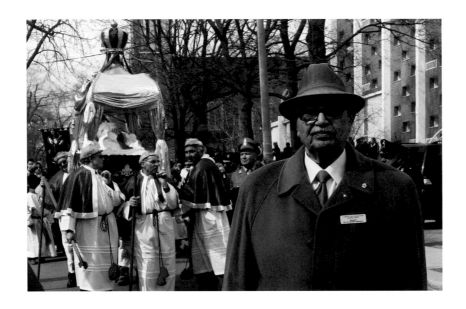

Cav Uff Giuseppe Simonetta, 85, is a founding member and President of the Lay Committee of the Good Friday procession, a retired officer of Italy's Arma dei Carabinieri (the national police force), and a long-time community activist who in the 1960s operated one of the earliest Italian cafes in the city. He currently heads the Canadian Italian Family Assistance Association, an organization which provides social service programs for the elderly, in collaboration with the Consulate-General of Italy. He was instrumental in guiding the development of the procession at key historical moments, and today continues to be a driving force of the event, working tirelessly behind the scenes. He has taken much of his inspiration from the efforts of his late daughter, Filomena Maneli, who for many years was a principal organizer of the procession and played the role of *Addolorata* (Lady of Sorrows). In a recent wide-ranging conversation in Italian, Mr Simonetta recounted the story of the birth of the procession and its subsequent growth.

Giuseppe Simonetta: The birth of the procession has the most interesting of origins. It came about as a result of an unusual discovery in the Church of St Agnes, the Italian parish that preceded St Francis of Assisi Church. It was there, through the efforts of a dear friend of mine, Vito Telesa, a master woodworker and decorator born in San Nicola da Crissa, Calabria, that a statue of Christ was discovered. Discovered, that is, because no one knew of its existence, as it was hidden behind a wall in the basement of the church. Vito, who was working at the church as sacristan, doing maintenance and repairs, had noticed a hollow sound when he tapped against a wall by the basement stairs. This went on for several days. He became suspicious, and the parish priest, Fr Riccardo Polticchia, encouraged him to investigate. By making a hole in the wall, Vito discovered that there was a hidden statue. He slowly brought it out into the open with Fr Riccardo's help, and to everyone's surprise, it was a statue of *Cristo Morto* (the Dead Christ). No one knew how it got there, and it was curious that it was not investigated as to how it might have gotten there. Obviously someone had hidden it there very carefully, but who? And why?

The statue was scratched, dirty and discoloured. Unrecognizable as the Christ really. You could hardly recognize the wounds on his body. But it was definitely the *Cristo Morto*.

Now, Vito was a devout person, whose brother was a priest in Calabria, and he was well-versed in these church matters of statuary. He realized the importance of his discovery, but he was in quite a shock. He came to see me at my café at College and Clinton Streets, and since we also were *paesani*, from the same town, he felt he could trust me. He told me of this incredible fact. He was still in shock. He said, "I can't explain what happened. But for days I was suspicious. I knocked on the wall, and I knew it was empty. After I made a small hole, I could tell that it was a statue. But of which saint? After I enlarged the hole, with Fr Riccardo's permission, we were able to pull it out into the open. And we could see that it was Christ. But he was almost unrecognizable because of the condition." He drank his espresso, then he said, "What should we do? We have to do something."

We decided that he should restore it, and we ended up purchasing crayons and paints in a children's supply store. Some reds, yellows. In those days, we didn't speak any English, so things were more difficult. It was 1962. The community was still small. In any case, with some encouragement, Vito took it upon himself to restore the statute the best he could. Some other carpenter friends made a wooden bier for the statue.

Then what? We should have a procession. Fr Riccardo was supportive, but he wasn't sure. How do you get a permit for that? And what if the church goes into debt? Processions were not common, but in fact there was already a procession of St Anthony, since he is a popular patron saint of many Italian towns, and the Barese community from the city of Bari, in Apulia, Italy, once had a procession of the Madonna of Constantinople—ah, what a beautiful Madonna—at the church of Mount Carmel [on St Patrick Street]. In any case, we decided to try out a small informal procession. We formed a small committee—five or six people. There was Foggetti Luigi, Felice Fermi, Prioriello, Luigi Ariganello. We ventured in the laneway behind the church [Plymouth Avenue], and came right back. And so this was our first procession, a community initiative that came out of the wonderful chance discovery. There weren't that many people, but it was a start. You could say we were testing the waters. We had no other statues, but we needed *Addolorata* to accompany the Dead Christ. So we used a statue of the Immaculate Conception as a stand-in, and covered her with a black cloak to symbolize her state of grief.

By 1966, the parish had moved up the street into St Francis of Assisi. We continued the procession, but only around the block, along Mansfield Ave and Henderson. College Street was out of the question, because we couldn't close the traffic. I think we got as far as College in 1968 for the first time. That's also when we started publicizing it, on the local Italian-language radio station.

We started collecting statues that were about to be discarded by other churches in cases where there had been a fire, or the church was undergoing renovations. Churches from Buffalo to Montreal to Quebec City. That's how we got our statue of the Calvary, the beautiful Pietà, the Encounter [of Jesus and Pilate]. The *Ecce Homo* (Behold the Man) was the last one, we got it from a seminary in Quebec City. My friends and I drove there with a small pick-up truck, for we couldn't let this opportunity pass us by. And that's how it went.

As the procession grew in popularity, we encountered many obstacles. The police department didn't like the idea of closing College Street. They were very insistent on that. There was even talk of moving the procession to a different location like the Canadian National Exhibition grounds. The priest, Fr Angelo, didn't feel strongly about it, but we felt it should be kept right in the community. We felt that we had to prove to the authorities, especially to the Chief of Police, William McCormack, that closing College Street would not result in chaos, that the community was law-abiding and hardworking. It so happened that at about this time, the mother of Chief McCormack passed away, and as a gesture of solidarity, we [the Lay Committee of St Francis of Assisi Church] decided to attend the funeral and pay our respects. The gesture was very much appreciated, and a month later, we followed with a memorial service right in St Francis Church, in accordance with our tradition of a 30-day memorial Mass. We first had to persuade the reluctant priest, of course. This was a historic opportunity for us to make inroads with the police and other authorities, many of whom attended.

So we worked on building relationships, and slowly it worked. That is the secret of our success. This work should have been done by our parliamentarians, but we are always guided by our own sense of pride and faith. Without faith, you can't do anything.

Now the procession is world famous and has caught the eye of many people. In 1998, an extraordinary Baroque crucifixion statue dating from the eighteenth century was brought over from the town of Recco, in Liguria. That community simply wanted to be part of our procession. Their statue is carried aloft by a single person, who balances it on a special harness tied to his body, but without ever using his hands. It is a national treasure of Italy, and people came from as far away as Boston to see it in the streets of our community. In 2003, Pope John Paul II watched a live transmission in Rome, and he sent his congratulations to the diocese. We've worked with many priests, Fr Isidore, Fr Ralph, Fr Raymond, Fr Gregory, Fr Jimmy. We don't always see eye to eye on everything, but after 53 years, the procession lives on. It's a far cry from those early days with Fr Riccardo. Then, we only had our faith to keep us going.

LUIGI ARIGANELLO

Luigi Ariganello, 87, is one of the co-founders of the Good Friday procession. He immigrated to Canada at the age of 22 with a group of men from his native town in Calabria, with no possessions other than a few personal effects. He landed his first job in Canada cutting trees in the bush near Thunder Bay in northern Ontario. It was the winter of 1951, and working and living conditions were brutal. Within one year, Mr Ariganello started to travel widely in search of better work, first to Sault Ste Marie, then to Welland and Niagara Falls in southern Ontario, later to Val d'Or, Quebec and Timmins, Ontario, ultimately settling in Toronto. He variously worked as a logger, miner, construction worker, and shopkeeper before finding permanent employment with the City of Toronto as a cement finisher on roads, where he was quickly promoted to foreman and inspector overseeing construction jobs. In the procession, he has always worked behind the scenes, taking a leading role in organizational and logistical arrangements. Because of his role as an usher during church services, his presence in the church has been a source of constancy for me as I documented the procession through the years. I spoke with Mr Ariganello in February 2015.

Luigi Ariganello: I was born in Serra San Bruno, Calabria, and I came to Canada in 1951, and have lived in Toronto since 1955.

If I couldn't go to the procession, I would go crazy.

It started at St Agnes, when Fr Riccardo was there. We started with two statues, the Dead Christ and the *Addolorata*, which we still have. They are the only two statues that we have from the beginning.

In my hometown Good Friday is the principal procession that we have. It is the only one that goes around all across the town. The other ones for St Francesco, St Bruno and St Biagio limit themselves to a gathering in front of the particular parish, and that's it. But the Good Friday procession starts off in the morning, and by the time that it returns to its home base, it is night-time and dark. The procession calls on every church, there is a short service, and then it proceeds to the next church. Also, one of my uncles was a priest—the brother of my mother, to whom I felt very close, so I was always felt a kinship with the church.

Here in Toronto I began by becoming an usher at St Agnes Church, and after a while, the others and I said to Fr Riccardo that we should hold a procession. He said, "The people here are not the way you think they are. Not Catholics like in Italy. Here they are Protestants...." We said, "Let's try it out anyway, and see how it goes." He thought we would end up with debts. But we didn't. We made some money, and gave all the money to the Church. The money collected on Good Friday is out of reach to anyone; it is reserved only for the Church. And from there we moved to St Francis Church.

We used to carry the statues on our shoulders. I was in charge of everything there. I always walked in front, the priests know that I tell the people the route that they have to take, and what they have to do. For example, take the police. The police wanted to get paid. I told them, this is not a procession for making money. This is a procession for making improvements to the church, for paying bills, covering food expenses of the priests, etc.

The first time we must have been about 500 or 600 people. But they were devout. We established good roots at St Agnes, very good roots. Did you hear what the Pope [John Paul II] said? That he thought that the biggest procession was in New York. And yes, they do have one in New York. But it's never like the ones we have in Toronto. In terms of organization, or number of statues, the crowds of people.

How many statues do we have? Who has bothered to even count them? Let me see, there's the *Cristo Morto*, the *Addolorata*, Mary Magdalene, St John, *Ecce Homo* (Behold the Man) and others. And they are all on wheels now. That was Felice Ferri's idea, who has since passed away. We have torches too, but for the past few years, they haven't used them. One year they didn't put enough wax in them, and so the flames burnt out. The priest said, "What's the use of carrying them dead?"

I saw the procession grow from nothing. It was us, the core group of volunteers. The idea for the procession came from the community. From people like me. And there was Felice Ferri, Pasquale Martino, Cav Simonetta, Prioriello, quite a few others. We were all ushers. There was also a brother of mine who was an usher, Franco Ariganello, who felt very close to the procession.

The procession continues to grow. People came in bus tours, organized from St Catharines, Rochester, Niagara Falls, Welland. The way we go to other processions, like the Madonna of Utica, New York, they come to ours.

As for the future, there is no end because there are too many people interested. On Good Friday, we arrive at the church at 6 am to get everything ready. The statues are stored up by near the organ. The crosses are in the garage. We have to get them out and dust them. Sometimes there are strong young men that help us. First we position the *Madonna Addolorata*, and the cross beside her, then all the others in order.

This procession is not like the rest. For example, if you do one in Vallelonga, it is only for the people of Vallelonga. But this one is for all the people—of Italy and Canada—and people of other nationalities, like Germans, French, South Asians. The procession represents people from all over the world. Imagine, even the Pope thought that New York's was larger!

I have never carried a banner or a statue. Either you're in charge, or you carry the cross, as the saying goes. Except for the *bara* (bier). Especially in the early days. The cover for the bier was made by a master tailor, found by Felice. We bought the material, and we saw that he had the right passion for the job.

People who want to play a character let it be known to the committee. It's on a first-come, first-served basis. We then ask them to make a donation to the church. We have to pay bills like the marching bands. We also have a book with all the people who carry the statues recorded, kept by the late Tony Maneli.

To me personally, the procession means everything. At night when I go to bed, I say my prayers. I've had two cancers. Then I was cut open all across my chest, open-heart surgery. Thanks be to God, I've never had complications.

For the city of Toronto, the procession has become a great thing. We work with the police, and are able to close all the roads that we need, no problem. It is famous all over. It has had a big effect. Big-wig politicians come to be seen. There's even a procession in North York from which they bring their own statue [St Maria Salomè] to carry in our procession! They tell us ahead of time, and we assign a spot to them. We do it no matter what the weather. But one year we had to cut it short, because of bad weather, and we took a short-cut through a laneway.

The procession is renowned in Canada, not just in Toronto. It has grown. There are many other people, Protestants who come too. If you go to the 8 am mass, you'll see the variety of people who come to church, people who don't even live in the neighbourhood, but they come.

RAFFAELE PAONESSA

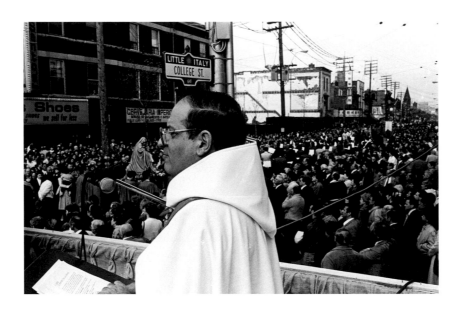

Fr Raffaele (Ralph) Paonessa, OFM, is an American-born Franciscan priest who is part of the Third Order of St Francis based in New York. He was assigned to St Francis of Assisi Church from 1 March 1984 to 1 July 1990, a period of time when the Good Friday procession had evolved from a small local event into one of the largest religious festivals in Toronto's immigrant communities. Fr Ralph, as he is affectionately known, fit in perfectly in the community since he was not only fluent in Italian, but being of Calabrian ancestry, he also understood many of the southern Italian dialects spoken by the older generations among his parishioners. Since moving from St Francis, he has been actively serving the community in a number of immigrant parishes in the Toronto area. When I was a city planner, I collaborated with Fr Ralph, in community development projects in the late 1970s and early 1980s. I was particularly eager to reconnect with him and hear his views on the procession. In February 2015 I caught up with him at Villa Colombo, an extended care facility for the elderly which he visits six days a week to celebrate Mass.

Fr Raffaele (Ralph) Paonessa: Well, the *Cristo Morto* is in the tradition of the so-called Latin people; so processions are very popular say in Spain, Italy, South America, Portugal. Procession is something religious. A parade is a secular manifestation.

This was the way of honouring the patron saint and getting the people involved. They would sing. They wanted to celebrate their patron by parading a statue all over the town. In a certain sense they were imploring the saint's intercession or protection in their town. Often it was a way of involving everybody, because very often when they had a statue it would go by a sick person's house who could not come out, they would stop over there, turn the statue towards that person's house. So it was a way of getting people involved and honouring the saints, who are heroes of our faith!

Together. Community. Now you have to think of those times when they didn't have TV, they didn't have all these means of modern communications. But these were powerful ways to express themselves and often they involved their culture, their songs, hymns in their own dialect or their own language.

At St Francis of Assisi parish, most of the parishioners were from southern Italy. I mean heavily Calabresi, some Abbruzzesi and I think some were from Le Puglie. Not too many Sicilians, I don't think. The Sicilians were more in the east part of Toronto, the Danforth area at that time. And there were people from Molise and those areas, in other words southern Italy, and maybe Frosinone too. When I was there I wasn't aware of too many from northern Italy, very few.

I felt very much at home at St Francis. I spoke Italian, but I also spoke dialect although I didn't have to—most people spoke Italian to the priest. Very few, the real elderly ones, might have spoken dialect which I could understand because that was the language we spoke at home. So it kind of thrilled me to hear them.

Fr Isidore was elderly, so I was always the one who marched in the procession. The priests—the spot that that priest would be was usually in front of the statue, marching with, maybe altar boys carrying candles. Carrying the holy relic, and actually praying with the people, they would say the rosary, join in the singing, and naturally the procession was so long that I didn't see the beginning or the end of it really. Sometimes they said—I don't know if it's an exaggeration—that 100,000 people were there.

It had expanded as much as everyone who wanted to participate in Toronto could. So people came, different societies or social clubs from different parts of Italy carrying their banners... and it was their identity, and a celebration.

So we celebrate the Passion of Jesus Christ, the suffering and death, and of course Resurrection. Passion in this sense means suffering. *Patire* in Italian. From *passione* which is the suffering of Christ. Jesus came out of love, no greater love than this: that a man laid down his life for his friends and this is what Jesus did.

During Lent the bells are silenced, even at communion time. Instead of the bells they have these wooden clappers, because bells are also a sign of joy or rejoicing or celebrating—it's sort of the idea of mourning, you know? And a lot of people are dressed in black because traditionally—at least in southern Italy—people wore black at funerals.

Covering the statues used to be obligatory, it no longer is obligatory. The idea of covering the statues put the church in a mood of sorrow. Sorrow for what our sins have done to our good Lord, put him on the cross, you know. In a theological sense we're all guilty for having him die. On Easter Saturday, when we have the Mass of the Resurrection, the statues would be uncovered, and we'd say, "Oh!" even the Saints now rejoice with us. I mean we're trying to make this in a vibrant way, in a celebratory way.

I think you could go anywhere in Toronto and speak to Italians and most of them will tell you, "I've been to the Good Friday procession at St Francis." They were part of it. Either they lived in that area or they just simply go down. That's the big thing to do. Of course from the Church's point of view, the main thing is the liturgical function; the official celebration of Good Friday which is scripture reading, and all that. But this is a popular expression or manifestation of Good Friday which people probably enjoy more because they understand it better. The other one, the liturgical, requires a bit more understanding, a bit more reflection. It takes place in the heart of Little Italy. All these things, we're all smelling the incense, we're all hearing the organ music, we're all seeing the priest with the holy relic, we're all hearing the same bells, we're all singing together. It was amazing to have cohesion there, you know? And some of these things still have value. For one thing they unite us with the past, and we celebrate the present and prepare us for the future too!

The procession provides a continuity with the past, and a renewal, and it gives it colour and it involves the emotions too, not just the intellect, see? And you know emotions are important too. And I think ritual appeals.

It portrays the way the Italian immigrants brought over their traditions and were able to manifest them here in a very wonderful way. It brought the Italians together, it expressed them in a common way in the Catholic religion, their love and devotion in Jesus Christ and Blessed Mother. I think it united them, even though they came from different parts of Italy. They had a common language. When they came to the procession they didn't talk, "Oh well this is Calabria, I'm Sicilian." They were all Catholics, we're all Christians, we wanted to express our devotion and we want to transmit it to our children, the next generation. They did it in words, they did in singing, they did it in many ways. I think it is a great manifestation. It went beyond the parish boundaries.

I think it makes them feel close-knit. I think when people immigrate the hardest thing for them is to break from their hometown, and they want to reproduce what they did there. I mean otherwise you're alienated, you've lost your roots. This keeps them in touch. I think in the next generation they'll ask, "How did our parents live? Why was it so important for them?" Maybe they recapture these things. When I was a kid when I went to school, the Italians wanted to bend over backwards to show they were American. Now the next generation what do they want to do? They want to go back to who they were.

ISABEL MAZZOTTA

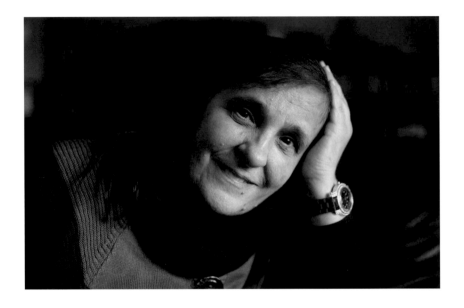

Isabel Mazzotta has worked as a professional artist in Toronto for over 25 years. A graduate of the George Brown College Graphic Design Programme, she specializes in drawing, painting, face Painting, and origami and teaches art in community programmes in various schools. Ms Mazzotta has held numerous exhibitions and earned numerous awards her work. She is a tireless volunteer in the local arts community in institutions like the Art Gallery of Ontario as well as community centres, and is particularly dedicated to teaching young people. Ms Mazzotta has been a longtime volunteer and an organizer of the Good Friday procession, and for many years has played the role of Veronica. According to Christian tradition, Veronica was a woman in the crowds watching Jesus carry the cross. When he fell under the weight of his burden, Veronica broke free from the crowd, and rushed to wipe his face with a cloth. When she rose she discovered that the blood from the face of Jesus had formed an image of his face on the cloth—which became known as the Veil of Veronica. The following text has been excerpted from interviews with Ms Mazzotta in the winter of 2014–2015. She reflects on the Good Friday procession in the context of personal fulfilment, community and heritage.

Isabel Mazzotta: To play Veronica, it was in my heart to do it. Because, being an artist, I saw the cloth—the shroud—and the spiritual sense of Jesus. In a dream I saw the face of Jesus, and then I woke up the next morning and said to myself I really want to play that part because I am carrying the face of Jesus—that's why I wanted to play that part. For me to wipe the face of Jesus, it was magical, more than anything else, an inspiration.

I was telling people that I was no longer Isabel, I was Veronica, because I was changing into the character of Veronica. She was very spiritual, pure, maybe an angel but not a saint. It was more purity than anything else you know. It was just like Mary Magdalene. You know, from a hooker she became a saint. It's along the same feeling that I feel when you see the cloth being transformed into the face of Jesus, that's very magical—it's a metamorphosis.

Something happens inside you. It just lightens up, it's like when you see a candle being lit up, and you see through the flame. To me the Good Friday is in my heart and in my soul. And that's exactly what my feelings are when I play Veronica.

Good Friday is a day where we have to revamp and revoke. It's soothing into the soul. Just like if you listen to classical music or if you like Celtic music or whatever. It's a moment where you reflect on a person, you reflect your own life. Isabel has made mistakes but yet it's a reflection on how you want to be a better person and how you can sort of say, "Hey this girl is going through poverty, count your blessings."

It's an inspiration. It makes me feel really positive and good that I'm doing what I'm doing. Being the very high-spirited person that I am, right now because of Jesus saving my life the way he did, that's why I became so positive and so involved with spirituality.

My parents were very strict, so that's why the church for me was a source where I could go and relieve the anxiety, relieve the depression and get away from that atmosphere at home.

When I started acting in the procession I was showing people the shroud, it gave me a chance to say, "Hey this is Jesus, this is our belief, and that's what's in my heart because he changed my life he can also change yours." As years went on and I was walking as Veronica I felt that Jesus played a part in my life, and it has evolved so well. A lot of things happened in my life you know, my brother had an aneurysm, we've had three deaths in the family. And when my uncle saw me play Veronica in the procession he said, "Wow, this girl is really lighting up." Playing the role of Veronica was lighting up. You know when your eye as a photographer sees something through a camera—it's the same way that I feel. My soul really started getting like a photographer—it lightened up. When you see a candle, and you light it up and you can see inside the fire. All the beauty of the fire.

I was born right in the community; this is where my parents immigrated, for example, so I call it our roots. When I was growing up we would have candles lit in the house for Good Friday. Light the oil, the incense and stuff, but it was a very solemn, very spiritual, very religious day.

We would have the English songs, and the Italian songs. I was part of the choir too. The Italian songs would give you goose bumps. We used to stay up for Holy Thursday when we were kids, and we would sing all of those songs—*"Viva la Croce"* ("Long Live the Cross"), *"Dov'è Carita e Amore"* ("Where is Charity and Love?"). It would give you goose bumps! To me the music and the bands that would come out and play these funeral songs would be inspirational to you on Good Friday.

We all know who you are, Vincenzo. I know when I was coming out of the church with the costume and holding the shroud, I would look around, and I wanted to know, "OK, where is he? The photographer." It's like being part of a pillar of a church. You're part of the bricks of the church. That's the way I felt when I was part of the church.

Way back, they used to rent the costumes from that place—Malabar—on McCaul Street. They used to rent the soldiers' outfits there at one time. And then it got too expensive so all the ladies of the church would come down and they would start sewing and cutting. Fr Raymond started all of that, and we made the soldiers' kneepads, the skirts and stuff, the vests, everything.

Every year I would buy tape, all these things that you needed, because at that time it wasn't in the computer. You had to do everything by hand. Signs, everything was all done by hand. Fr Raymond did all of the beautiful illustrations and I did the type on the computer, like 'Character 1', 'Character 2', 'Character 3', etc. Because we had the stations of the cross, we thought why not have banners, so he ended up getting some donations from people. So that's why they decided, you know, why don't we do a recruitment of people? So that's how I ended up doing the board [of characters] and I ended up being at the back of the church every year to recruit characters. And I did a damn good job because I got them all filled!

The older people started passing on, like the lady who played *Addolorata* for years. They started dwindling. Even the kids, like those at St Francis School, when I went to school there we had like 250 kids, they've only got 80 now. So that's why I started the recruitment. Mauro started calling out to the clubs, sending letters to the clubs because those were the days we didn't have any computers either. Clubs such as Simbario, Madonna di Montica, Club Vallelonga, San Nicola da Crissa, you know all the *paesani* clubs that have events and stuff in their own little community.

And of course it's up to the priest too. He tries to keep up with the traditions. You know then you've got Cav Giuseppe Simonetta. I hope Giuseppe, God bless him, that he lives until he's 100. I think once he goes, I think it's going to kind of dwindle.

GIUSEPPE RAUTI

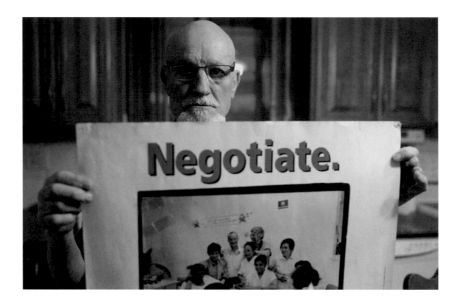

Giuseppe (Joe) Rauti has been performing the role of Jesus Christ carrying a wooden cross since 1968, when he was 31 years of age. Now 77, he keeps on going, and it seems to be understood within the community that the role has been reserved for him, indefinitely. A deeply spiritual man, he was moved by the processions that he witnessed as a young man in the streets of his native town, Chiaravalle Centrale, in Calabria, Italy. His life-long commitment is because of a vow that he made when he experienced a moment of doubt in his faith after the birth of a severely disabled child, Chiarina. My relationship with Joe and his family goes back to 1978 when his second daughter, Angela, collaborated on a children's book, Marco and Michela, that I co-authored and illustrated with photographs. Our paths crossed again in 1995, when I photographed Joe and his co-workers at a municipal home for the elderly for a series of posters about labour activism commissioned by the Ontario Federation of Labour. I interviewed him in February 2015, and his wife Francesca occasionally joined in the conversation, between looking after Chiarina in another room.

Giuseppe Rauti: I started [in the procession] in 1968. When I arrived in Canada, I noticed that they were doing processions like they did in the town where I was born, Chiaravalle Centrale [Calabria]. I said to myself, "It's like I arrived in Calabria."

When my daughter was born in 1963, my first born, Chiarina, we noticed that she began to be sick. We brought her to the hospital; but at the hospital they did not know what she had.

I went to Rome, to the *policlinico* (hospital). They told me, "For your daughter there's nothing that can be done. Return to Toronto, because what they can do there is better than what we can do here in Italy, because Toronto has the largest hospital for children in the world."

We waited for a whole year, and then we took her to The Hospital for Sick Children. They said, "There's no hope for your daughter. God has given her to you in this condition, and in this condition you have to keep her. And bear your cross."

Francesca Rauti: Five doctors called us in, plus an interpreter because we didn't speak English. We were surrounded in a room by all these people. They wanted us to understand so they made an example for us of a pig—as if she was a pig—"She has a brain like a pig's brain, they said, and it's dried-out. What can we do to your daughter's brain? There's nothing that we can do." They made this example for us to understand. The condition is meningitis. "Her brain is dried up, you must have patience and courage."

Giuseppe: I came home from Sick Children's. Walking. My brain was full of emotions. I no longer believed in the saints—not in the Madonna, not in God, not in St Anthony. I left my wife at the hospital, and I hurried home alone. When they told me that my daughter could not be saved, I filled my head with many things. When I get home, I said to myself, "I'm going to get the statue of St Anthony and throw him out."

When I got there, in front of the door, that statue of St Anthony did not let me enter the house, nor leave. I couldn't move. I was frozen.

Francesca: He stopped him. St Anthony. Someone stopped him on the spot.

Giuseppe: And so I stood there, in shock, in front of the door. I made the sign of the cross, and I said to myself, "God forgive me." So when I saw the procession of Good Friday, I said to myself, "I have to take part in this, I have to play the part of the Lord. Because the Lord suffered for us, and I want to suffer also for my daughter, and carry the burden of the cross. As long as God gives me the strength, I have to carry the cross."

For me it was a miracle. Because God gave me strength, he gave me serenity. I didn't change religion, nothing. God let me stay unchanged, the way I was made by my mother and father. God gave me the first cross with my daughter, and now he's given me another cross that I have to carry in order to understand that God exists.

At first I thought of carrying it for one or two years, maybe three. Now it's already 46 years.

There was only one year when I didn't carry it because of an operation on my back, on a disc, and the doctor said I can't do the same work as I did before, because I have to fall three times, and it's risky. A specialist who treated me came down to College Street to see me.

I had prostrate cancer, and changed three specialists. I went to Princess Margaret Hospital, and when the specialist, Dr Tony Finelli saw me, he said, "Are you Jesus Christ?" My daughter asked him how he knew that her father was Jesus Christ? He

said, "Because my mother comes to see the procession every year, and my mother cries when she sees you fall down."

Before I carry the cross, I fast for three days. I don't drink many liquids. From my mouth there's never a blasphemy or a curse. Whatever happens, happens, but in my mouth there's never any blasphemies.

My wife says, "Eat." The doctor told me I cannot carry on like this.

I used to listen to the elderly, like my mother, who would say to my father, "Today I will not eat. I will prepare food for you, but I will not eat. I will endure penance."

The first time that I ever carried the cross, I wore a tunic and then a coat over it because it was cold. I had a crown made from barbed wire. No shoes—sandals—but no socks. The Lord didn't have any socks either. or gloves. If you accept to carry out this act of sacrifice, you have to do so with faith. As I walk, I hear people who are watching me cry. Especially when I fall, and I say in my mind, "Lord forgive everyone, forgive the world."

At one time, the procession was done with more faith in our hearts. My other daughter is part of it now, along with my son-in-law, and my grandson, who dress up as characters. At the time of our parents, the community was more united, the churches fuller. From the time that we began, to now, people don't cry as much. Our ties with the towns that we left behind were tighter, people didn't speak English. Many people carry the torch ahead: Fr Riccardo, Fr Isidore, Fr Gregorio and Federico, Raffaele, and also the committee like Simonetta, Ariganello and Mauro. Fr Raimondo [Raymond] gave his heart to the procession. Today we have Fr Jimmy and Fr Corrado, they have seen how we did it, and they are following through.

When I turned 33, I thought to myself, I don't think that I can carry on. Yet he gave me the strength to continue. If I had remained in Calabria, I would not have been involved in such a procession. We are all immigrants, from different parts of Italy and now people from other countries too take part. There are Filipinos, Greeks, Chinese and others.

Three years ago they put me up on the cross, and when they put me on the cross, and they raised me up with it, I saw the world as a ball. And when I saw the Dead Christ arrive in the church, I felt like I was the person who had gone inside my own heart. And so after the Lord arrived in church, they lowered me down to the ground, in the arms of the Madonna. I felt better, stronger, my mind was sharper. I felt an internal strength because when they moved me, I felt like I was going to faint. My head was spinning.

MARIA GALATI

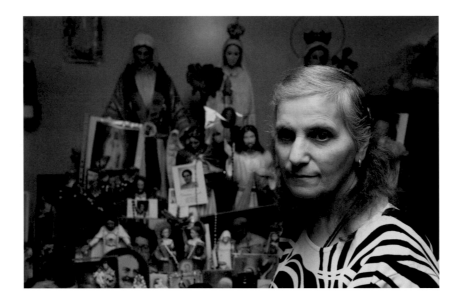

Maria Galati was born in Torre di Ruggiero, a small town in rural Calabria. She immigrated to Canada 1965 at the age of 13 with her family, and they settled in Toronto's Little Italy a few blocks from St Francis of Assisi Church, where they still live. She worked in a textile factory in Toronto's garment district along Spadina Avenue, where thousands of recently arrived immigrant women found their first job in Canada. Mrs Galati has been active in the procession for over ten years, playing mostly the role of the Madonna carrying the crown of thorns. In 2014 she was asked to substitute for the role of *Addolorata*, and as a deeply devout person, she was greatly moved by the spiritual experience. I was in conversation with her in the family's basement kitchen/living room, next to her elaborate table-top home altar adorned with a myriad of small statues, pictures of saints and deceased relatives, and votive candles. Mrs Galati focused on the deep spiritual significance of her involvement in the procession. Near the end, we were joined by her husband, Vincenzo, and her elderly mother, Marianna.

Maria Galati: I play the part of *Addolorata*. She is the mother of Jesus. I dress in black because Jesus has died, her son has died. It is a devotion that I have, because in Italy, I also participated in the procession. In the procession I get a certain feeling, I become emotional when I do this. I feel the pain that the Madonna felt for her own son, because the Madonna suffered so much for her son, and I feel it in my heart. I am also a mother.

In Italy I participated in many processions: Good Friday, *Madonna delle Grazie* (Lady of Graces), and others that I can't remember now. Always in my hometown, Torre di Ruggiero, in the province of Catanzaro [in Calabria].

The Good Friday procession was very beautiful. We used to walk to Mount Calvary, outside the town. From the church we went to Calvary. There, we went close to the cross of Jesus. I was 13 years old. We attended classes given by the Sisters, and the Sisters taught us many things.

I don't remember exactly the first year that I got into the procession here. But it was many years ago. Before Fr Raymond started. More than ten years.

In previous years I used to dress up in the role of the Madonna who carried the crown [of thorns] of Jesus. Last year I played the *Addolorata*. I was asked. At first I felt that I should continue with my traditional role of many years, but then it was like a voice inside me that said, "No. You must do it." And so I said yes. I felt it was like a calling that I should do the *Addolorata*. So I did it.

So, whenever I do the procession of Good Friday, I feel very close to the Madonna since she has suffered and I also have suffered. So I feel that Jesus was on the cross, and each one of us has to bear our own cross.

I suffered because my daughter had fallen sick, and so I prayed to Jesus and the Madonna, and they granted me my prayer. Otherwise my daughter would have either died, or remained paralyzed. Jesus together with the Madonna granted my prayers.

The moment that I put on that cape, I think of the Madonna. And the pain that she suffered for her son. I get inside her clothes. I do it with affection, with devotion. Because when my daughter was sick, it was them that I beseeched for help.

The cape that I wear is not mine, it belongs to the church. I believe it was made by the woman who passed away recently, or she had it made. She played the part for many years, and then she sadly passed away [Filomena Simonetta Maneli].

Despite the cold weather, I don't feel the cold during the time that I walk the procession, because I have that devotion, and the cold doesn't affect me.

I always wait with anxiety as Good Friday approaches. It's about something that comes from the heart. Sometimes when I do the procession, my heart beats fast, so much, and I say to myself "Oh, my Jesus, you have suffered so much, for us, for us sinners, for the entire world." And then, as I continue in the procession, tears come because I think of that. There is too much emotion. It's very moving for me. The others talk and chat, but I am always focused on my role.

Actually I don't like it when people talk, it's an important procession. Like the priest said, one shouldn't speak during the procession, or laugh, or say hello to others. It is like a day of mourning, a serious, solemn moment, not a time for light-heartedness.

The music is special. It is a funeral march. You feel it in your heart. Like now, as I'm talking, my heart is beating very fast, because I think always there. I my eyes I see Jesus crucified, I see the Madonna at the foot of the cross, it's a big emotion for me.

The children who accompany me—who hold the cape—they attend Catechism classes and are well prepared. They are like little angels. They don't talk to me, as I [maintain my silence]. Sometimes their mothers would tell them not to pull the cape too hard. But I wouldn't complain or say anything. One mother said to me, "*Signora*, Madam, tell them. Tell them not to pull too hard." But I never said anything to them.

I walk in silence. It's beautiful to be that way. I like it when it's treated as something solemn. I get that sense of something nostalgic for Italy, of the time when they did all those processions. I remember when we used to go to Calvary, we were many. It was beautiful.

I used to play the part of the Madonna who carries Jesus' Crown, in Banner 12. And there is a woman who carries a white cloth. Veronica is the one who cleans Jesus' face, and his image appears on the cloth. Laura played that role one time. She did it twice. My daughter. Then she didn't do it any longer because she would feel faint. Later she wanted to do it again, but I said to her, "No if you don't feel well enough, you shouldn't be doing it. It would not be a good for you to do it."

For preparation, I pray the *Via Crucis* (Way of the Cross). I do it right here next to my altar. They used to do it at night at church, and I used to go. I used to always go. But now, after the arrival of new priests, they do it in the morning, after the 8 am Mass. It's very beautiful. I bought the book to follow it through. The Good Friday procession is a tradition. And also a memory from Italy, of something that we used to do there. I was only a child.

Vincenzo Galati, Maria's husband, joins the conversation: I would like to say that perhaps there are people who come who are simply curious onlookers, not in a bad way, but simply curious about how well the procession is organized. I think that they are proud, especially the people who come from the small towns such as ours.

I think that now, in the way that we do it in Toronto, it has become more important, and naturally the public accepts it more and participates. I think it participates with great pride. First of all we are living in a foreign land, 'foreign' only in terms of the language and the system of laws.

It's become important because of the coming together of people from different towns, provinces, and regions. That is quite important, and the people value it more to participate. In fact they even come from Hamilton, and maybe even from the United States in organized trips with buses.

Marianna, Maria Galati's mother has been listening to our conversation in the background, and she suddenly offered a comment: Soon after we arrived in Canada, I remember running into Johnny Lombardi [a prominent businessperson] the first time that I went to College Street. I told him that I had just come from Italy. I was on my way to the back to make a small deposit. He said to me, "*Signora*, I wish for you that you will love College. It's on College that I arrived, and it's on College that I have to die." That phrase stayed with me all these years, and I never wanted to sell our house. I love College.

FABIO GESUFATTO

Fabio Gesufatto is an entrepreneur who has been actively involved in the Italian Canadian community for many years. As President and CEO of Blu Stella Entertainment Group, a company that organizes large-scale social events, he has been involved in planning musical concerts, corporate, sporting, and other large-scale cultural events in Toronto and cities across Ontario, including receptions for visiting Italian film stars, the official celebration of Italian National Day by the Consulate General of Italy, and the 20th Anniversary Gala dell'Arma dei Carabinieri (Italian Police Force) in 2014. He is President of the National Congress of Italian Canadians and a member of the Board of Advisors at the Italian Contemporary Film Festival. For almost two decades, he has been playing the role of Jesus being whipped and beaten by the Roman soldiers on his way to Mount Calvary to be crucified. In a recent conversation in Vaughan, Ontario where he lives, he reflected on his unusual, and sometimes controversial role due to the highly dramatic re-enactment of the flagellation of Christ.

Fabio Gesufatto: I play Jesus Christ. In that role, I'm pretty much whipped and beaten by the soldiers that keep pulling me in directions, on the way to Mount Calvary—just before they crucify Christ. That was my role.

You know I've been warned many times to tone my role down and I've been warned and warned, and I find that a lot of people that come down—and I hear this from a lot of people—is that they look forward to the role that I play, and also Rauti. It's not just walking the procession. I add a lot more emotion, a lot more drama into my role as Christ. So when the Roman soldiers beat me and whip me, they're actually beating me and whipping me. I could tell you one year I went to the hospital because I had a bruised rib. Every year I play that role, my Roman soldiers—and I have the same Roman soldiers for the last 17 years now, they're all just as committed as I am. They come and it's all about passion. Some people try to stop the procession. They try to stop my Roman soldiers from whipping me. So many times we'd have to stop the procession and let people know that this is not really real.

I get really emotional because you have a lot of *nonnas* and *nonnos* (grandfathers and grandmothers) and you can see the tears in the their eyes. Being able to have the honour of re-enacting this moment, playing the role of Christ. It's touching, it really is.

They keep resisting, they keep stopping and I keep asking them to continue. Every time it's always a struggle, my soldiers keep saying, "Fab, you sure it's okay to proceed?" And I say, "Yes, please continue. And if it gets to the point where there is excruciating pain then I will let you know. But until then, keep whipping." When they whip, they really whip. It hurts, it really does. The whips are made of rope and leather, and I feel it more if the weather is damp or if it's rainy and cold.

So I'm wearing a gown and I've also got a wig that I've used since day one, since I played Christ in 1999 for Joe Rauti, who had back surgery. I have my wrists and my hands are tied. I've got blood—we have a make-up artist for that. I'm wearing a crown of thorns, and the thorns have the real nails on them. And there are times that the real nails are actually grinding into my scalp. So we have blood on our face, our hands, our feet. I've got sandals on, I wear no socks. It's very cold. There were a couple of Good Fridays where it was warm but for the most part it is cold, absolutely.

There was one year—I'll never forget this regarding the sandals. I've had the same sandals from 1999 until five years ago when my dad passed away. I remember my dad passed away on 1 March, and Good Friday was shortly after. I've got to tell you, I remember it was a cloudy day, we started the formation outside, and we started walking. Both sandals just ripped. The sun came out and I remember we were walking towards College Street—just before College Street where you see all of those people lined up. Both of my sandals just ripped open, just ripped apart. And I was so shocked, and my soldiers were all shocked because I was just walking. And at that point, one of my soldiers just grabbed my sandals and I walked barefoot for the rest of the procession. In my eyes I would say it's probably a message from my dad, you know, that he's there, he's watching over me. Because I was in a moment—my frame of mind was very... it was an emotional time for me in that period of time after my dad passed away.

Filomena Maneli asked me do the procession as a favour, and I thought, "Okay, let me try let me see what this is all about." After I played the role, I had this feeling of comfort, accomplishment. It was—I can't describe it—it was a good feeling. I thought, I will continue this for as long as I can. It was a very good feeling, inspiring.

On my drive down on Good Friday to the church, I just block out everything or I just kind of think about family I've lost over the years, friends. And I stay focused on why I'm doing this role and why, what this means to me. You know, I lost my sister and my dad in one year—for me it's making a connection with them. Missing one year—I'm not sure, I've never missed one year and I always made the effort every year, attending and making time for it. You know also taking part of the Good Friday committee, I assist with that and I always do what I can to prepare for the Good Friday procession. There's a lot of work that goes behind the preparation of this. I mean, we're talking about hundreds of thousands of people. This is actually broadcasted all across the world. I mean I remember one year I had my grandmother call my mom at a time I'm on College Street, saying that they're watching me walking the procession. So, this is big, this is a big production in North America—not production sorry, procession.

What it is for me, it's my own ritual. I'm inspired by it. For me it's continuing the faith and it's my way connecting with God. Like I said everyday we get so caught up into our lives whether it's work or. I would say it's made me a better person. It keeps me grounded. It keeps me—it's more of a reminder why I'm here, so it keeps me grounded. It keeps me in check.

I've got to tell you—we see each other once a year, and every time we see each other it's like taking off from where we left off. So for me it's great to see everyone, connecting with them again. They're there for the same reasons as me—passion—and you know, and it's nice because a lot of their families come down, they have kids, babies, and there's certain parts in the procession where we stop and their kids come running proud of their dad.

I don't see myself as a star. I mean people approach me all the time, they stop me and they ask questions but I don't see myself being a star. I just see myself being Fabio Gesufatto giving back. Just maintaining our faith.

The only thing I'd want to mention is that Joe Rauti has been there such a long time doing it, and he inspires me as well for someone who has been doing it as long as he has. So I commend Joe Rauti and wish him another *cent'anni* (a hundred years). God bless.

We probably see each other once a year, I mean I try to keep in touch with everybody but it's difficult. But on Good Friday it's nice to reconnect with everyone and work together.

LIST OF WORKS

All photographs taken at the Church of St Francis of Assisi, or within the streets of its parish in Little Italy, Toronto.
Where available, the names of participants are given in square brackets.

 p 4 Statues covered in purple with Lenten veils, 2015.

 p 6 The official board of characters in the procession, 1995.

 p 29 Hands in prayer during all-night vigil in church, after the Good Friday procession, 1972.

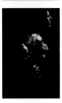 p 30 Women pray during all night vigil after Good Friday, 1971.

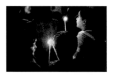 p 31 Children with candles during Mass of Resurrection, a service held in darkness in the pre-midnight hours before Easter Sunday, 1972.

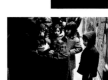 p 33 Children are curious about a statue of *Ecce Homo* (Behold the Man), representing the Flagellation of Christ, used in the Good Friday procession, 1975.

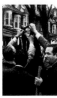 p 34 Men make last minute preparations for the *Madonna Addolorata*, (Our Lady of Sorrows), 1971.

 p 35 Statue of *Addolorata*, 1971.

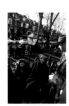 p 36 Two women chatting on the church steps, 1970.

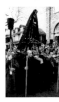 p 37 Statue bearers prepare to carry *Addolorata*, Grace Street, 1972.

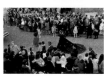 p 39 Led through the streets of the parish by a car, the Aggrieved Mother precedes *Addolorata* portrayed by a young girl in a black robe, Beatrice Street, 1969.

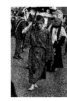 p 40 Man portrays Jesus, barefoot, Dundas Street West, 1969.

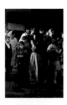 p 41 The Aggrieved Mother, symbolizing all mothers, Dundas Street West, 1969.

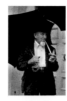 p 42 Man smokes a ceramic pipe outside the church waiting for the procession to commence, 1974.

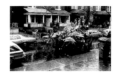 p 43 Man portraying Jesus precedes statues representing *L'Incontro* (The Encounter), in which Jesus is held to judgement by Pontius Pilate, Grace Street, 1979. [Giuseppe Rauti.]

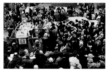 p 45 Crowd of faithful follow the *bara* (bier), in procession, Beatrice Street, 1975.

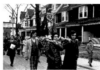 p 46 Young men carry a statue of *Ecce Homo*, representing the Flagellation of Christ, Grace Street, 1975. [Background left, Tony Daniele.]

 p 47 Women carry the accoutrements of the Crucifixion: whip, crown of thorns, and nails, Grace Street, 1971. [Left, Rosa Losiggio; right, Rosa Franzone; right, in back, Antonio Prioriello; second from right in the back, Luigi Ariganello.]

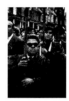 p 48 Torch bearers, Grace Street, 1971.

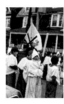 p 49 Altar boys carrying candles and Vatican City flag, Grace Street, 1975.

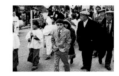 p 51 Young boy in his Sunday suit, Grace Street, 1975.

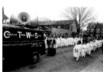 p 52 Fr Isidore De Miglio leads schoolchildren into prayer with a loudspeaker, Clinton Street, 1971.

 p 53 The Third Order of St Francis Prayer Group shares the road with a streetcar, College Street, 1979.

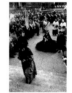 p 54 The Aggrieved Mother and a young girl portraying *Addolorata* return to church, Grace Street, 1970. [Three priests in background are, left to right, Frs Isidore De Miglio, Ambrose De Luca and Riccardo Polticchia.]

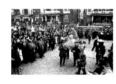 p 55 Statue of *La Pietà* returns to church, Grace Street, 1970. [Man in front wearing sash, Felice Ferri.]

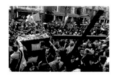 p 57 The Bier and the Cross, 1971.

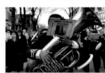 p 59 Tuba player, from the *Filarmonica Lira Bom Jesus*, a Portuguese band from Oakville, Ontario, Manning Avenue, 1983.

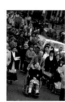 p 60 The crowd winds its way through Beatrice Street, 1986.

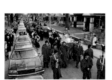 p 61 *La Pietà* with cars, Beatrice Street, 1986.

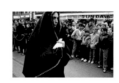 p 63 *Addolorata* College Street, 1986. [Anna Galati.]

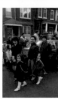 p 64 Two sisters dressed as *Addolorata*, 1983.

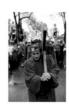 p 65 Man portrays Jesus in red gown, 1980. [Giuseppe Rauti.]

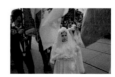 p 67 Three girls in First Communion dresses, College Street, 1981.

p 68 Flag bearers leading the procession wait for a break in traffic, Beatrice and College Streets, 1980.

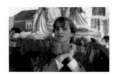

p 69 Young man carrying a statue, College Street, 1982.

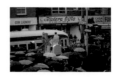

p 71 The eastbound streetcar catches up with the procession, College and Beatrice Streets, 1980.

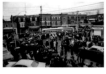

p 72 The westbound streetcar intercepts the procession, College and Beatrice Streets, 1980.

p 73 The Crucifixion, with umbrellas, Mansfield Avenue, 1980.

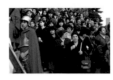

p 74 Roman soldier with crowd, 1983. [Roman soldier, Raffaele Simonetta; woman with candle, Mariangela Barbuto.]

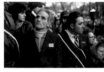

p 75 In mourning, Grace Street, 1982. [Left, Maddalena Cioffi; second from right, Francesco Marchese.]

p 76 Franco Grosso, peanut and popcorn vendor, Grace Street, 1983.

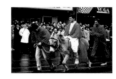

p 77 Man rides a donkey in portrayal of Jesus's arrival in Jerusalem, College Street, 1980.

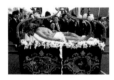

p 79 Woman in reverence of *Cristo Morto* (Dead Christ), Grace Street, 1984. [Mariangela Barbuto.]

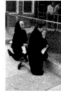

p 80 Women kneel in reverence as the saints pass by, Grace Street, 1984.

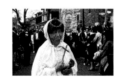

p 81 Devout woman portrays Jesus, Grace Street, 1984.

p 82 The Bereaved, Bellwoods Avenue, 1988.

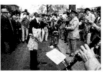

p 83 Maestro Drago conducts the *Italian Band*, Grace Street, 1984.

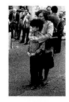

p 84 Mother and son, Bellwoods Avenue, 1984.

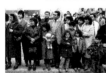

p 85 Crowd watching the procession, Grace Street, 1984.

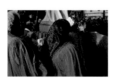

p 87 Black veil and red gowns, College Street, 1982.

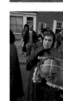

p 88 Woman carrying crown of thorns, Grace Street, 1982. [Rosa Franzone.]

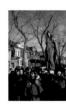

p 89 Women statue bearers carry *Maria Maddalena* (Mary Magdalene), Beatrice Street, 1982. [Left, Maria Cioffi.]

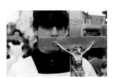

p 90 Altar boy with cross, Grace Street, 1986.

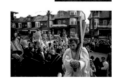

p 91 Jesus returns to church after the procession, 1982. [Giuseppe Rauti.]

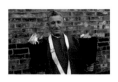 p 92 Torch carrier, 1986.

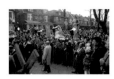 p 93 Statue carriers gather at the end of the procession in anticipation of their re-entry into the church, 1981.

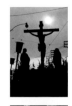 p 95 Three kinds of power: spiritual, natural, and man-made, College Street, 1986.

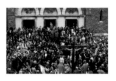 p 97 The crowd gathers in front of the church at the end of the procession, 1981.

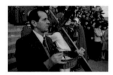 p 98 Usher offering prayer cards, Grace Street, 1983. [Pasquale Cariati.]

 p 99 Young woman kisses *Cristo Morto* adorned with a flock of hair offered in devotion by a believer, 1982.

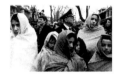 p 101 Women in shrouds, known as the Pious Women, Grace Street, 1999. [Background, left, Joseph Cordiano; right, Manfredi Antonucci.]

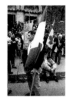 p 102 Men with Italian and Canadian flags wait for the procession to start, Grace Street, 1993.

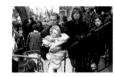 p 103 Family waits on the church steps for the procession to start, 1999.

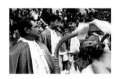 p 105 Members of the Congregation of the Crucifix, a spiritual group, stand by the *bara*, Grace Street, 1992.

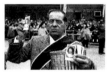 p 106 Usher distributes traditional prayer cards of *Ecce Homo*, Grace Street, 1992. [Pasquale Cariati.]

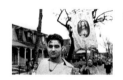 p 107 Penitent followed by banner of the Sacred Heart of Jesus, Bellwoods Avenue, 1993.

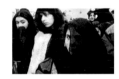 p 109 Women dressed as penitents, Grace Street, 1996.

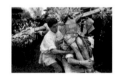 p 110 The eighteenth-century Baroque sculpture of the Crucifixion from Recco, near Genoa, Italy was brought to the Toronto procession in a one-time visit in 1997. [Sergio Bacigalupo.]

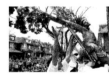 p 111 The Crucifixion is lowered to clear the church door for re-entry. [Sergio Bacigalupo.]

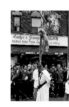 p 111 The sculpture of the Crucifixion is carried through the streets by one man, who according to tradition must balance it using a special harness with his hands clasped behind his back. [Left to right: Sergio Bacigalupo, Nanni Vullo, Alberto Spallarossa.]

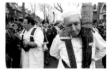 p 111 Carriers of the Crucifixion from Recco, Italy. [Left, Attilio Tasso; background (wearing sash "Gente"), Luigi Ripandelli; right, Titta.]

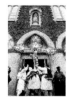 p 112 The Crucifixion re-enters the church. [Clivio Claudio, Alberto Spallarossa, Attilio Tasso.]

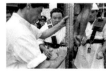 p 112 Carriers of the Crucifixion prepare the sculpture for its journey in the streets. [Left to right: Sergio Bacigalupo, Attilio Tasso, Alberto Spallarossa.]

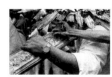 p 112 The Crucifixion from Recco, Italy (detail).

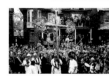 p 113 The end of the procession. [Left to right, in white: Alberto Spallarossa, Clivio Claudio, Titta, Attilio Tasso, Sergio Bacigalupo; others in foreground: Divo Dulbecchi ("Gente de Liguria"), Filomena Simonetta, Tony Maneli, Pino Fusca.]

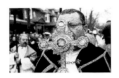

p 115 Priest with Relic of the True Cross, Grace Street, 1998. [Fr Albert Micallef, OFM.]

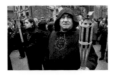

p 116 Members of the Third Order of St Francis of Assisi, a spiritual group, dressed as monks, Grace Street, 1992.

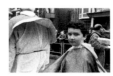

p 117 Young boy, dressed as an apostle, accompanies the *bara*, Grace Street, 1999. [Domenic Galati.]

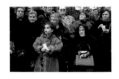

p 118 Young girl and elderly women on the sidelines, College Street, 1997.

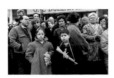

p 119 Young girl and boy with popcorn and toy gun, College Street, 1992.

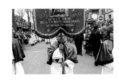

p 120 Man carries banner of the Confraternity of the Seven Sorrows of the Blessed Virgin Maria Addolorata, from St Nicola da Crissa, a small town in Calabria, Italy, Grace Street, 1993. [Vito Garisto.]

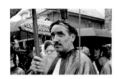

p 121 Man with crown of thorns, member of the Confraternity of the *Seven Sorrows* of the Blessed Virgin Maria *Addolorata*, Grace Street, 2002.

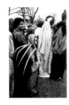

p 122 Girl carrying palms, Grace Street, 1992. [Woman on left, Caterina Galati.]

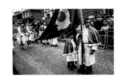

p 123 Father and son, members of a *confraternità* (confraternity), a spiritual organization, Grace Street, 1991. [Boraggino.]

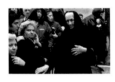

p 124 Elderly woman on church steps, Grace Street, 1997.

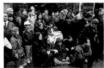

p 125 Crowd watching the procession, College Street, 1997.

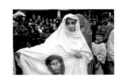

p 126 Veronica displays the veil on which the likeness of Jesus appeared after she wiped his bloodied face, Grace Street, 1999. [Isabel Mazzotta.]

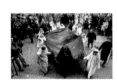

p 128 *Addolorata* returns to church, 2002.

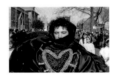

p 129 Portrayals of *Addolorata*. [Top left, Emanuela Maneli, 2000.]

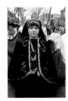

p 129 Portrayals of *Addolorata*. [Right, Teresa Simonetta, 1999.]

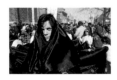

p 129 Portrayals of *Addolorata*. [Bottom left, Teresa Simonetta, 1996.]

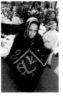

p 130 Portrayals of *Addolorata*. [Left, 2001.]

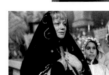

p 130 Portrayals of *Addolorata*. [Top right, 1998.]

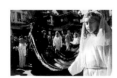

p 130 Portrayals of *Addolorata*. [Bottom right, 2004.]

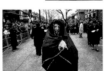

p 131 *Addolorata*, Grace Street, 1992. [Vittoria Cosentino in Maneli.]

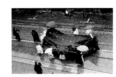

p 133 *Addolorata* with child attendants holding her mantle, College Street, 2000.

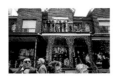 p 134 Watching the procession on Manning Avenue, 1997.

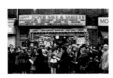 p 135 Faithful walk and pray with crowd of onlookers, College Street, 1993.

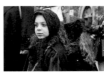 p 136 Young girl dressed as *Addolorata* (Lady of Sorrows). Grace Street, 1992.

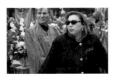 p 137 A member of the organizing committee [Filomena Simonetta.]

 p 139 Statue of *Addolorata* makes its way along College Street (overhead shot), 1996.

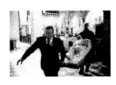 p 140 At the conclusion of the procession and service, *Cristo Morto* is taken into storage until the following year, 1999. [Right, Joe Martino.]

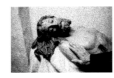 p 141 *Cristo Morto* in storage and a caressing hand, 1999.

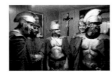 p 143 Actors receive last minute instructions in the basement of St Francis of Assisi church, 1996.

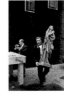 p 144 Carrying the statue of *Addolorata* into storage, 1993. [Right, Jerry Monaco.]

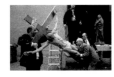 p 145 Removing the statue of the Crucifixion from its platform, for storage, 1992. [Second from right, Felice Ferri.]

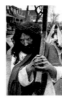 p 146 Portrayal of Jesus carrying the cross, Bellwoods, 1993. [Giuseppe Rauti.]

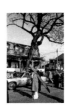 p 147 Actor dresses up in costume to portray Jesus, basement of St Francis Church, 1995. [Giuseppe Rauti.]

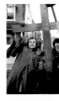 p 147 Jesus shows the cross to onlookers, as the procession gets underway, Mansfield Avenue, 1977 [Giuseppe Rauti.]

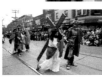 p 147 Jesus is about to fall the second time, College Street, 1993. [Giuseppe Rauti.]

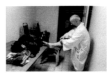 p 148 Jesus carries the cross along Bellwoods Avenue, 1987. [Giuseppe Rauti.]

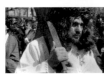 p 148 Jesus, College Street, 1990. [Peter Morfea.]

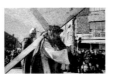 p 148 Jesus at the corner of College Street and Grace Avenue, 1996. [Giuseppe Rauti.]

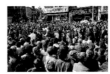 p 149 Jesus blessing the crowd, College Street, 1987. [Giuseppe Rauti.]

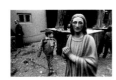 p 151 Statue of Jesus from *L'Incontro* waiting for storage, 1992.

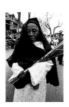 p 153 Woman with palms, Grace Street, 2002. [Myrtle Maylor.]

 p 154 Young man with banner of St Michael the Archangel, from Muskoka Lake, Ontario, 2005.

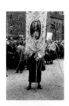

p 155 Woman with banner of Sacred Heart of Jesus, Mansfield Avenue, 2003.

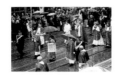

p 156 Priests led by Nicola De Angelis, Auxiliary Bishop of Toronto (front, middle). Fr Raymond Falzòn, OFM is carrying the Relic of the True Cross, College Street, Toronto, 2002.

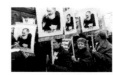

p 157 Members of the "Prayer Group Friends of Padre Pio at St Bernard Church", visiting from Hamilton and Niagara Falls, Ontario, Mansfield Avenue, 2003.

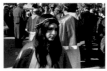

p 158 Penitent wearing crown of thorns, Mansfield Avenue, 2005.

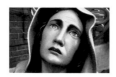

p 159 Statue of St Maria Salomè (detail), St Francis of Assisi Church, 2005.

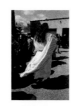

p 160 Unidentified biblical character, 2001.

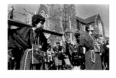

p 161 Young men portray the two thieves crucified with Christ, with St Francis of Assisi Church in the background, Grace Street, 2004.

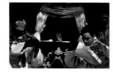

p 163 The *bara con il Cristo Morto* (bier with the Dead Christ) is carried out of the church, one of the most solemn moments of the procession, Grace Street, 2008.

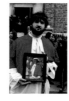

p 164 Man with picture of recently-deceased grandfather, Grace Street, 2015. [Domenic Galati holds photo of Nicola Galati.]

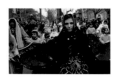

p 165 Woman portrays *Addolorata*, Grace Street, 2014. [Maria Galati.]

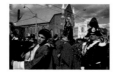

p 167 Statue of *Addolorata* in front of St Agnes Church, where the procession was founded in 1962, Dundas Street, 2013. [*Carabiniere* in dress uniform, Mario Vitale.]

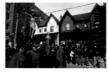

p 168 Statue of the Crucifixion, and a statue from *l'Incontro* (The Encounter), with renovated homes, Manning Avenue, 2009.

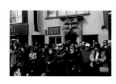

p 169 Crowd along the gentrified College Street, 2009.

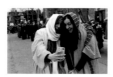

p 170 Girls in biblical robes taking a selfie, Mansfield Avenue, 2015.

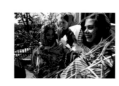

p 171 Girls with palms, Mansfield Avenue, 2014.

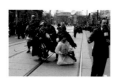

p 173 Reporting live, College Street, 2005. [Jesus portrayed by Fabio Gesufatto; soldier on right, Paul Saltero; reporter, Giorgio Mitolo.]

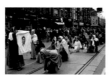

p 175 Veronica displays the veil with Jesus' face imprinted on it and the crowd of Pious Women fall on their knees, College Street, 2015. (Left, Isabel Mazzotta; fourth from left, Chagall Sierra.]

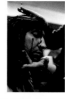

p 176 Make-up applied on the *Ecce Homo*, or the Flagellated Christ, 2004. [Fabio Gesufatto.]

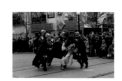

p 177 Jesus is pilloried by Roman soldiers, College Street, 2016. [Fabio Gesufatto; Roman soldiers in this and other images performed by Pasquale Cerundolo, Antonio Gorito, Rocco Marelli, Mario Rea, and Paul Saltero.]

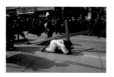

p 177 Jesus falls, College Street, 2015. [Giuseppe Rauti.]

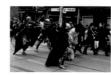

p 177 Jesus whipped by Roman soldiers, College Street, 2015. [Fabio Gesufatto.]

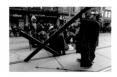 p 177 Jesus has fallen and is helped by Veronica, College Street, 2016. [Veronica: Isabel Mazzotta; Jesus: Giuseppe Rauti.]

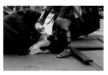 p 178 Jesus is helped by Mary after he falls, College Street, 2015.

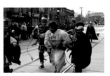 p 179 Jesus shackled and brutalized by Roman soldiers, 2005. [Fabio Gesufatto.]

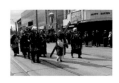 p 180 Moments before succumbs to the weight of the cross and falls, College Street, 2016.

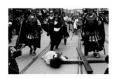 p 181 As Jesus falls for the third time, Mary his mother runs to him, College Street, 2015. [Woman screaming, Francesca Cerundolo; with glasses, Bianca de Carvalho.]

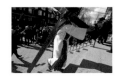 p 182 Jesus returns to the church, 2013. [Giuseppe Rauti.]

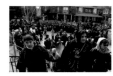 p 183 *Addolorata* returns to the church, 2013. [Rosa Callipo in Dileo.]

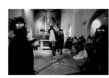 p 185 After the procession, Christ is raised on the cross inside St Francis of Assisi, 2008.

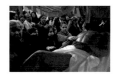 p 186 The ritual of Good Friday ends with the faithful lining up to say one last prayer and touch the statue of *Cristo Morto*, 2009.

 p 187 As a sign of devotion and farewell, a woman reaches out to touch the statue of *Cristo Morto*, St Francis of Assisi Church, 2013. [Maria Valentini.]

PUBLICATION HISTORY
OF PHOTOGRAPHS

Selections from *Ritual* have appeared in different iterations, or as a work-in-progress, sometimes accompanied by the artist or other contributors.

Books

de Klerck, Denis and Corrado Paina eds *College Street Little Italy Toronto's Renaissance Strip*, Toronto: Mansfield Press, 2006.

Pietropaolo, Vincenzo, *Not Paved With Gold*, Toronto: Between the Lines, 2006.

Rossi, Erno Delano and Giuseppe Iaconis, "The Italians", *Many Cultures Many Heritages*, Norman Sheffe ed, Toronto: McGraw-Hill Ryerson, 1975.

Stanger-Ross, Jordan, *Staying Italian: Urban Change and Ethnic Life in Postwar Toronto and Philadelphia*, Chicago: University of Chicago Press, 2009.

Verdicchio, Pasquale, *Bound by Distance: Rethinking Nationalism through the Italian Diaspora,* Fairleigh: Dickinson University Press, 1997.

Exhibition catalogues

Agosti, Paola and Maria Rosaria Ostuni eds, *L'Italia Fuori d'Italia immagini di emigrazione*. Roma: Seconda conferenza nazionale dell'emigrazione, 1988.

Cocchiarelli, Maria ed, *Vincenzo Pietropaolo: Not Paved With Gold*, New York: Italian-American Museum, 2007.

Magazines and Journals

Burton, Randy, "Ritual: Photographs of Good Friday", *Blackflash*, Winter 1998, pp 7–10.

Chiesa, Peppe, "La Passione di Cristo", *Il Laghetto dei Serresi nel Mondo*, Anno XXI, no 2, 1999, pp 12–18.

Fisher-Taylor, Gail ed, "Item", *Photo Communiqué*, vol 7, no 1, 1985, p 4.

Fisher-Taylor, Gail ed, "Item", *Photo Communiqué*. vol 7, no 2, 1985, p 4.

Macfarlane, David, "Stations of the Heart", *Saturday Night*, vol 102, no 4, 1987, pp 44–50.

Paci, FG, "Rituals", *Photo Communiqué*, vol 7, no 3, 1985, pp 20-25.

Pietropaolo, Vince, "Ritual photographs of Good Friday", *The Photo Pipeline*, vol 1, no 9, pp 18–19.

Pietropaolo, Vincenzo, "The Good Friday Ritual", *This Country Canada*, no 10, Spring 1996, pp 66–75.

Pietropaolo, Vincenzo, "Little Italy's Good Friday processions", *The Toronto Star*, 10 April 1998.

Pietropaolo, Vincenzo, "March of Time 30 years of Photography at the Good Friday procession", *Eyetalian,* Spring 1998, pp 16–20.

Pietropaolo, Vincenzo, "From College Street to Campo de' Fiori: A Journey in Social Documentary Photography", *Italian Canadiana*, vol 16, p 49.

Ungar, Karin, "Streetwise A Conversation with Vincenzo Pietropaolo", *Photo Ed*, May/June 2001, pp 8–15.

The author at the Good Friday procession, c 1995.

EXHIBITION HISTORY OF PHOTOGRAPHS

ABOUT THE PROCESS

EXHIBITION HISTORY OF *RITUAL*

Solo exhibitions of *Ritual*

1984	The Photographers Union Gallery, Hamilton, Canada.
1986	De Meervart Museum, Amsterdam, The Netherlands.
1987	Photographers Gallery, Saskatoon, Canada.
2015	Ryerson Artspace, Toronto, Canada.

Selections from *Ritual* included in solo exhibitions

1986	The Italian-Canadians. Canadian Academic Centre, Rome, Italy.
1986	Italiani in Canada. Touring exhibition opened at Sasso di Castalda, Italy.
1999	The Streets Were Not Paved With Gold. Pier 21, Halifax, Nova Scotia.
2003	Vincenzo Pietropaolo. 30-year Retrospective, Stephen Bulger Gallery.
2006	Not Paved with Gold. Fototeca de Cuba, Havana, Cuba.
2007	Not Paved with Gold. Italian-American Museum, New York.
2011	In Retrospective. De Luca Fine Arts, Toronto.

Group exhibitions

1973	Two Documentations. Ontario Institute for Studies in Education, Toronto, Canada.
1988-90	Italy Outside of Italy. Touring exhibition, Rome, Italy.
1988-90	Fotografía Canadiense Contemporanea. Touring exhibition through Mexico.
2001	Fotografía Canadiense. Fototeca de Cuba, Havana, Cuba.
2010	Fotografia Migrante. Università di Roma Tre, Rome, Italy.
2011	State of the Arts. Venice Biennale, Italian Overseas Pavilion, Italian Cultural Institute, Toronto, Canada.

The creation of this book has been a long time in coming, for it has been my intention for many years to distill the thousands of photographs that I have made into a visual narrative in book form. The process has been challenging not only because of the vast number of images (almost 20,000) but also because of the mix of photographic technologies. Working with 35mm cameras, I experimented with a variety of films. I began with black-and-white film in the 1970s, switching to colour negative film (used by professional cinematographers but packaged for use in still cameras) in the early 1980s and colour transparency film (slides) in the later 1980s, before returning to black-and-white film in the 1990s. I have been shooting with digital since the early 2000s.

The span of time covered by the book also proved somewhat daunting, for how does one construct a narrative of a recurring event without resorting to the use of photographs that may be all too similar? I resolved to structure the book in four broad sections, organized loosely by decade, though not chronologically within each decade. I scanned hundreds of negatives and slides, and eventually I made about 1,200 digital work prints. Scrupulously reviewing the contact sheets became a process of discovery and delight as I came across images I had never before enlarged and were total surprises. Some of these made it through the various editing stages and into the final selection. The process became very physical, as I meticulously sorted and laid out the photographs on a large floor space to begin selection and sequencing.

I began the narrative in the same way that the procession begins: from the intimacy of people at prayer in church. The procession spills out of the church, and the reader can follow it through the pages of the book as it winds its way, not only through the streets of the neighbourhood, but also through time, ultimately returning to the interior of the church. At the end the reader meets some of the main performers and organizers in their own homes, who tell the story of the procession "in their own words". The index of photographs contains brief descriptions with dates and names of individuals if known.

ACKNOWLEDGEMENTS

Sometimes it takes a village to create a book. Such was undeniably the case with this book, as it involved the collaboration and support of many people across a wide cross section of the community.

The prototype of the book was created as partial fulfilment of the requirements for the degree of Master of Fine Arts in Documentary Media, School of Image Arts, Ryerson University, 2015. I am indebted to Katy McCormick, my thesis supervisor, for her support and for sharing invaluable insights about the transformation of a vast archive of photographs into a photobook. I am grateful to Professor Marc Glassman, my thesis advisor for his appreciation and support of my work, as well as to Dr Blake Fitzpatrick, Dr Gerda Cammaer, and Professor Sara Angelucci for their input and practical suggestions. Thank you to my fellow classmates with whom I exchanged ideas about the process and concept, and who followed the book from an abstract idea to reality. I am grateful to Katie Anderson, Juan Pablo Pinto, Francesca Sasso and Ali Weinstein who documented me as I photographed in the procession, and in particular to Amin Toyouri who also created my crowdsourcing film.

I would like to thank Giuliana Colalillo, my wife and life partner, who has been a part of the process of the making of this book from day one, for her contributions and support; my daughter Adriana Pietropaolo, who has painstakingly designed the prototype with me; my daughter Cristina who copyedited my texts; my daughter Emily and her partner Andrew Arseneault who designed and managed my crowdsourcing site; Jorge Guerra who helped me develop the original concept of the book; Art Kilgour who shared his invaluable expertise on digital file preparation; filmmakers Paola Marino and Benedetta Marassi who documented the making of the book; and Laura Sky and Nino Ricci who endorsed the book.

A special thank you goes to Manuela Fugenzi who worked tirelessly to help me edit and sequence the book, and Don Snyder and Maia-Mari Sutnik for their illuminating texts and valuable suggestions.

I am also grateful to the following members of the community for their practical help and suggestions: Luigi Ariganello, Teresa Callipo in Dileo, Rosa Callipo in Dileo, Joanne Dileo, Rocco Domisio and Nicolina Raimondo and family, Mauro Fallico, Fabio Gesufatto, Maria and Vincenzo Galati, Ricardo Aleixo Gomes, Catherine Macleod, Roberto Martella, Isabel Mazzotta, Fr Ralph Paonessa OFM, Kamelia Pezeski, Anna Prior, Giuseppe and Francesca Rauti, Cav Uff Giuseppe Simonetta, Angela Surdi, and Fr Jimmy Zammit OFM (Pastor, St Francis of Assisi Church).

I am indebted to the following individuals and organizations who generously supported a crowdsourcing campaign, without which the book could not have been published (in alphabetical order):

Deborah Brent, Silvio Ciarlandini, Valerie Elia, Elizabeth de Boer and Ross Redfern, Brendan Calder, Connie Dilley, Janusz Dukszta, Wolfe Erlichman, Ron Ginsberg and Magdalene Winterhoff, Marc Glassman and Judy Wolfe, Dolores Gubasta, Jorge Guerra, Karen Holtzblatt, Kim Kehoe, Victoria Lee and Philip Hébert, Iolanda Masci with Michael Mannara and Raffaella de Simone, James Rottman Fine Arts, Nichola Martin and Art Kilgour, Bruce McCormick, Katy McCormick, Joe Montesano, John Montesano, Peter Paul Charitable Foundation, Damiano Pietropaolo, Domenico Pietropaolo, Mary Pietropapolo, Liane Regendanz and Michael Craig, Ken Rockburn, Rochelle Rubinstein, Giuseppe Simonetta, Bill Sinclair, Maia-Mari Sutnik, Carole and Howard Tanenbaum, Nick Torchetti, Ursel Phillips Fellows Hopkinson, and all the other crowdsourcing supporters, too numerous to list.

I am grateful to the staff at Black Dog Publishing, especially Albino Tavares and James Brown, for their care and commitment throughout the process.

Finally, I would like to express my deepest gratitude to the Mariano Elia Chair in Italian Canadian Studies (Prof Gabriele Scardellato, Chair), who provided me with generous support from research to production stage.

Black Dog Publishing Limited
10a Acton Street, London, WC1X 9NG
United Kingdom

t: +44 (0)20 7713 5097
e: info@blackdogonline.com
www.blackdogonline.com

Designed by Albino Tavares at Black Dog Publishing.

British Library in Cataloguing Data
A CIP record for this book is available from the British Library

ISBN 978 1 911164 07 4

Black Dog Publishing Limited, London, UK, is an environmentally responsible company. *Ritual* is printed on sustainably sourced paper.

Page 213: Photograph by Vincenzo Marchese.

Concept by Adriana Pietropaolo.

The
MARIANO A.
ELIA CHAIR
in Italian-Canadian Studies

art design fashion
history photography
theory and things

black dog
publishing

london uk

www.blackdogonline.com